# MODERN PHOTOGRAPHIC TECHNIQUES

WOLFGANG FREIHEN

# MODERN PHOTOGRAPHIC TECHNIQUES

**TRANSLATED FROM THE GERMAN BY
A. A. CHALKLEY**

**BOOK CLUB ASSOCIATES
LONDON**

*First published in Great Britain* 1976 *by*
JOHN BARTHOLOMEW & SON LIMITED
12 Duncan Street, Edinburgh EH9 1TA
And at 216 High Street, Bromley BR1 1PW

This edition published 1977 by Book Club Associates
By arrangement with John Bartholomew & Son Limited

Reprinted 1978

German edition published by Falken-Verlag, Wiesbaden, under
the title *Moderne Fotopraxis*

Printed in Great Britain by W. S. Cowell Limited, Ipswich, Suffolk

# CONTENTS

# FOREWORD

If you know little or nothing about photography, you have many pleasures yet to discover, and this book will prove a reliable guide to help you on your way. You must already know that the art of taking a good photograph is not solely dependent on the camera, otherwise you would not have picked up this book, but would instead have bought one of the many cameras advertised as only needing a button pressed to produce 'perfect' results every time. Photography, though, is not simply a mechanical process; for true success there has to be something of your personality reflected in the pictures, and this book will show you how to make the best use of your camera, how to use the various accessories, what is commonly considered a mistake, and how you can exploit such 'mistakes' to produce pictures that stand out from the run-of-the-mill snapshot, in short, how to take better photographs.

The second part of this book is intended for reference purposes. Here you will find in glossary form an explanation of various photographic terms; the glossary is extensive enough to fulfill the role of an index so that you will quickly be able to find any term with which you are unfamiliar. Darkroom techniques are not discussed in these pages: the emphasis is on producing the best possible results *before* processing.

# THE CAMERA IN PERSPECTIVE

## A BRIEF GLIMPSE INTO THE PAST

Although the *camera obscura* had already been known for many centuries, photography was not truly discovered until the first half of the nineteenth century; the great breakthrough came with the discovery of light-sensitive materials by the two Frenchmen Niépce and Daguerre. The stage reached in photographic technology today has only been reached by the simultaneous development of both cameras and film materials, and it has been self-evident since the very beginning that the one is not possible without the other.

For hundreds of years the *camera obscura* was a mere curiosity, consisting of a dark room with a small hole in one of its walls. A reduced inverted image of the world outside was projected through the hole on to a whitewashed wall opposite. This phenomenon was noted by the Arabs as early as the eleventh century, but not until the end of the sixteenth century did Italian academics first hit upon the idea of fitting a converging lens into the hole in order to give a brighter and sharper picture. Another hundred years passed before a practical use for the *camera obscura* was found, as a gadget for the creative artist: collapsible and portable, and later when reduced to a compact miniature size, it proved a comparatively easy way of enabling artists to exactly reproduce perspective in pictures of landscapes, buildings, and even in portraits. At about the same time, the world's first 'reflex camera' using a mirror was made, and indeed it was this type of camera that was used by Niépce and Daguerre in their first experiments. The first photograph, taken in 1826 on a lead plate coated with light-sensitive asphalt, needed an exposure time of eight hours.

Since these early days there has been an infinite amount of research in the field of photography, but the apparatus we now use is nevertheless no more than a *camera obscura* in principle, albeit miniaturized and equipped with all the refinements available: high-quality lenses have replaced the simple converging lens, resulting not only in a greater degree of sharpness, but also allowing a lot more light to get through. In conjunction with this, the development of highly sensitive film materials has brought about a massive reduction in exposure time. Whereas photographers were formerly limited to taking pictures using a tripod, handheld exposures lasting a fraction of a second are now the rule. An adjustable diaphragm, such as that used in the

'reflex camera' of the eighteenth century, was no longer sufficient to ensure that the right amount of light was let in. A precision shutter was needed so that the exposure time could be measured exactly in hundredths and even thousandths of a second. An electric lightmeter, often built into the camera, ensures the right exposure for each shot: a whole roll of film can now be exposed instead of individual plates, high-quality viewfinders show the precise distance setting and the limits of the field of view. Above all, our modern cameras are synchronized for use with flash, or even have a flashgun built in and ready for use. This facility allows them to be used independently of the prevailing light conditions, which used to impose strict limits on a camera's scope.

There are so many cameras and accessories on the market today that it becomes confusing and extremely difficult to choose the one most suitable for the job. If price were the only criterion, it would simply be a case of buying the dearest to obtain the best: of course, there is no question of any one camera being the best. Each model has features which may make it more or less suited to a particular purpose, so it is well worth taking a few fundamental points into consideration before making a purchase.

## POINTS TO CONSIDER BEFORE BUYING A CAMERA

The fact that some famous photographer uses a particular model is no reason to follow his example: nor should you let a friend persuade you to buy a camera simply because it has suited his purposes. What you want is a camera that is going to respond best to what you yourself demand of it.

Make sure why you want to take photographs, how often you are going to pick up the camera, and what the subjects are likely to be. Do you simply want to take the odd souvenir snapshot now and again, or do you want to use your camera more often, capturing holiday experiences or combining photography with one of your hobbies? Do you require a camera for your work, or do you want to try to earn some money with your pictures? It is quite clear that there is no need to splash out on a precision-built, quality camera just for a few snapshots: on the contrary, you want as few technical problems as possible. In this case, what you need is ease of use; look through the viewfinder, press the shutter and it's done. This is offered only by the 'Instamatic' kind of camera, where the introduction of cassettes has even simplified film changing. If this type is not sufficiently adaptable, you should ask yourself whether it is worth paying a great deal more money for a camera with greater capabilities, simply for the sake of a few photographs that are out of the ordinary. How often, for example, are light conditions going to be so bad that you really need a camera that goes down to $f1 \cdot 2$? An amateur can expect to count the number of times he takes such

shots on the fingers of both hands. If this is going to be the case, it is more sensible to put the extra money aside towards useful accessories. Go for a camera with a lens having a more normal $f1 \cdot 9$ or $f2 \cdot 8$, and if the need arises put in a faster film.

Where you are going to take your pictures is also important. If climatic conditions around you tend to be extreme, say in the humidity of the tropics or in ice-cold mountain areas or near the poles, then clearly only an expensive and rugged camera, able to endure such hardships, should be seriously considered.

The next question is who is going to see these photographs? Just you? Or are they for the benefit of others too? If it is a question of earning money with pictures, it must be borne in mind that, while miniature format is sufficient for exhibitions, there is a preference for large format if colour photographs are to be printed (although nowadays slides are usually of sufficient quality for printing purposes); format is not nearly so important a problem when black-and-white photographs are being sold.

You must be quite clear about the quality of the picture you are after, and what price you are prepared to pay to achieve it. Anyone laying great value on exceptional detail and a broad spectrum of tone needs as large a format for his camera as possible: but this of course involves not only greater expense for films, camera, and accessories – and the extra luggage that this entails – but also considerably more work and time. For convenience, large-format work is normally left for static shots, with smaller, hand cameras being used in most other situations. It is important to bear in mind that there is a much more extensive range of accessories for small- and medium-format cameras than for those giving large-format pictures.

The importance of personality should not be overlooked; a calm conscientious worker may do very well with the large format, whilst all the advantages of the more dynamic miniature camera are perhaps better suited to a slightly more impulsive person.

All these pros and cons show that there is no ideal solution to the question of size alone, so a compromise must be made. The largest camera catering for a particular group of subjects will be chosen by the person placing great importance on the technical quality of his work: something smaller is better suited to the person laying more value on being ready to shoot and having less work to do.

It is self-deception to suggest that if one is working for oneself high quality becomes less important. True satisfaction can only be obtained from photographs that have really come out well, are technically faultless, and are recognized as such by others. Photographs of which the photographer cannot feel proud get shoved into a drawer and the joy of photography is soon lost. So do not make the mistake of thinking that an amateur should be happy with a camera inferior to that used by a professional. The only difference is that a professional is liable to be called upon to take a greater variety of different sorts of photograph and so needs a universal camera; nor is he going to get away with just having the one: others will be necessary for special purposes. As an amateur, though, you only need to photograph what you want, so you can do without those extras which you would not use to their full advantage.

Choose your camera, then, according to what you want to photograph. Admittedly this is easier said than done, for the beginner always wants to take photographs of everything, which of course is not possible. You will have to be clear about this: something that is made easier by the fact that you know best what you like. If your interests lean towards sport, art, nature, or whatever, you can be sure that this is what your camera is going to be needed for. This is by no means to say that you should limit yourself to this or that subject, but is simply to suggest that one particular interest is likely to predominate. The great majority of amateur photographers automatically combine their photography with an interest they already have, and it is just as well, for as the saying goes, the better you understand the things you are trying to represent, the better the pictures will be: knowledge is combined with a camera that is best suited to the special demands made on it. If your interests conflict too much (from a photographic point of view), the only thing to do is buy a second, or even a third, camera.

If, after taking all these factors into consideration, you find you need a camera that costs a lot more than originally estimated, buy it anyway! Never buy another model simply because it costs less. In the long run you will still be better off paying the extra rather than finding out that you have made a mistake, and have to pay out for the dearer one after all. There is, moreover, no need to buy the latest model if you can get last year's at a much reduced price. Even a second-hand camera can be first-class: in many cases you can arrange a trial period during which, if you are not happy, you can return it. Also make sure you get a full guarantee.

Without a border, the picture seems to grow out of its confines and gives an impression of size and grandeur.

## TYPES OF CAMERA

Cameras are distinguished according to format, lens mounting, viewfinder system, and shutter, apart from any particular use they may have.

## DIFFERENCES IN FORMAT

Using film material as a guide, we distinguish between pocket and miniature cameras, and those of medium and large format. The following criteria are involved: the larger the format, the better the reproduction of detail and the general sharpness, and the greater the richness of tone values; graininess, dust, and scratches are less obtrusive in enlargements and the negatives are easier to retouch; it is also easier to make enlargements of parts of the negative. Light sensitivity can be used to full advantage in the large-format camera, whereas the increase in graininess associated with this means that limits are set on smaller formats. Precise techniques are particularly necessary with microfilms, so if you are not going to take on the work yourself, they should only be processed by dealers who offer a special microfilm service.

Large formats are therefore unequalled for quality: against them is the fact that costs for medium- and large-format equipment are very much higher. The miniature camera gives best value for money, as well as possessing the further advantage of not needing as much space and having the capacity for long lengths of film. Where fast work is called for, as in reportage, series shots, and other such areas, small- and medium-format cameras find great favour as they cut down the time spent changing films.

Pocket cameras are impressive because of their almost unbelievable precision. Because of the limited enlargement possibilities – only up to half-plate without obtrusive grain – they cannot establish themselves in the field of picture-taking: for this reason it is perhaps preferable to go for the smallest possible miniature camera, if it is only a question of having one small enough to put in your pocket every time you go out. The negatives they produce are gigantic compared to those of the 'micro-camera', and have all the advantages that go with the increase in size.

Miniature cameras are the most popular type of camera, having $24 \times 36$ mm. as their most usual format – the market for smaller ones, even half-frame, is tiny by comparison. Various, sometimes interchangeable, viewing systems, a large range of changeable lenses, and extensive lists of accessories mean that miniature cameras can deal with most photographic requirements. Because they produce such sharpness, and because they are so convenient, they are particularly attractive when speed is an important factor. Cameras with motor drive or sprung rewind enable sequences of photographs to be taken. Amateurs who want to confuse themselves with technology as little as possible will find automatic and semi-automatic cameras in this

category. A serious amateur is best advised to choose a semi-automatic model, despite the attractions of the completely automatic type; with the former he can play a part in the creation of the picture by his free use of aperture and exposure time; this is impossible with a fully automatic camera.

Medium-format cameras are ideal when a multi-purpose model is needed; they are available with simple viewfinder or as double- or single-lens-reflex cameras: in this last instance, we are talking about high-quality cameras with a vast range of accessories. The most frequent negative size is $6 \times 6$ cm., which, although relatively large, is by no means unwieldy, and is fast enough for snaps and pictures of moving objects. Anyone who finds that

35 mm. results do not match up to his requirements, and who needs to turn his camera to more varied use, is best advised to buy one in this category.

The first miniature camera was developed in 1925 by Oskar Barnack. It was marketed under the name Leica (LEItz CAmera). It was to be a long way from the first Leica to the latest M5.

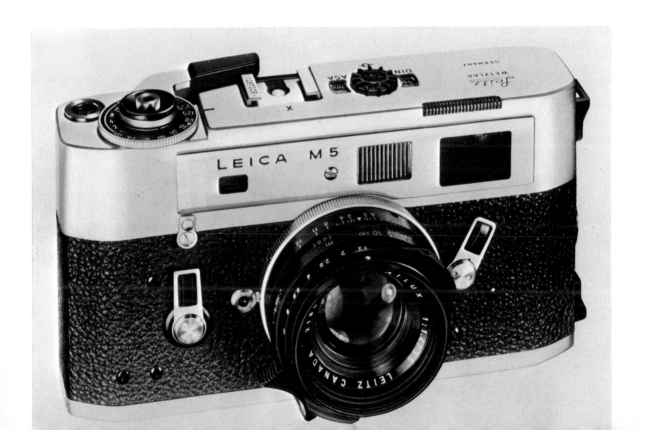

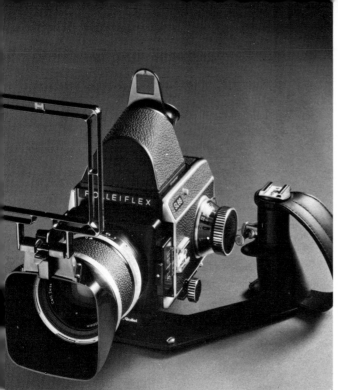

Large-format cameras are also known as studio, plate, or ground-glass cameras, usually taking a negative of 9 × 12 cm; there is occasional use of larger sizes. Their lenses are mounted in such a way that they can be adjusted to overcome the problems of perspective, which occur particularly in architectural pictures: this facility ensures that unattractive lines as well as tapering perspectives can be avoided. It goes without saying that these cameras are tiresome and time-consuming to carry around, and they are mostly used on a tripod. Although they have no amateur application, these cameras excel for photographs that have technical, advertising, or architectural application. They are used mainly for high-quality studio photography.

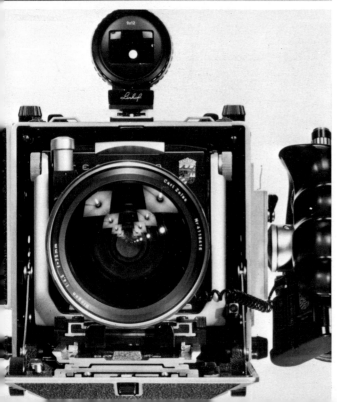

Top:
The Rollei SL66 is an example of a medium-format single-lens reflex camera which can be dismantled. It is shown here with a 150 mm. lens, prism viewfinder, sportsframe attachment, and hand grip.

Left:
A Linhof camera.

Right:
The Master Technika as an example of the tubular runner system; among large-format cameras it is reckoned to have the widest range of applications.

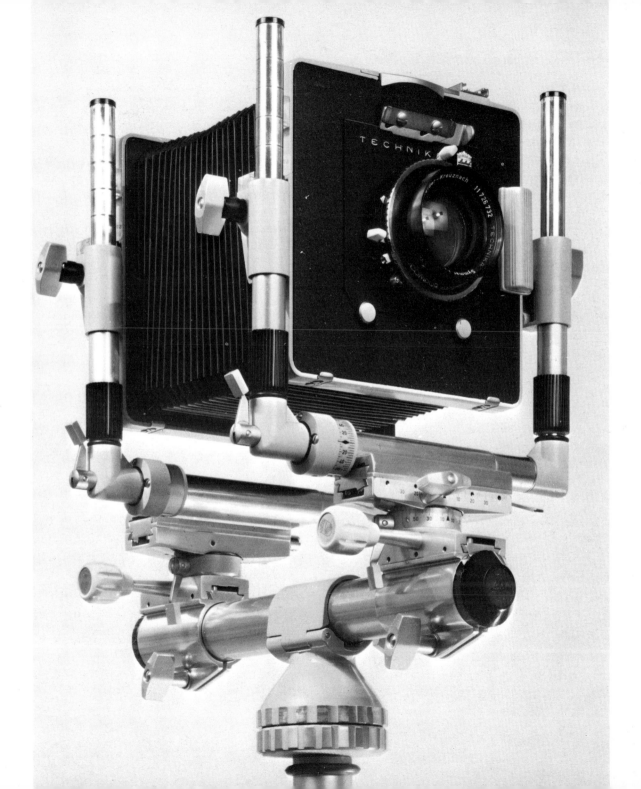

## DIFFERENCES IN LENS MOUNTINGS

This section deals with the differences between fixed lenses, detachable lenses, and composite lenses.

Most simple amateur cameras are equipped with fixed lenses, which allow everyday shots: but anything verging on the extraordinary is beyond their capability. Adding supplementary lenses merely makes close-ups possible, within certain limits.

Rollei SL35 with its complete range of lenses is an example of the versatility of a miniature reflex camera.

The variety of photographs that are possible with interchangeable lenses is much greater. But if the shutter-release system is incorporated in the lens, only special lenses can be used: and only a limited number of these are now available, which makes the camera rather less versatile. The maximum focal distance for such cameras is 200 mm., and for close-up work they are no better equipped than those cameras with a fixed lens.

Cameras with a complete 'programme' have a focal-plane shutter and a reflex finder, or at least make provision for one to be fitted. Any lens can be attached as long as it corresponds in size to the format of the camera, so the manufacturer does not have a monopoly on the lenses used for his camera. Other makes of lenses can either be fitted by a photographic mechanic, or can be attached using

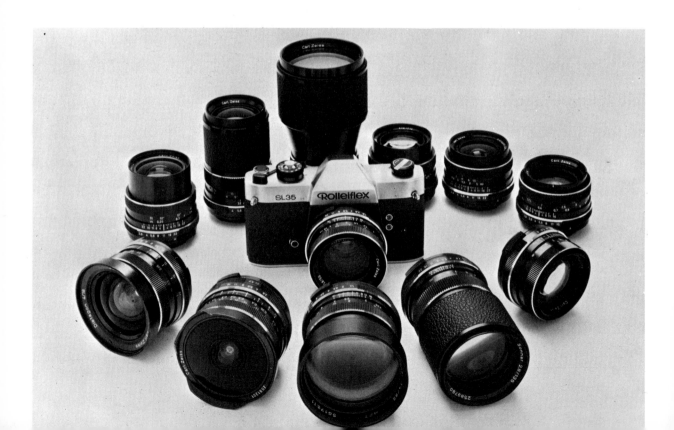

an adaptor available as an accessory. This makes such cameras truly universal, for they can cover all areas of photography, from macro to telephoto. Lenses of all focal distances can be used, from variable to fish-eye.

Composite lenses come halfway between the above two categories. The rear part of the composite lens remains attached to the camera while the front part is changed for a different lens of the same system, but are normally restricted to variation in the focal distance of 1:4 which sets severe limitations on their adaptability.

## DIFFERENT VIEWFINDER SYSTEMS

The utmost attention must be paid to the viewfinder when buying a camera: it is, after all, the principal control over what will be photographed. In it the pictures are composed, parts left out, and obtrusive details and unattractive intersections spotted. It is normally linked to the distance setting, and is even

Top: Double image through a rangefinder using a prism.
Middle: Displaced image through a rangefinder using a mirror surface.
Below: Neither duplication nor displacement of image occur when the distance is correctly set.

partly responsible for the control of depth of focus: all good reasons for not underestimating the value of a large bright viewfinder. If several cameras all match up to your requirements, choose the one with the best viewfinder.

Cameras with a simple straight-through viewfinder or a rangefinder show a small image compared with the format of the negative; this of course means that they are not so useful for controlling the composition of the picture, unlike larger reflex finders. Another point to consider is that the impression given by the viewfinder will not be that eventually realized on the photograph; the photograph will be built up of sharp and blurred zones with a gradual transition from one to the other. The problem of parallax is yet another disadvantage.

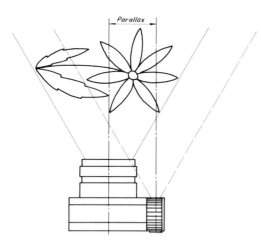

The parallax problem.

Since lens and finder do not lie in the same optical plane, the subject is seen from a slightly different angle in each case. This does not make much difference over long distances or even medium distances, but at short distance, and especially with close-ups, it can cause great problems. The advantage is in size and ease of handling: the subject is not lost when the shutter is released, and, if lighting conditions are bad, distance can be measured more easily with a rangefinder than with a reflex. The rangefinder is simply a question of bringing two images together, which makes it useful not only for available-light photography, but also for all photographs taken in natural settings, and particularly those where speed is all-important to capture a passing moment.

Cameras with ground-glass screens are very time-consuming to transport. Nevertheless, the picture on the screen is exactly what is going to appear on the plate, so there is total control in this respect; but the image is inverted and gets darker towards the edges, and, moreover, you need a dark cloth over your head to see it clearly enough to make the necessary adjustments and to keep out stray light. Finally, the tripod is indispensible since the screen must be changed with the plate, which rules out moving subjects. The ground-glass system is found on the old bellows cameras of grandfather's days, on some medium-format cameras over 6 × 9 cm., and on all large-format studio cameras. It has therefore little significance for the amateur, although many of its advantages – but not its disadvantages – are used in the single-lens-reflex camera. The SLR system consists of a sprung mirror crossing the light

path at 45°: the lens thus becomes an extension of the eye, and projects an image on to a horizontal ground-glass screen, which is similar in size to the negative. This system eliminates parallax, and still permits full control of distance and depth of focus. Since there is a gradual transition from blurred to sharp, the normal method of focussing is to go past the sharpest setting and then return. When the shutter is released the mirror jumps up, letting the light through to the film. This makes snapshots as easy as with a rangefinder. The advantages of this system used on small- and medium-format cameras with a focal-plane shutter give a camera *par excellence*. There is of course some price to pay for these advantages: dimensions are larger than those of a rangefinder camera, there is a noise when the shutter is released, and the image momentarily disappears.

Versatility on SLRs is achieved by the interchangeability of the various basic parts: reversing rings, extension rings, and bellows can all be used, together with the greatest variety of lenses, including those with perspective control, variable and fish-eye lens, right up to the longest telephoto lenses. It is almost taken for granted that a modern camera of this sort will have through-the-lens metering: those without a built-in CdS cell can be fitted with a special viewer which does the same job.

Photographers with a particularly wide range of interests should make sure that the viewer and screen are interchangeable, so that the camera may be used at eye or chest level: many single-lens-reflex cameras unfortunately have the prism built-in, which prevents the fitting of a box viewfinder. The film magazines of the top-quality 6 × 6

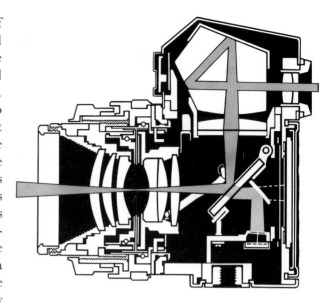

Section through a Leicaflex single-lens-reflex miniature camera. The light rays go through the lens and hit the hinged mirror, and from there are transmitted to the eyepiece through the pentaprism.

A small opening in the middle of the mirror allows a beam of light to be reflected off another mirror onto the double photo-cell, giving a spot reading.

When the shutter is released, both mirrors snap together and are lifted against the viewing screen, giving the light free access to the film.

cameras are interchangeable, so that you can change from black-and-white to colour, or vice versa, by changing the magazine, and it is even possible to use plates, sheet film, or Polaroid cassettes if so desired. This is particularly useful when

photographing objects in both black-and-white and colour in the studio. The only alternative would be to waste film or use two cameras.

A camera with one lens above the other is known as a twin- or double-lens reflex: the upper lens is for the viewfinder, and behind it lies a mirror; the lower is the lens through which the light has access to the film. The whole thing is therefore like two cameras joined together. It is built with both lenses on the same control system, so it follows that when the picture on the screen is sharp, the setting on the camera lens is also correct. These cameras are only available in medium format, and are not as adaptable as the single-lens variety.

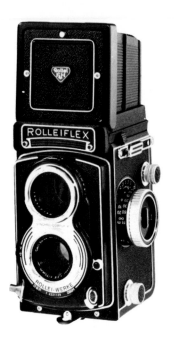

Twin-lens-reflex camera with box viewfinder.

## SHUTTER-RELEASE TYPES

The shutter rations the amount of light allowed to act on the film, and there are two different sorts.

The shutter release can be between the lenses, in which case it is an iris diaphragm: this opens fully for the specified time and snaps shut again. Thus the whole picture is exposed at once. Its greatest advantage is for flash photographs, since every shutter speed is synchronized with the flash; the disadvantage is that an iris diaphragm cannot deal with exposures of less than 1/500 second. It also limits the scope for interchangeability, and with the shutter being part of the lens, rather than the camera, the price of the former is increased.

The alternative, the focal-plane shutter, consists of two rolls of spring steel or rubberized cloth. They act as a curtain immediately in front of the film and expose a strip of film as they run, the width of which depends on the exposure time, which can be measured down to 1/2,000 second. The focal-plane shutter does not affect the interchangeability of the lenses in any way, which is why most of the better cameras use this system. However, only

speeds that leave the whole of the film exposed at once can be used if flash photographs are being taken, which normally means 1/30 second: anything shorter would only expose part of the negative. Such a relatively long exposure means that a double image can result if there is enough daylight to have an effect; this can only be overcome by the use of long-burning flashbulbs, or by substituting a lens with an in-built shutter.

## SPECIAL CAMERAS

Apart from the camera models already described, there are a few others that have been developed for specific purposes.

Cameras with motor drive, for instance, allow a whole series of photographs to be taken consecutively. It can of course be used to produce series photographs of a fast-moving object so that the movement can be broken up into its different stages.

Super-wide-angle cameras have an angle of view of up to 90°: those with a movable lens can go up to 120° or 140°, in which case the film is lit by a continuous strip, rather like a focal-plane shutter: they are known as panorama cameras.

Stereo cameras have a pair of lenses separated by a distance of about 2¼ in. All settings are coupled, so that pushing the button gives two pictures. If the shots are then projected or looked at through a special viewer, each eye sees the picture intended for it alone, which, with the elements of the photograph clearly standing apart from one another, gives a strong impression of depth.

The amateur has no use for special aerial cameras or infra-red equipment, although underwater cameras are enjoying an ever-increasing popularity. There is still only one camera specially constructed to be waterproof, but there will soon be underwater casings available for almost all 'normal' cameras.

To conclude, we must mention the Polaroid instant-picture camera, which use a fairly large format to produce album photographs in just a few seconds. You need 15–30 seconds processing time for black-and-white, a minute for colour. The emphasis in all Polaroid cameras – and there are going to be twenty different amateur and industrial models available soon – is on ease of carrying and ease of use. With their automatic focussing and vast range of accessories they can master the majority of photographic tasks.

Underwater
camera.

Polaroid camera.

## CHOOSING THE RIGHT CAMERA FOR THE JOB

The following table should be a useful guide in helping you to choose the best camera for the work you are going to do most often.

| Subject | Type of camera |
| --- | --- |
| Aerial photographs | With the exception of micro cameras, any others having normal to short focal distances. Above all, special aerial cameras using larger film sizes. |
| Animals in general | All cameras, but best are single-lens-reflex cameras with a large range of accessories and TTL metering. Motor drive and wide aperture are also useful. *See also* Aquaria photography, Tele-, Micro- and Macro-photography, Close-up and Underwater photography. |
| Aquaria | Although rangefinder cameras can be used, single-lens-reflex cameras are much better since they can be used with supplementary lenses, extension rings, bellows, and reversing rings. Since the magnification involved reduces depth of focus, the maximum format for good effect is 6 × 6. If series of photographs are needed for behaviour studies, e.g. spawning, a camera with motor drive, taking several photographs per second, is best. |
| Architecture | Small- and medium-format cameras are only useful within limits, because of the problems of positioning them, and the need for a PC lens. Otherwise studio cameras of the types described above are the only practical sort. |
| Available light (for photographs taken under the worst light conditions) | Above all miniature cameras, as they let the most light in; a rangefinder is more effective than reflex if the distance is to be set with optimum accuracy. |
| Close-ups | Micro cameras without accessories. Rangefinder and twin-lens-reflex models with supplementary lenses, taking great care to avoid mistakes due to parallax. Best of all are single-lens-reflex cameras with extension rings or bellows, and preferably through-the-lens metering. Static subjects can be shot in close-up with studio cameras having twin directional tubular runners and a manoeuvrable lens. |

| Subject | Type of camera | Subject | Type of camera |
|---------|----------------|---------|----------------|
| Documents | All cameras, if possible with reproducing lens; rangefinder cameras need an attachment to show the extract precisely. Reflex and groundglass-screen cameras. Small formats have their size as an advantage: whole archives can be microfilmed. | Fashion | Above all single- and twin-lens reflex, medium format. |
| Double exposures | Any camera that does not have a guard against double exposure, or where this can be overridden. | Flash photographs | Any camera will do, but best are those with a completely synchronized between-the-lens shutter. |
| Effects | Any, but principally reflex or ground-glass using vignettes, greased filters, soft-focus attachments and light diffusers, multiplying prisms, trick filters and lenses. Possibilities of double exposure, sandwich shots, projection and back projection, with the full choice of out-of-the ordinary films and lenses, lighting and darkroom techniques. | Flowers | Again, any camera, the best effect for close-up work coming from single-lens-reflex models with extension and reversing rings and bellows. Supplementary lenses are also useful; through-the-lens metering is most important. Groundglass-screen cameras with double extension and swivels can give an extended focussing effect. For a series of fast-sequence photographs a motor and automatic shutter release are necessary. |
| | | General photography (Family, holidays, snapshots) | All cameras except large-format models. |
| Extreme wide-angle shots | Super-wide-angle and panoramic cameras using a moving lens, or else a camera with a fish-eye lens or supplementary lens. | Industry | Medium- and, better still, large-format cameras. |

| Subject | Type of camera | Subject | Type of camera |
|---------|----------------|---------|----------------|
| Infra-red photography | Any camera for which infra-red film is available; an infra-red filter must be used, and care taken to make the adjustment to the distance setting. | Landscapes | All cameras except micro-cameras; interchangeable lenses are advisable; also super-wide-angle and panoramic cameras. |
| Inside photographs | All cameras, particularly those with wide-angle PC lenses, or even super-wide-angle cameras. To avoid unpleasant perspective lines, a studio camera is desirable. For available-light photography a miniature camera with a wide-aperture lens is best, but otherwise flash can be used. | Long-distance shots | Single-lens-reflex cameras and those having rangefinders: a focal-plane shutter and through-the-lens metering are desirable. |
| Instant photographs | Polaroid cameras, or plate and reflex cameras able to take Polaroid cassettes. | Macro-photographs (magnification photography) | Small or medium single-lens-reflex cameras, or rangefinder cameras with focal-plane shutter to which a reflex chamber can be fitted. Use must be made of extension rings or bellows and a reversing ring, and if possible macro-lenses. Through-the-lens metering is desirable. |
| Journalism | Light, handy miniature cameras, medium-format cameras, or special reporter's cameras. Many lenses including wide-aperture. Rangefinder cameras are more suitable than reflex; cameras should have a built-in meter, if possible through-the-lens. Semi-automatic, or Polaroid cameras. | Microfilms | see Documents. |
|  |  | Micro-photographs | Any but the smallest cameras, but best with single-lens-reflex; use the magnifying lens and the microscope focussing, but be sure to use the extension tube recommended by the manufacturer. |

| Subject | Type of camera | Subject | Type of camera |
|---------|----------------|---------|----------------|
| Motion studies | Cameras with their own motor, or which can have one attached, i.e. miniature or 6 × 6. | | an Iscorama supplement in their lens system. |
| Nature photography, general | Again any, but top-quality reflex cameras with all the interchangeable parts, in miniature or 6 × format, are best. Motor drive is best for long-distance work, and where tricks of the light are being used. | People | Cameras no larger than medium format, as wieldy as possible, with rangefinders or reflex system; for candid photographs use lenses with long focal distances, or unobtrusive pocket cameras. |
| Night-time photographs | Any cameras with a B or T shutter setting. | Plants | see Flowers. |
| Objets d'art | Reflex and groundglass-screen cameras; the larger the format the better. | Portraits | Anything, as long as the focal distance is not too long, but especially reflex and groundglass types. |
| Paintings | Studio cameras above all, because they are easy to position correctly. In general large format is better than small: reproducing lenses should be used. | Reportage | see Journalism. |
| | | Reproductions | see Documents, Paintings. |
| Panoramas | Any camera can be used, and the individual shots pasted together to produce the whole. To avoid the joins, you need a panoramic camera with a moving lens. To a certain degree it is possible to use cameras having | Self-portraits | Cameras with an automatic shutter release built-in, or attached later; alternatively, a cable release can be used. |
| | | Series photographs | All cameras; for long-distance studies of motion and for quick-motion pictures small- or medium-format cameras with motor drive are best. |

| Subject | Type of camera | Subject | Type of camera |
|---|---|---|---|
| Simple souvenir photographs | *see also* General photography. Anyone just photographing now and again and wishing to avoid technicalities is best off with a small fully or semi-automatic camera, or any style of small- or medium-format camera. | Theatre, stage, or circus | Normally miniature range-finder cameras with a fairly long focal distance. Wide aperture is necessary to avoid the need for flash. |
| Sport | Preferably quick and easy rangefinder cameras or single-lens-reflex cameras, in 35 mm. or 6 × 6 format, with a fairly long focal distance and fast focusing. | Time-analysis shots | Particularly cameras with motor drive and an electronic shutter release that can be pre-set to take photographs at pre-determined intervals. |
| Stereo photographs | Primarily stereo cameras, but also those that have a stereo attachment as an accessory: small format. | Time exposures | Any camera that can be set for B or T exposures. |
| | | Travel | All sorts, particularly small or medium format, preferably with interchangeable lenses. |
| Technical photographs | Ground-glass and reflex systems are best: for small objects the same applies as for close-ups. Flat objects, such as architects' models, need full depth of focus using a manoeuvrable lens. | Underwater | All cameras that can be sealed into a watertight casing. For very deep work the casing must be able to withstand high pressures. |
| | | Variation effects | Only possible with single-lens-reflex cameras that take variable lenses. |

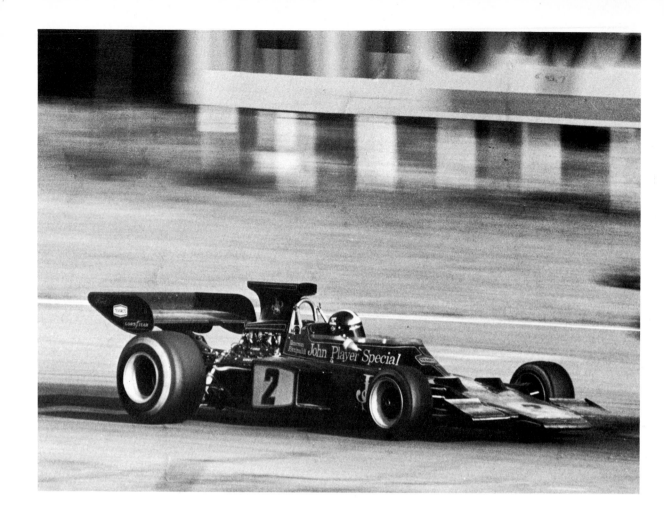

Above:
In this Grand Prix photograph the panning of the camera
captured the speed of the event – suggested by the blurred
background – yet retained the detail in the main subject.

Right:
The use of blurring in the composition of a photograph:
Children on swings are seen here in three different stages of the
movement; the child on the right is in full swing, the one on the
left at the furthest extent of her swing, where a pause makes her
appear sharper, and the one in the middle has stopped.

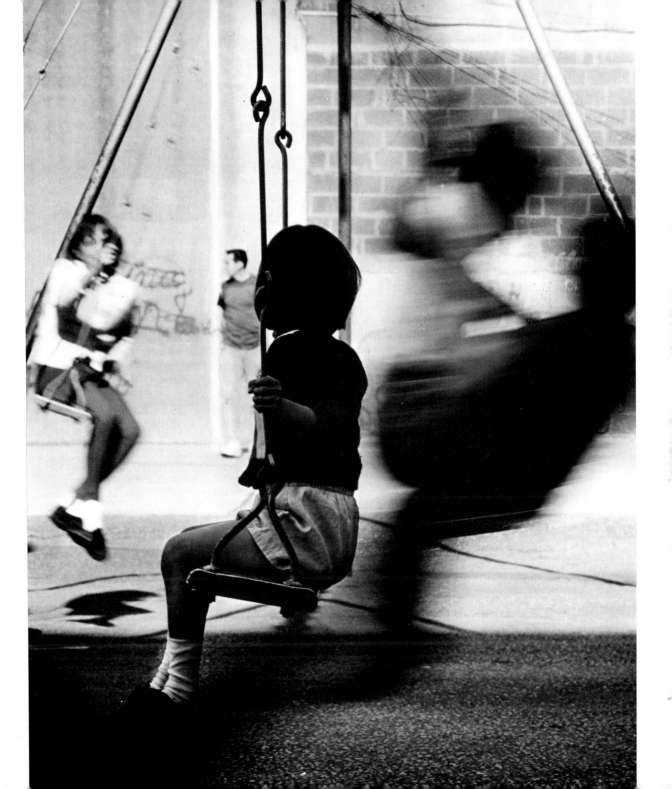

## USING THE CAMERA

If you have just bought yourself a new camera, you should not simply ask the dealer to put a film in it for you. First of all make a careful study of the instructions, and try out all the ways of holding it until you feel perfectly familiar with the size, weight, and controls. The easier the camera feels in your hand, the less you are going to be held up later by technical problems, the readier the camera will be for fast action, and the more undivided your attention to the subject.

You must learn to set aperture and shutter speed correctly: in other words, to judge accurately the amount of light required to expose the film. This is measured by the exposure meter and is thought of in terms of intensity and duration. That means that it makes no difference to the film if the light is either of high intensity but of short duration or if the aperture is stopped down but the shutter speed reduced. Especially short or long exposures are exceptions to this rule.

By shutting down the aperture one stop, the light entering is reduced by half, two stops and only a quarter of the light remains. In the opposite direction, the intensity of light is doubled every time the aperture is increased by a stop. In the same way, the shutter speeds are arranged so that each one has either half or double the value of the one next to it. This of course means that they can be set in conjunction with the aperture setting.

The relationship between speed and aperture can be seen clearly if we make up a table of corresponding aperture and speed settings:

| Aperture | 1·4 | 2 | 2·8 | 4 | 5·6 | 8 | |
|---|---|---|---|---|---|---|---|
| Exposure time | $\frac{1}{2,000}$ | $\frac{1}{1,000}$ | $\frac{1}{500}$ | $\frac{1}{250}$ | $\frac{1}{125}$ | $\frac{1}{60}$ | sec. |

| Aperture | 11 | 16 | 22 | 32 | 44 | 64 | |
|---|---|---|---|---|---|---|---|
| Exposure time | $\frac{1}{30}$ | $\frac{1}{15}$ | $\frac{1}{8}$ | $\frac{1}{4}$ | $\frac{1}{2}$ | $\frac{1}{1}$ | sec. |

What is the point of all these various combinations if they all give the same result? The reason is quite simply because the apparently similar end results show quite startling differences in reality: whether movements appear blurred or sharp depends on the time setting, whereas the aperture setting regulates the depth of focus. Thus the choice of a particular aperture/time relationship is an essential part of the composition of the picture.

Colour Plate 1: A host of colourful subjects is offered by an Oriental market such as this one in Omdurman.

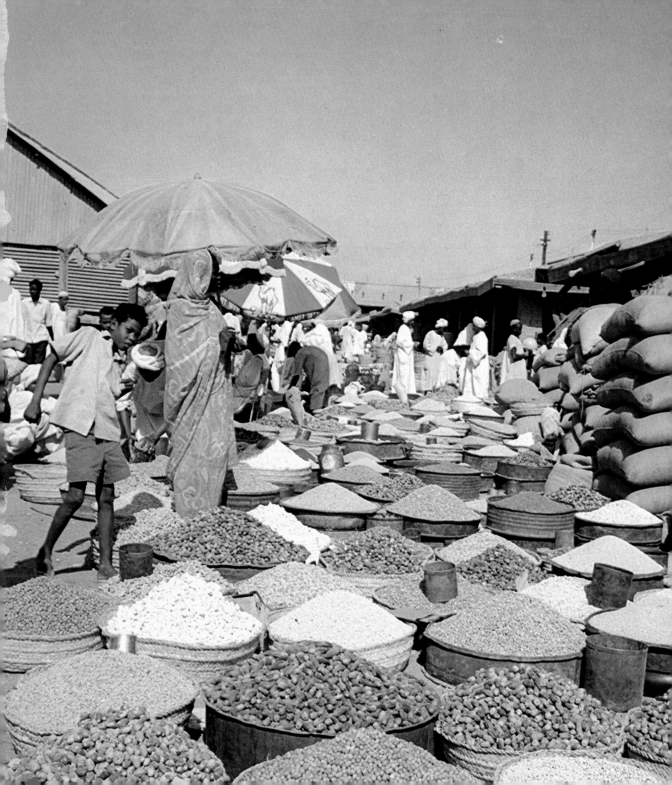

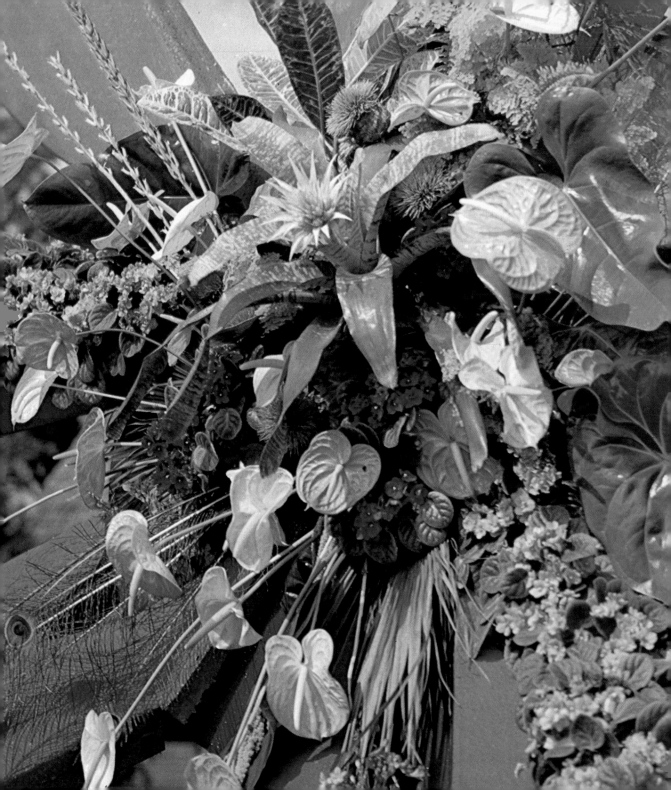

## CALCULATING THE EXPOSURE TIME

Exposure time depends on the subject. A motionless subject always calls for a time exposure and the use of a tripod. The same is true of movements that are represented by a curved path of light, as in the case of fireworks and light-writing with a torch. A different technique is called for if one wishes to photograph pedestrians, moving cars, and sportsmen without losing the sharpness of the picture: for this, very short exposure times, which become shorter as the movement of the subject becomes faster, are necessary. Concepts such as fast and slow are, of course, extremely relative in photographic terminology.

A jet fighter travelling at 750 m.p.h. appears to us as a black dot on the horizon edging its way slowly across the sky. If, though, we are trying to take a photograph of an ant from as close up as possible, it requires a great deal of effort to keep it in the viewfinder. Although it may seem paradoxical, the closer one approaches with a camera the faster the movements appear to be. Therefore it makes no difference if you take a photograph of a car race from nearby or if you use a lens with a long focal distance to bring Formula 1 racing cars closer to you: the effect is the same. But it is important to consider whether the direction of motion runs across the camera's field of view, at a diagonal, or

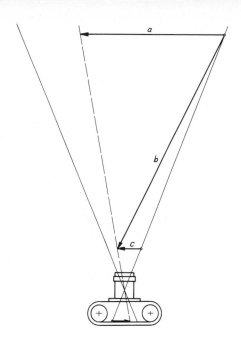

If, in a similar period of time, the distances a, b, or c are covered it is clear that the objects involved are moving at different speeds. But the same exposure time in each case will give a sharp picture since they all cover the same distance on the film.

even straight towards the camera. In the first case a considerably faster shutter speed is needed to maintain sharp definition. The deciding factor is the angle of motion. Some movements – such as those of a pole-vaulter, or of a pendulum – have their own particular characteristics (cf. photograph p. 31).

If it were only a question of eliminating blur from pictures no further consideration would be needed: it would simply be a matter of using the fastest shutter-speed setting. But for most shots careful

Colour Plate 2: A bouquet of flowers. A typical example of a photograph built up of many small areas of colour.

attention should be paid to both depth of focus and sharp definition. A good balance can only be achieved if the slowest shutter speed is chosen that will still give a clear picture of the moving object: this almost always allows the use of a wide enough aperture to give sufficient depth of focus.

It is useful here to return to the guidelines laid out at the beginning: when using black-and-white film it is preferable to stand somewhat further away from the subject and then only enlarge the desired portion of the negative, although quite clearly one must not carry this too far. It is also desirable to have the movement diagonal to the camera rather than straight across; so it is better to stand on a bend if photographing racing cars, and for safety reasons make sure it is the inside of the bend. Where possible, take the shot when a movement is at its turning point.

An exposure time of 1/125 second is sufficient for most amateur work: only sports and cars require something faster. For some forms of nature, scientific, and technical photographs even the shortest available exposure times are too long: only an electronic flash capable of measuring fractions of a thousandth of a second can fulfil such stringent requirements.

Properly used, the blur created by a shutter speed that is too slow can create an attractive effect, analogous to that obtained by panning the camera. Panning involves following the subject whilst keeping it in exactly the same spot in the viewfinder, and at the same time releasing the shutter. The shutter speed is reduced so that if the camera were not panned a clear picture of the subject would be impossible; a panned photograph keeps the main subject sharp with a background of horizontal blurs. A wide variety of impressions of movement can be achieved by using different combinations of exposure time and aperture: it can be captured as though frozen, caught at the turning point of a swing, or left undefined and flowing.

a, b:
The blur picked up by the camera at 1/15–1/30 sec. is enough to make the car unrecognizable.

c, d:
1/60 and 1/125 sec. The motion of the car is still clear, without complete loss of detail.

e:
Even at 1/250 sec. the movement of the car (which is travelling at about 40 m.p.h.) is not frozen, but nor is the blur sufficient to convey any real feeling of motion.

f:
The result of panning the camera with a shutter speed of 1/30 sec.

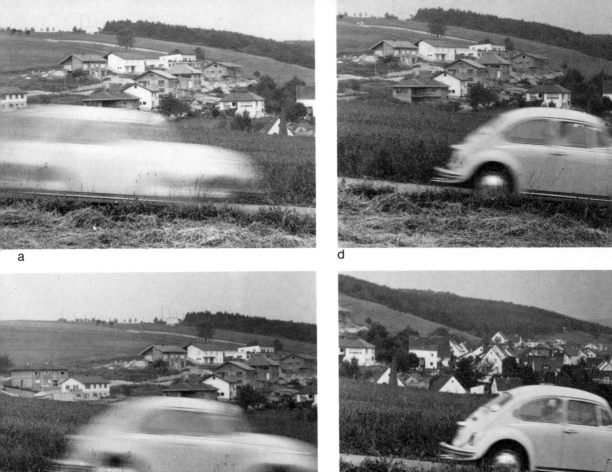

a

b

c

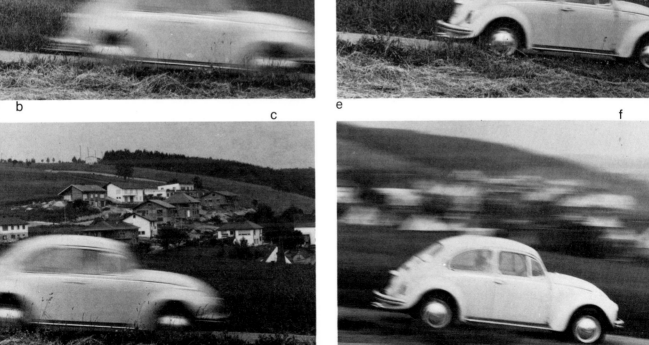

d

e

f

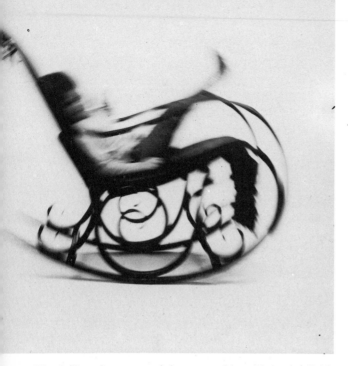

The feeling of movement is best created by a blur, even if this involves an almost total lack of definition.

## DEPTH OF FOCUS

Illustration showing how depth of focus works using different apertures and with objects at different distances.

Key:
B – aperture
H – central plane of lens
b – subject distance
f – focal distance of lens
f′ – film-to-lens distance
Z – diameter of area out of focus

Essentially, a lens can only produce a sharp image of an object if it is focussed on the plane in which that object lies: any light rays reflected from objects either side of this plane cannot meet in a point on the surface of the film because their point of intersection lies either in front of it or behind it. As a

result these rays appear as circles, perhaps even to the point of spoiling the picture with distortion.

Our eyes can be fooled, and this is why it is possible to take a sharp photograph of a three dimensional object. If the out-of-focus circles are small enough they have the same effect as dots, so the parts of the photograph that they make up still look sharp. It only becomes apparent that something is out of focus when certain limits are exceeded; the deception is clear when a very big enlargement is made. The only reason that slides projected on to a screen still seem to be in focus is that we are necessarily standing further away from the picture than we would be if looking at a print, and, consequently, the 'soft' areas are not so evident.

The general rule being that large-format negatives do not need to be enlarged as much as small ones, the maximum permissible diameter of the blurred discs does not have to be the same for all photographs. It can be calculated as about 1/1,500 of the focal distance of the standard lens; this gives us the following table:

| Negative Format | Focal length in mm. | Diameter of discs in mm. |
| --- | --- | --- |
| 24 × 36 mm. | 50 | 0·03 |
| 6 × 6 cm. | 75/80 | 0·05 |
| 6 × 9 cm. | 105 | 0·07 |
| 9 × 12 cm. | 150 | 0·10 |

Stopping down the aperture restricts the amount of light that can pass through and makes the out-of-focus circles smaller. The depth of focus is variable and can be controlled to effect; *it increases*

- with greater subject-to-camera distance,
- with lenses of shorter focal length,
- with smaller apertures,
- with larger permissible distortion diameters.

*It decreases*
- the nearer one approaches the subject,
- the longer the focal length of the lens,
- the wider the aperture, and
- the smaller the permissible distortion diameter.

It should also be pointed out that changing the lens will only make a difference if it makes a difference to the size of the image. So if, for example, standing in the same place, you take a shot with a wide-angle, a normal, and a telephoto lens, each time you will take a different section of the view, which will be correspondingly reproduced on a different scale: in this case, the greatest depth of focus will be given by the wide-angle lens.

A further experiment would run as follows. Again take the picture from the same spot, but once with a miniature camera, then with a medium-, and finally with a large-format camera, using a normal lens with each one so that the same image is recorded by all three; because of the different negative sizes each image will be reproduced on a different scale, and, as might be expected, the depth of focus varies on each: it will be at its greatest on the miniature camera, smallest on the large-format sheet film.

From this we can conclude that the depth of field increases in inverse proportion to the format of the camera. If similar results are to be achieved with larger cameras as with miniature, a corresponding reduction in aperture must be made.

If you want to fill a frame with a picture of a flower, using three different lenses as above, the picture will be proportionately the same size, which means that the depth of field will not change: using a lens with a shorter focal length will have no advantage, it will merely alter subject distance and perspective.

## USING THE DEPTH-OF-FOCUS SCALE

The ground-glass screen in plate cameras and single-lens-reflex cameras permits depth of field to be controlled directly, but in any case all cameras of any quality are now provided with a scale; this lies alongside the distance setting. On each side of the central mark there is a symmetrical row of aperture numbers, which are to be tied in with the distances opposite. If, for example, you set the distance at 12 ft. on a 50 mm. normal lens for a small camera, you can see at once that the depth of field will be from 8 ft. to 26 ft. at aperture $f8$.

Depth-of-field scale

If you want everything in the picture to be in focus, and the lightmeter indicates 1/60 sec. at $f11$, put the ∞ (infinity) mark under 11 on the distance scale on the right hand side, which will give you a reading of 8 ft. on the left: you would have to be that far from a branch if you wished to keep both it and the landscape behind in focus. In fact on this setting only objects 16 ft. distance will be in *perfect* focus, for that is the point on which the lens is focussed, giving reproduction made up of points, not of small circles. For this reason it is important that you always use the depth-of-field scale exactly *not approximately.*

Close distance setting at $f1.8$

Setting at ∞ at $f1.8$

Depth of focus over the whole range at $f16$: to take a good landscape you have to be in full command of the depth-of-field setting, as the best effect is gained by keeping all elements in the picture sharp.

If you examine the scale on your camera, you will notice that the depth of field is always greater behind the point of focus than in front of it; as a rough guide, you can say that one third is in front, two thirds behind. Only when you are taking close-ups and macro-photographs where the depth of field is a matter of a few cramped centimetres will they be roughly equal.

If you want as little depth of focus as possible, in order to extract a subject from its surroundings, set the exact distance, open the aperture wide, and choose the corresponding shutter speed.

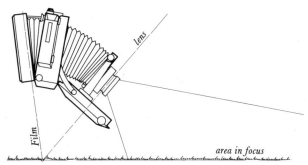

The only way to achieve an extended focussing effect.

## EXTENDED FOCUS USING A MANOEUVRABLE LENS MOUNTING

There are cases where stopping down the lens is not sufficient to give full depth of focus, and these can only be overcome by using a camera with a manoeuvrable lens mounting capable of adjustment in more than one plane. As there are very few amateurs who have access to a camera with a lens or filmholder capable of this dual plane adjustment, we shall only touch on this possibility. The conditions for extended focus are only fulfilled when the planes of film, lens, and subject intersect at one point. So it only works for two-dimensional pictures, not for normal three-dimensional objects standing one behind the other; although stopping down the lens does let one take pictures of slightly less flat subjects without spoiling the focus.

The technique is as follows: mount the camera on its tripod, then decide on the part of the subject to be photographed and focus sharply on the middle of the picture. The distance setting does not need to be altered again. The lens is swung gradually downwards and the plane of the camera likewise altered so that the centre of the image remains in the same place on the viewing screen: this allows you to check as the area in focus spreads over the whole picture. When this process is complete, leave the camera and lens as they are, and take the photograph.

Swivelling the camera in the vertical plane and the results: left, with the camera straight, right, with it 'bent'. Note the 'superperspective', which is a side effect!

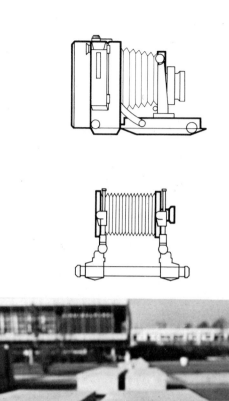
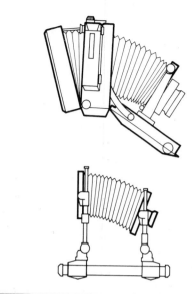

It is a great help to have an indicator on these cameras, such as that supplied with some lenses used on the Rolleiflex SL66. This indicator shows how high the camera must be from the plane of the subject and the angle through which the lens must be swung, and the correct distance setting for any given extent of surface, all of which is to be kept in good focus. An aperture-curve graph can be used to establish the maximum height an object may rise out of this plane if all of it is to remain in focus.

## TAKING THE PHOTOGRAPH

Up to now we have put in the film and set aperture, exposure time, and distance after taking a light reading. All we have to do now is release the shutter: for this you must make sure that you are standing steadily and have a firm grasp on the camera; hold your breath and press the button, making sure not to move.

The commonest mistake is jogging the camera, so blurring the picture. The effect of such movement is proportionate to the focal length of the lens, so choose a brief exposure time to counteract this. The rule of thumb is that doubling the focal length of the lens (in mm.) will give the exposure time needed to avoid hand shake if converted to a fraction: a 50 mm. lens needs about 1/100–1/125 sec., a 135 mm. telephoto 1/250 sec., a 250 or 300 mm. lens 1/500.

If you are using a longer exposure time than suggested by this rule of thumb, use a wall, or any-thing firm and solid, as a support. For very long focal distances a shoulder or chest camera rest is indispensable; these gadgets allow one hand to support the lens. A full tripod is needed for time exposures, with the emphasis on solidity: the pocket tripods, which are still sold by dealers, are simply not robust enough for the purpose. If there is a risk that the legs are going to sink into the ground, this can be overcome by using plastic plates under the feet. To prevent the feet spreading, if there are no strengthening struts, a piece of string will do admirably; if the floorboards move do not walk about when taking a time exposure, and if a heavy load drives past wait until the vibrations have died down.

It is self evident that a cable release must be used with a tripod and that it must not be stretched tight, bent, or squashed up: it should lie in a smooth arc. If you have no cable release to hand, but the camera has an automatic long-time exposure, make use of it in conjunction with the automatic shutter release. Once the timing mechanism has stopped running, any vibrations will have died out completely and sharpness will not be lost. As a piece of improvization even a piece of string can be used as a substitute for a tripod: one end is securely attached to the camera, and the other held down by one foot; when the photograph is taken the string must be held absolutely taut. Something similar is possible with reflex cameras having a box viewfinder if the neckstrap is tensioned while the image is viewed from above.

Never lean on the body of the vehicle when taking

photographs from a moving car, train, or aeroplane, or the vibration of the engine will transmit itself to the camera and will certainly spoil the shot. Try to absorb all the vibration into your body, and choose a shutter speed not slower than 1/250 sec; keep as close to the window as possible, or better still open it if it will open.

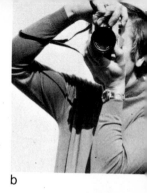

a

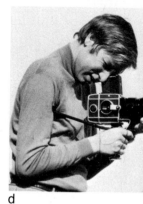

b

Ways of holding the camera:

a:
Horizontally.
b:
Vertically.

c:
A single-lens-reflex camera with a box viewfinder.
d:
As c, but with a long distance lens and shoulder support.

e, f:
The box-viewfinder enables photographs to be taken unobtrusively, and crowds or other obstacles can be overcome by holding the camera above their level and still being able to see the image clearly.

g:
Using a twin-lens-reflex model with the viewer-magnifier folded away, the camera can be held at waist level.
h:
The technique needed if the viewer-magnifier is brought into play.

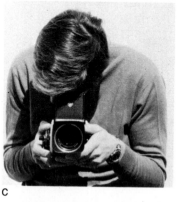

c

d

e

g

f

h

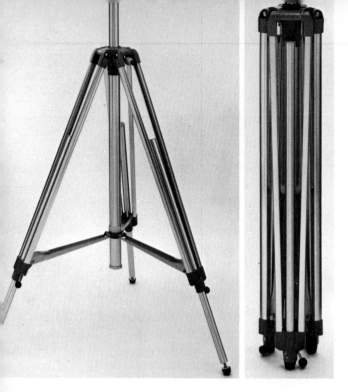

In order to be equipped for any sudden opportunity, make sure your camera is preset to a snapshot combination of speed, aperture, and distance settings. If you then make full use of the depth of focus, there is no need to alter the distance setting before snatching a shot. If the object is particularly close or distant, you can choose one of two settings:

|  |  | Close | Distant |
|---|---|---|---|
| Miniature camera with 50 mm. lens (normal) | Aperture | ƒ8 | ƒ8 |
| | Distance | 12 ft. | 23 ft. |
| | Depth of focus | 8 ft.–26 ft. | 11 ft.–∞ |
| 6 × 6 camera with 80 mm. lens (normal) | Aperture | ƒ11 | ƒ11 |
| | Distance | 13 ft. | 39 ft. |
| | Depth of focus | 10 ft.–20 ft. | 20 ft.–∞ |

A snapshot setting like this is not only desirable when going for a walk, but recommends itself for all occasions where there is going to be no time to make full preparations, as when photographing children or sport.

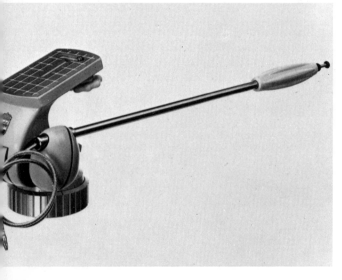

Solid tripod in light alloy with a telescopic central column. Extension of the legs is not limited by ratchets: they are held by locking keys.

Swivel head, with a cable release inside the handle.

## INFRA-RED PHOTOGRAPHS

These are possible with all cameras for which infra-red film can be obtained. Apart from the normal coating, there is a layer sensitive to higher wavelengths: if no filter is used, ordinary black-and-white results will be obtained. The infra-red effects can only be seen if the shorter wavelengths are filtered out. The best films are those with a maximum sensitivity of 750–850 nm.*

There is no need to use a black IR filter, as a normal photographic red filter will produce enough infra-red effect on a landscape to suit our requirements. If the high exposure factor involved means that a hand-held shot is out of the question, even a dark-orange filter, with a correspondingly lower factor, can be used without too much of the effect being lost. If you use an IR film that is 'blind' to yellow, green, and orange (this can be checked in the instructions), even a dark-yellow filter will suffice, and, indeed, produce the same results as a much darker red filter.

There is a difference in focussing here, since infra-red rays meet further behind the lens than those of visible light: the lens must therefore be extended a little more, as if the subject were nearer than it actually is. To this end, many cameras are provided not only with a normal central distance mark, but also with a red dot, called the IR index. The distance is set against this. In practice, you set the distance without a filter, and set the reading given against this mark: then the filter can be fitted and the photograph taken.

However, the focussing difference depends on the sensitivity of the IR film being used, and becomes greater as the film becomes sensitive to longer light rays. So really a different IR index is necessary for each grade of film, which is the main reason for many camera and lens manufacturers leaving the index off their equipment. The manufacturer must then be consulted as to what extra length is needed for a particular IR film. The instructions will be given for the camera when set at infinity. Eventually you can put a series of IR indices on the camera yourself, which can be used as described above.

Another, considerably dearer, possibility is to use supplementary lenses that correspond to the difference: again you take the distance reading without a filter, but this time you do not change it, you merely add the filter to the supplementary lens before shooting. You will need to go to your optician – not to a photographic dealer – to find out what value of lens you will need; if you have a mirror lens, no adjustments need to be made.

Since diffraction is greater than normal for IR rays, the lens should not be stopped down below $f8$, and $f5.6$ for close-ups. Also, the composition of the light affects the film sensitivity: the more IR there is, the more sensitive the film. As a rule, then, the film tends to be more sensitive by 3–4 ASA in the early morning or late evening than at midday or if there is much cloud. Because this cannot be

---

*1 nm. = 1 m$\mu$. = 1/1,000 $\mu$ = 1/1,000,000 mm.
1 = 1,000 m$\mu$. = 1,000 nm. = 1/1,000 mm.
1 A = 1/10 m$\mu$. = 1/10,000 $\mu$ = 1/10,000,000 mm.
nm. = Nanometre, m$\mu$. = Millimicron, $\mu$ = Micron,
A = Angström.

measured with a lightmeter, it is best to take several shots using different aperture settings.

One of the clearest characteristics of a black-and-white IR film is the deep black of the shadows; a very dramatic composition can be made by using light from the side or from the front. If front lighting is not used, blue skies also appear black: water is always dark, whatever side the light is coming from. Leaf green is light, bordering on white; this is known as the chlorophyll effect.

These peculiarities of IR film give one the chance to produce moonlight photographs on bright days, a technique very old in the history of trick films. To succeed, the exposure must be absolutely correct, and no clouds must appear in the picture: they would stick out with their shining whiteness against the pitch black of the 'night sky'. The light should come from the side, and perhaps even fall in beams: the chlorophyll effect can be used to show up green tree snakes or tree frogs with magnificent clarity, something that is not possible using normal filters. IR films have a particular application in war since they can pick out camouflage, but now that camouflage paint has been developed to react in the same way as leaf green, the demand in this sphere has been dying off. By contrast, it has found a new application in research into vegetation carried out by satellite. The different colours recorded, particularly by 'false-colour' film enables forestry experts to find sick or parasite-ridden trees in sufficient time to take action. Since IR can penetrate haze and very light mist better than the shorter light waves, long views and aerial photographs come out more clearly than on normal film. By looking through a dark-red filter you will be able to tell if it is worth trying an IR photograph: the effect is striking because of the extraordinary clarity of the image. Much more can be distinguished than with the naked eye; even the best IR materials cannot penetrate a thick mist, though.

It is just as impossible to take an IR picture through nylon or other man-made fabrics, despite what people say, nor is it possible to take an IR photograph of something hot which has just moved away, for instance a car with its engine running. Although IR waves are indeed associated with heat, the temperature and the exposure time involved are quite high; this means that stove plates and soldering irons can be photographed even before they start to glow, or, indeed, emit any visible light.

Much more impressive are some of the other peculiarities of the film: with strong filters, photographs can be taken through the wing cases of some beetles to show details that are not otherwise visible; it is often possible to see the original sketch under the top layer of a painting; it can be ascertained whether or not documents have been tampered with after their completion, since non-genuine alterations will appear lighter or darker than the main text, different inks having a different IR reflection factor; indistinct stampmarks will appear stronger, so that they can be clearly read; or, alternatively, passages obscured by such marks or crossings out uncovered. Even its own radiation will not fool the IR film.

As a light source, all you need are normal bulbs or photolamps that have a temperature of 3,200–3,400° K.

If you have any doubts about the genuineness of a document, take several shots using different IR

filters: IR reflection or penetration may only happen at a particular wavelength. In exceptionally difficult cases you can always take recourse to ultraviolet reflection or UV fluorescence.

Another field of application is in the use of dark flash, a technique for photographing nocturnal animals. Floodlamps may frighten and drive off such animals, and even endanger the lives of their young, but IR dark flash can produce excellent results. On a pitch-dark night an IR filter is not even needed in front of the lens. A lightproof holder for a black gel must be built for the flash unit: it is essential that no white light should escape. By bathing the flash bulbs in acetone the blue coating is then removed; since the fumes are dangerous, this should be done outside.

This is the flash-index table calculated by Günter Spitzing:

| FILM TYPE | FLASH INDEX for PF1 or AG3 bulbs, x-contact with Wratten filter 87 at 1/30 sec. |
| --- | --- |
| Kodak High-Speed Infra red | 25 |
| | developed in 1 + 40 Rodinal for 20 min. at 20° C |
| Kodak 'False-colour' film (Aerofilm 8443) | 18 |

The last-mentioned film is unsurpassed in the field of experimental photography: without a filter it gives a general purplish colour, but use a dark-yellow filter, as recommended by the manufacturer, and there is a strong purple/blue contrast; a medium-orange filter, conjuring up all colours, is highly suitable; a red filter restricts the colours again, this time to yellow and red. Artificial light at 3,200–3,400° K obviates the need for a filter, although a dark-yellow filter still gives the best effect: too much yellow is present if red or orange filters are used.

If the foreground of a daylight scene is further illuminated by flash the effect is especially impressive and strange: only clear flash bulbs may be used – electronic flash will have no effect because it has much the same temperature as daylight. If warm-colour gels are put over the flash as well as warm-colour filters over the lens, the colour combinations resulting are inexhaustible.

## STEREO SHOTS

Special cameras demand special techniques. Any camera can be used to take stereo photographs if there is a slit at the top of the tripod: after taking one shot the camera is pushed to one side and a second exposure made: obviously moving objects cannot be taken. This makes even landscapes very difficult, since the slightest breeze will make it impossible to coincide the contours of grass or leaves. It is of course better to use a proper stereo camera

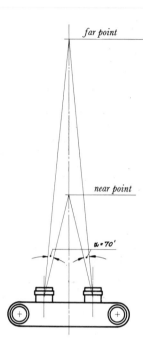

far point

near point

$\alpha = 70'$

The angle needed to ensure that stereo photographs will coincide.

photography, and that it should be decreased as you approach the subject. Stereo cameras can only look straight ahead and are not capable of converging to achieve true appreciation of the plastic: it is therefore not enough to take two photographs of the same thing, for the contours of each must coincide when they are seen through a viewer. This will happen only if an angle of no more than 70′ (just more than 1°), separates the nearest and farthest points of the subject; if this angle is exceeded the combined picture will begin to fall apart. The following table, for cameras with an 'interocular' distance of $2\frac{1}{2}$ in., gives the distances between which the two images will cover each other perfectly:

| Near-point: | 30 in. | 40 in. | 3 ft. | $6\frac{1}{2}$ ft. | 10 ft. | $10\frac{1}{2}$ ft. |
|---|---|---|---|---|---|---|
| Farthest point: | 40 in. | 3 ft. | 10 ft. | $16\frac{1}{2}$ ft. | 130 ft. | $\infty$ |

If the interoculary distance is less, the relationships improve. So for close-ups, up to a distance of $6\frac{1}{2}$ ft., attachments with a considerable reduction in this lens separation are called for. The rule of thumb for normal shots is that the depth of coincidence for a focal length of 50 mm. is the same as the depth of field at $f8$, and $f5\cdot6$ for a focal length of 35 mm. So by glancing at the depth-of-field scale you can see how far a series of subjects may extend into the distance. The picture must be composed so as to produce a compelling sense of depth, which means using all the depth available. The component parts of the photograph should not have too large a sur-

or attachment, so that both shots can be taken at once, and if a shot requires quick action, the camera can be hand held.

The purpose of stereo photographs is to reproduce three dimensions: subjects that do not fulfil this condition might just as well be discarded, for instance, flat pictures or long-distance views with no foreground. It should also be ensured that the depth of field is limited as befits three-dimensional

face area, and they should overlap decisively. The foreground assumes particular importance; and it must be emphasized in some way, perhaps by a flower or a twig jutting into the picture; this is most effective if some sort of frame can be found, such as an archway or a 'hole' in the branch structure of a tree, through which the scene can be viewed. This can be improved by using a proper frame, such as a window, to surround the picture, with the three-dimensional subject behind. One more thing: the camera must be held precisely level, which is why many stereo cameras have a built-in spirit level.

## POLAROID TECHNIQUE

When taking instant photographs the composition of the photograph must be decided upon before the shutter is released. Although it is possible, it is not usual practice to make a part enlargement later. As with slides, therefore, the whole format must be used for the original shot. So get well up to the subject!

Because of the high sensitivity of the black-and-white materials, and because of the small aperture, a large depth of field is achieved, making a distance setting almost superfluous. Nevertheless, the shutter speed is still fast enough to allow hand-held shots out of doors when other cameras would need a tripod, and the use of available light is possible indoors long after others have started to use flash. Even hand-held shots are possible of projected slides.

Correct exposure is ensured automatically by a completely transistorized shutter system linked to the photocell. As it is not possible to read off the exposure time that will be set, it is prudent to check that a hand-held shot will not risk camera-shake. This poses no problems, since the Polaroid camera does not prevent double exposure: the lens, but not the photocell, must be covered, and the shutter released. It is then easy to hear whether the exposure is short or long, whether a hand-held shot is possible or whether a tripod must be used. To avoid using a tripod, flash is of course necessary.

The Polaroid flash unit is manoeuvrable, so oblique flash lighting may be used. Cameras with a fixed-flash assembly do not, of course, allow this. Flash-to-subject distance should be at least 4 ft., and where flashcubes are used, one should stand not further than 10 ft. from the subject – illumination falls off beyond this distance.

Side-lighting, with not too much contrast, generally creates the best black-and-white prints. In the open air the ideal is a bright, slightly clouded sky, although photographs into the sun are also possible. For photographs into the sun the light/dark (aperture) setting must be moved about three stops towards 'Bright' to maintain good definition in shadow areas. Do not, even after this adjustment, shoot directly into the lightsource: it should be masked by a tree or a person to avoid incorrect exposures and unpleasant flare.

The Light/Dark setting must always be altered if a subject is particularly contrasty. If, for example, one wishes to photograph a chimney-sweep against snow, the control-ring must be turned towards 'Bright' if the features of the face are to be brought

out clearly. If on the other hand a light subject is to appear on a very dark background, the control must be turned towards 'Dark' otherwise the main subject will appear too light.

In the case of colour films it must be ensured that the Polacolour film is daylight sensitive. Colour reproduction can be affected by the development time: underdeveloped pictures have a red tinge, whilst blue will become predominant as the development time is increased. This phenomenon can be used to good effect in the composition of the picture: this means, for instance, that sunsets can be given an even redder glow than they ever in fact possess.

Development time for Polaroid films must be strictly adhered to, bearing in mind that it depends on temperature. If it is very cold, colour, but not black-and-white, films must be wrapped in a protective case, which is an accessory provided with every camera: precise instructions are provided on the box. Then the positive can be peeled away from the rest of the film. To avoid touching the residual chemicals, the negative must now be folded, damp side inwards, it can then be put in the film carton or packing until the next waste-paper bin. Be careful not to get any of the chemicals on your skin or clothes, above all not in your eyes or nose, and keep the negative away from animals and young children.

The picture will not be affected by light when it is peeled off, and it can be examined immediately. Black-and-white films should be wiped 6–8 times with a varnish sponge, supplied in each film pack. The only film-types developed to dispense with this treatment are 87 for 'Zip' and 'Colorpack' and 20C for the 'Swinger': instead they should be fixed to the gummed cards provided to prevent damage by being rolled up or dropped.

Taking photographs with the Polaroid camera. After the exposure both white strip and picture are withdrawn simultaneously and without separating them: seconds later the picture can be peeled off.

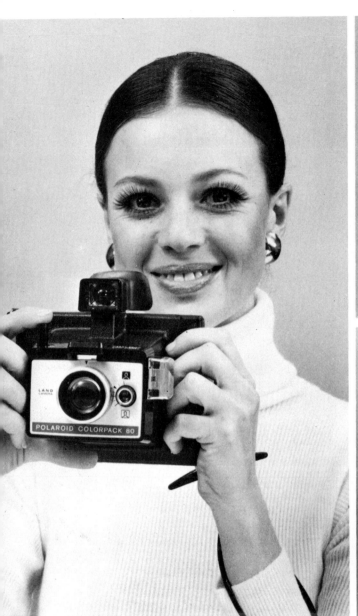
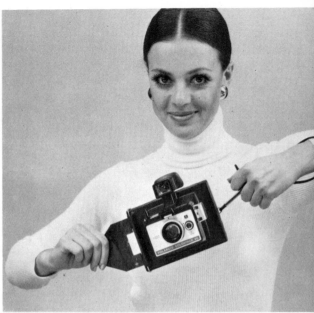
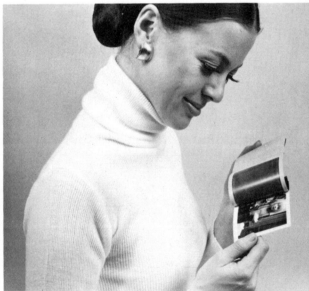

# THE PATH TO BETTER PICTURES

## THE EYE AND THE CAMERA

The construction of the camera is often compared to that of our eyes, and there is nothing wrong with this comparison, except that those making it forget that the visual impression is often different in many respects from that given by the photograph. To recognize this fact is to take the first step towards producing better photographs: it helps us to develop a conscious photographic eye.

Our eyes see in three dimensions, and yet the fact that this means we are unable to see everything in the field of view clearly does not worry us: this is because our eyes feel their way through the field of view gradually, focussing on individual objects without our noticing it, and we do not miss the lack of an overall depth of focus. The outcome is that we only concentrate on what is most interesting, hardly being aware of anything of secondary importance: everything we look at is locked in its surroundings and is judged in this context. Strong contrasts are not a serious handicap, for the eye is quick to adapt

to any change in light conditions. Colour vision gets worse in the dark, and, most important, we are unable to store up light impressions any more than we can drag out movements to see them as a series of phases. Our appreciation of colour and perspective is largely conditioned by our knowledge of the true relationships involved, so that we are unable to see objectively. The angle of view always remains the same, and at very short distance we no longer see clearly: the only way we can alter the angle of view, magnify things clearly and make distant objects appear closer, is by using technical aids.

A camera does not merely work when in the hands of its owner, but can be operated from a distance with complete reliability, which means that we can look upon it as an extension of the eye. Moreover, the vast range of supplementary and alternative parts means that it can in fact magnify, so enlarging our vision considerably. Depth of focus can be altered at will, extended almost to infinity or reduced to a minimum. Impressions of light are stored up, which can make a recognizable picture from a very badly-lit scene. Infra-red rays enable

the camera to penetrate darkness and mist, making the invisible visible. Because light impressions can be stored it can capture the path of a moving light source, indirectly making movement visible. In the same way a fast movement can be reduced to a series of individual stages, with full definition. The camera can see things that we cannot, but it cannot picture objects in three dimensions or capture motion itself, nor can it appreciate the same range of contrasts as the eye, and it is of course no more than an instrument, a tool in the photographer's hand. It will register everything in its field of view with machine accuracy: absolutely objective, it is incorruptible and will make no distinction between the important and the inessential. Lines and colours are therefore shown where we had no inkling of their existence, and we are sometimes confronted with unusual but absolutely correct perspectives.

The image of a subject on a photograph has to speak for itself, for it is released from its environment. Movements are frozen, and three dimensions are cramped into two. Feelings have to be translated into visual images, if the observer is to experience the same reaction to the subject as the photographer. If something out of the ordinary is photographed, the effect of the shot is almost always good. But even the every-day subject can make a good photograph if it is shown in a completely new light or if an ingenious technique is used. The composition of the picture has to be clear and free from distracting, non-essential elements: special techniques should suit, indeed be subordinate to, the subject. Gimmicks used for their own sake become cheap effects and interest in them is soon lost.

You should look at as many pictures as possible in photographic journals and magazines; analyze them and try to see why some have a striking effect and others do not. Then feel free to try to copy or even improve upon them; there is no reason to shrink from this approach. Every day we profit from the ability and knowledge of others, imitate them, and finally start to work originally having learnt the subject thoroughly: should photography be any different? Get used, therefore, to seeing things as the camera does. You will soon learn to tell what is photogenic and what is not, and what subjects to choose and use meaningfully in your pictures: this is not only a question of polished composition, but also a matter of better control over your camera and its capabilities.

To see what a picture will look like, shut one eye so that the subject is reduced to two dimensions as in the photograph. You will soon see what is going to work, and what will look awkward. Then make a frame out of the thumb and forefinger of each hand and look at the subject through that to extract it from its surroundings. If you move your hands towards and away from your eyes it will be easy to see how much you want to leave in, which will help you choose the best lens and/or subject distance.

Always consider a subject not only from the closest convenient position, but also from a few paces either side, from a crouching position, and from a platform. If the subject is static and cannot run away you will have plenty of time to choose the best position. Be careful of intrusive lines, and make a careful study of the illumination: if it is not correct re-arrange it or move your model. If neither is possible come back another day when the conditions

are just what you want. Being as choosy as this must give better pictures: only rarely will chance give a good result.

The same consideration of time and place must be made for live shots as for static: live shots require the capture of an expression, the high-point of an event, or the humour of a situation. The decisive moment can often, but not always, be guessed correctly; so when the decisive moment arrives expense and film should not be spared. How annoying it would be to have missed the perfect shot for the sake of saving a couple of inches of film.

A few words are necessary on the subject of film use in general. Do not think that using a lot of film labels you as a bad photographer or as a beginner – take several shots of the same subject. You can be sure that one picture, usually not the first, will shine out beside the others, because here, and only here, everything is absolutely spot on. This does not mean that you only need to snap away mindlessly to have one good picture in a desert of rubbish. Each one needs as much consideration; then you will only take home good photographs, of which some are better. It is of course important to decide on a subject that attracts you and means something to you. It is even better if you know enough about it to feel a part of it.

Many photographs suffer because the only atmosphere they have is the lack of interest on the part of the photographer, resulting in bad composition.

## ELEMENTS OF COMPOSITION

Up to now I have used the terms 'good' and 'bad' in a purely technical sense: it does not take a lot to learn how to produce sharp, correctly exposed pictures, and yet there are many photographs that 'say' nothing although they are technically perfect. Mastering camera technique is therefore only one step towards producing better photographs. The second step is learning the art of good composition: there are laws for this, too, which can be learnt and absorbed so that you will soon know instinctively whether or not a picture is worth taking.

Let us first judge a photograph by the basic graphic elements, the interplay of lines, dots, and surfaces, which react with each other by means of various degrees of brightness and colour contrast. Essential factors are whether the picture is composed of many small surfaces or a few large ones, if the pattern they form is symmetrical or asymmetrical, repetitive or not, and whether the colour juxtaposition is harmonious or harsh. The fewer confusing elements and intrusive details there are in a photograph, the simpler and clearer it is, the more it will hold the attention.

Simple lines have a clear language of their own: if horizontal, the effect is of solidity, tranquillity, and reliability; several parallels moving across the picture carry the eye into the background making the picture seem broader. Vertical lines also have a stabilizing effect, but they cramp the eye and prevent a full appreciation of the background. Diagonal lines join the corners and create tension in the picture, an impression that is increased if they run

from bottom left to top right, and decreased if they run in the opposite direction: lines between these two extremes seem lost and unstable, and need a vertical to support them. Lines of wave motion radiate freedom, a sense of flying, cheerfulness, and music. Zig-zag lines have a nervous feeling about them. Lines that lead out of the picture divide it into surfaces: indeed all straight lines split things to a certain degree, regardless of the direction in which they are lying. Zig-zag lines and a series of straights, by contrast, seem to join neighbouring surfaces together.

A theory that has been rejected by science for a long time, but that still haunts a lot of books on photography, concerns lines running into the picture, leading the eye to the main subject as though on predetermined paths. We must perhaps accept that there are lines that, although not visible on the photograph, are conjured up by our imagination without any conscious effort. In photographing a couple or two people discussing or arguing, one instinctively senses a relationship between the eyes as they look at each other. Points spread over the picture, like a row of street lamps, seem to be strung together on a common thread like a string of pearls. Small points are set against large expanses, which creates a feeling of tension. The influence of all these optical impressions upon the effect of the picture is just as important as that of lines that are genuinely there.

If points and other expanses lie far apart, then the optical lines make their presence felt again: this time their effect is to create optical surfaces. Depending on how they are arranged, the picture can appear peaceful and calm, or it can lose all sense of coherence and burst out of the limits of the print. It is in this way that a feeling of movement is conveyed in a picture, for the optical surfaces force the content of the photograph in a particular direction. This is the case with unequal triangles that have one side parallel to the edge of the picture. In the same way ellipses and many 'free' shapes seem to move in a predetermined direction. By contrast, circles and equilateral triangles give an impression of solidity and immovability, as do unequal triangles that have no side parallel to the edge of the photograph. The same is of course true for all quadrilaterals and right angles whose sides are parallel to the edge of the picture.

Clearly, then, the organization of surfaces and the subdivision of expanses has almost a greater importance for the composition of a picture than the organization of lines. With the picture slightly out of focus, you can use the image projected on to the ground-glass screen in the viewfinder to exercise complete control over the subdivision of expanses and of areas of light and shadow. Since the contours of the picture are now lacking in clarity the subject is 'depersonalized', and only those individual areas that are juxtaposed in varying degrees of brightness and colour are recognizable. The nearer the main subject is to the centre of the picture, the more symmetrical the construction of the photograph, and the more reassuring and tranquil its effect. It can even be downright tedious. This means that you should strive for some sort of irregularity, which will break up the monotony by attracting the observer's eye, and making the picture more interesting. Life and movement can be brought into the picture by putting a large object towards one edge

or in a corner so that a tension is created by this imbalance.

A large surface area has a fuller, less-boring effect if it has a texture within itself, for instance, a cornfield. A large free area has the danger of appearing dead and impersonal: this can be counteracted by finding a small point to contrast with it. If the intent behind a picture depends on one point, then this must be placed according to the rule known as the Golden Mean. Let us use an example to clarify this: assume that we are photographing a narrow, long bridge, which a man is in the process of crossing. We shoot the scene into harsh light so that our subject stands out black against a bright sky. The bridge now appears like a long, narrow balcony split into two parts by the miniature figure of the man. Applying the principle of the Golden Mean the ratio of the shorter part to the longer will be the same as that of the longer to the whole length of the bridge: it is self-evident that this rule has to be followed in both the horizontal and the vertical plane. The picture will then appear well balanced without being tedious. It is only in rare instances that the photographer can apply the Golden Mean according to strict academic principles, and he is more often required to implement it intuitively.

The ratios given by the Golden Mean are: 2:3; 3:5; 5:8; 8:13, etc. These ratios can also be used to set large groups of people or surfaces side by side in the correct proportions. This rule is often used in architecture, particularly in the case of windows and doors.

The elongated shadows of this picture run diagonally towards the subject and give the whole a feeling of depth.

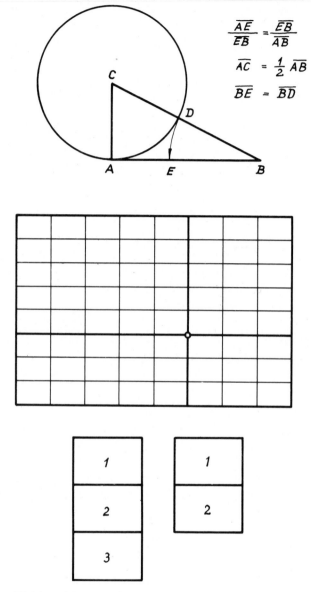

$$\frac{\overline{AE}}{\overline{EB}} = \frac{\overline{EB}}{\overline{AB}}$$

$$\overline{AC} = \frac{1}{2}\,\overline{AB}$$

$$\overline{BE} = \overline{BD}$$

Division of lines and spaces according to the Golden Mean.

## CONTROL IN THE PICTURE

The most frequent mistake in picture composition is a lack of control in two particular respects: the first is that too much is crammed into the picture, the other is that too little attention is paid to the background. The former fault is normally caused either by standing too far away from the subject, or by using a lens with too short a focal distance. This can be corrected, when black-and-white pictures are being taken, by printing an enlargement of an extract of the negative, but if a reversal film is being used, the composition has to be correct right from the start. Do not be afraid to approach the subject, and use a long rather than a short focal length. The less unnecessary material recorded on the film the less confusion will result, and the message of the picture will be clearer. The true master is shown by what he leaves out, by limiting himself to the essential!

You should give special attention to the background. It is by no means a subsidiary part of the picture. On the contrary, it has as much significance as the main subject, since it is in a position to destroy the whole composition of the photograph. Make sure that your model does not have a tree or a telegraph post growing out of his head, nor a blade of grass up his nose. Keep the background as simple as possible and make sure it does not overpower the main subject because of a particularly strong colour or structure. It will convey the intentions behind the picture all the more clearly if it is kept simple, limited to a large surface area and to toned down colours. You should try, therefore, to detach your subject from its surroundings: there are various ways of doing this:

● Try out a suitably neutral background or use a back-cloth.
● Choose the sky as a background, kneel down and thereby make the horizon very low on the picture.
● Stop the aperture right down to reduce the detail of the background to a misty haze.
● Make use of flash – it is only effective over short distances – to leave an obtrusive background in the dark.
● Free a subject in close-up from its surroundings by interposing a piece of cardboard or a piece of cloth.

## PICTURE SIZE AND FORMAT

The larger the picture, the better its effect in general. Layout artists of large magazines have known this for a long time and for photo-reports use as many full-page or double-page pictures as possible. Only when the emphasis is on the written word can the pictures be smaller, since they serve more as supplementary illustration.

We can also make use of this experience at home: if all you want are a few souvenir photographs for your wallet, then a format of 3 × 4 in. is quite sufficient. If, however, the pictures are intended for an album, they should be bigger. When a photograph is too small, the overall image can be appreciated, but not the detail; moreover, the eye is very easily

distracted from the picture to whatever lies around it. Another side effect is that the correct impression of perspective is not conveyed.

For a photograph to be seen in the same light as that in which it was taken, it must be looked at from a particular distance: this will give the correct angle of view and the correct perspective. This is not as easy as it might seem: the distance required for very small photographs may be less than 8 in., below which the eye cannot focus clearly. All pictures are therefore looked at from the same distance – that used for reading, on average from 10–12 in.

Let us try putting the cart before the horse: do not attempt to calculate what the correct viewing distance is for each photograph, but how much a negative has to be enlarged for the correct impression of perspective to be maintained at normal distance. This gives the formula:

Enlargement factor equals viewing distance over focal distance.

If, for example, we have a miniature negative $24 \times 36$ mm., taken through a 50 mm. lens, the enlargement factor is $25:5$, equals 5. Our negative must therefore be enlarged this many times, which gives a print format of approximately 5 by 7 in. If the picture had been taken with a 35 mm. wide-angle lens, the print would have to be 7 by $9\frac{1}{2}$ in. This does not mean that it is a mistake to use bigger enlargements: quite the contrary! It is true, that the correct perspective is lost if the viewing distance is not increased at the same time: but the picture gains in effect. It will become the central point, the 'eye-catcher' of a whole series of photographs. It cannot be taken in at a quick glance, and the eye wanders over the picture pausing here and there and examining details, which are only clear because of the degree of enlargement.

If all pictures are enlarged to the same size there is a risk that the overall impression will diminish, because the sense of the exceptional is lost. It is therefore advisable only to blow up the very best shots to full size. The juxtaposition of other, smaller, pictures will then create a counterbalance, as well as expressing at the same time the difference in importance between the photographs. Where possible the size of the other pictures should be chosen to give the correct perspective. If they are made smaller than this, several shots should be placed together to create a compensatory effect.

Variety can be achieved not only by changing the size of the photograph, but particularly by changing the format: it can be square, vertical, or horizontal. That chosen depends entirely upon the subject. The only exception arises if one is using photography as a source of income. It is then necessary to print the photograph in both vertical and horizontal form, so that the editor is given the opportunity to choose the picture that best suits the layout. In general, vertical prints have the better chance of being accepted.

The most difficult format to get used to is the square: all feeling of tension is lost because of its equal sides. It is an unimpressive, reticent format, evoking a feeling of peace and composure. It is therefore most suitable for those subjects that possess these qualities. It is well-nigh impossible to use it to express effusive liveliness and infectious dynamism. An extremely fine composition technique is

Format. The narrow vertical print makes the toadstool seem
even taller. The shot would lose much of its effect if presented
in a square or, even worse, in a horizontal print.

By contrast with the photograph on the previous page, this shot *gains* because it is presented in horizontal format.

required to give the subject the correct feeling. The photographer must be capable of 'thinking square'! A very strict division of the space is required. Because of this it is sometimes necessary to put more into the picture than when using vertical or horizontal prints. Despite the shortcomings and the difficulties arising from them I personally prefer to produce square prints: when I am taking black-and-white photographs, all its disadvantages disappear. I can of course cut out what I want in the enlargement but, even so, I take the shot bearing in mind whether I am later going to use a vertical or horizontal format. When taking slides – which is often the case – I choose the square format because when projected it completely fills the screen. On top of this the resolving power of 6 × 6 photographs is far greater than that of 35 mm. slides.

The fact that the format can be fitted to any subject means that one is in no way limited by using a square negative. It is still possible to determine the picture construction and compose its content; one also has the ability to contrast content and format

Colour Plate 3: Anthurium. The large surfaces and the clear construction of this photograph contribute much to its effect.

in order to increase tension. Great skill is needed to do this, however, because if the composition is not convincing and dominant, a completely false impression can be created by a bad choice of format.

The best balance is obtained by using a format with the sides in a 1:1·5 ratio, according to the Golden Mean. Very tall, thin prints attract the eye strongly because of the unusual proportions. Much of their effect undoubtedly comes from very harsh editing, which means sacrificing all that is not essential to the picture. Most amateurs do not appreciate how much power lies in concentrating on the essential.

Colour Plate 4: Above left: Rose. This shot has been taken according to the principle of the 'Golden Mean'. The effect of the different brightness of the red and the green is increased by the fact that they are complementary. This also increases the feeling of depth in the shot.

Below left: How brightness can be given to colours by contrasting them with the 'non-colour' black. This is a coral in the Red Sea.

Above right: Aarhus, Denmark
By skilful composition some subjects that would normally be better suited to the horizontal format can be squeezed into a square format.

Below right: Monochrome colour effects, like this sunset by the Red Sea, show that a great variety of colour is not necessary to produce a good picture.

The horizontal format radiates even more tranquillity and security than the square: by contrast, the vertical format forces the subject out of its lethargy. It has a dynamic effect and underlines the sense of striving upwards, as well as that of fathomless depths. It is a very cheerful format, which expresses elation, but which can also have a graceful, unsettled, or even disruptive effect.

It is often the case that amateurs present subjects, which, by their very nature, are better suited to the vertical format, on horizontal prints, simply because the camera is more easily held horizontally. This means that they have to go further away from the subject, which is correspondingly reduced in size and surrounded by much that is unnecessary to the photograph: then they ask themselves why the picture has a dull effect. This can be corrected when printing negatives, but clearly not when taking slides. For this reason you should get used to using the format of the film to the full, which means a reiteration of my earlier advice: 'get close to the subject'.

## USE OF THE BORDER

You should consider how great a difference is made to a picture by whether or not it has a border. A border should only be used when the subject is complete in itself with nothing missing. This is seldom the case. In general it would be far better to print the pictures without a border, which means that

they can grow out of themselves and appear bigger than they actually are. If the picture is to be stuck into an album, it should fill the page completely, or else the effect of printing it without a border is lost. Rather than using photo-mounts, it is better to stick the pictures in, using very thin adhesive film: this is easy to use and holds the pictures securely.

The finish of the paper can also change the character of a shot. Stippled surfaces are less sensitive and can give the picture a very pleasant effect: but much of the brilliance of the photograph is lost by using them. Where the emphasis is on sharpness and detail, high gloss should always be used. Be careful of fingerprints! The hard effect of blue-black prints can be transformed by the use of sepia toners. To give a sense of continuity in a photograph album, only prints with the same finish should be placed side by side.

# BLACK-AND-WHITE OR COLOUR?

Only a very limited number of amateurs choose their film materials with care. The following considerations should be taken into account if the photographs are to be used to earn money: for use with lectures, slides should be chosen; for publication black-and-white prints are in much higher demand. The financial reward may be lower, but you can be sure that your photographs will be seen by a larger number of people than if you offer the publisher colour pictures. Moreover, an editor will be quite content with black-and-white photographs from a miniature format, whereas he will want colour pictures and slides in medium or large format.

There is absolutely no ground for the common view that it is easier to take black-and-white pictures than colour: the opposite is nearer the truth. Colour relates most to one's experience of reality, and therefore the beginner is best advised to use it. The relative cost should be borne in mind: a 35 mm. colour reversal film is hardly more expensive than a black-and-white film if the price of the former includes processing and framing. The price of colour photography only becomes prohibitive in the case of large-format cameras.

Of course, there is no overriding advantage held by one over the other, since each has its own properties for different forms of expression: when one is trying to reproduce things as naturally as possible, colour is called for; sensitivity and feeling are also generally better expressed in colour than in black-and-white. If it is simply a question of examining particular shapes and movements, however, black-and-white is the better choice to make. Up to a few years ago black-and-white tended to be preferred because colour was not capable of abstraction: the situation has changed now with the development of colour materials that can even produce a colour print from a black-and-white negative.

## BLACK-AND-WHITE PHOTOGRAPHS

The first stage of a black-and-white photograph is the negative, in which highlights appear dark and

shadows light. The only way of producing the correct tone relationship is by making a print, which reverses the negative effect.

## FILM SPEED

Films are available in varying degrees of sensitivity, known as low-speed (up to 50 ASA), medium-speed (50–160 ASA), fast (160–500 ASA) and ultra-high-speed films (over 650 ASA).

The last two are used when light conditions are particularly bad, or when a particularly short exposure is wanted without a corresponding increase in depth of field. Ultra-high-speed films can be used for hand-held shots using only candles as a light source: for most amateur purposes, though, a film speed of around 100 ASA is sufficient.

The ASA number is no indication of the quality of a film: this is shown, rather, by the speed at which one can use it without having to stop down the aperture fully and use very short exposures. Without this choice of film we would be robbed of one of photography's greatest assets: the ability to choose the depth of field, or, in the case of moving objects, the ability to produce a conscious blur effect.

Film speed is indicated as a DIN or ASA number:

| DIN | ASA | DIN | ASA |
|-----|-----|-----|-------|
| 13 | 16 | 24 | 200 |
| 14 | 20 | 25 | 250 |
| 15 | 25 | 26 | 320 |
| 16 | 32 | 27 | 400 |
| 17 | 40 | 28 | 500 |
| 18 | 50 | 29 | 650 |
| 19 | 64 | 30 | 800 |
| 20 | 80 | 31 | 1,000 |
| 21 | 100 | 32 | 1,250 |
| 22 | 125 | 33 | 1,600 |
| 23 | 160 | 34 | 2,000 |

In the DIN system, an increase of 3 DIN is equivalent to the sensitivity of the film being doubled. If, for instance, an 18 DIN film required 1/125 sec. at f8, then a 21 DIN film would need 1/250 sec. at the same aperture setting, or 1/125 sec. at f11. This is the reason for its being called 'faster' than the less-sensitive film. A 15 DIN film under the same conditions would need 1/60 sec. at f8, or 1/125 sec. at f5·6.

Under the ASA system, the sensitivity or speed of the film is doubled when the ASA number is doubled.

## SENSITIVITY

The fact that all colours are reduced to tones of grey on black-and-white film does not reduce our appre-

ciation of the picture: on the contrary, we rarely notice the absence of colour immediately, but of course ultimately it is the first unnatural thing that we notice, never mind the lack of the third dimension and of movement. This does not stop photographers striving to portray reality as closely as possible, which means using film materials that convert colours to tones that seem right to the eye. Depending on their colour sensitivity, films fall into three categories:

Orthochromatic film is sensitive to blue and green light, but not to red, which appears black as a result, just as blue appears too pale. This sort of film is cheaper than those that are also sensitive to red, and has a much steeper gradation curve; its only real use is in scientific and technical work, but if the lack of sensitivity to red is not important, as, for instance, in architectural or landscape photography, it can play a rôle in creative work as well. It is important to remember that the speed is considerably lowered in artificial light because of the lack of red-sensitivity. There are two types of film that are also sensitive to red light: orthopanchromatic (up to *c.* 200 ASA) films record the correct tone value for all colours except blue, which is still a little light. Films having the highest speeds are extra sensitive to red light, and correction filters must be used to counteract this: it is often found necessary to change the tone values in general by the use of filters. This is the case when two colours that would give the same tone of grey on film are juxtaposed, as, for instance, green and red: without a filter detail would be lost, and the picture appear flat, lifeless, and unrealistic. A comparison of two photographs will show that even if the tone values are reversed completely, the result is more realistic.

The best filters are those that are made of plain glass with an anti-flare coating, although plastic filters in a suitable holder are also good, and cheaper. Totally unsuitable are those filters consisting of a layer of coloured gelatine sandwiched between two sheets of glass. If you choose glass filters, go for those with a screw or bayonet fitting: they are less likely to fall off and get lost than those that simply slide on. You will save money if you buy filters to fit the largest diameter of lens that you have: you can then use adaptors if you wish to attach them to smaller lenses.

## USING COLOUR FILTERS

It makes no difference whether you are using correction or contrast filters: they let pass, first and foremost, their own colour, and cut out the complementary colour – the one lying opposite it in the colour circle. This means that you can only contrast colours that *are* complementary, and never those that lie side by side in the circle. Monochrome subjects cannot be given greater contrast by using a filter: this can only be achieved by a film of higher contrast or by lighting positioned to emphasize contrast.

Because using a filter involves a proportion of the light being cut out, either the exposure time or the aperture must be increased: the necessary multiplication is the index engraved on the filter mount. If the filter has a factor of two, and the exposure

meter indicates an aperture of $f8$ at $1/125$ sec., then for the same aperture an exposure of $2 \times 1/125$ sec., i.e. $1/60$ sec., will be needed: if you wish, though, the time can be left, and the aperture increased to $f5\cdot6$. For a factor of $1\cdot5$ the aperture would be increased by half a stop, for a factor of $3$ it would need an increase of $1\frac{1}{2}$ stops. It is quite easy, then, but it is advisable not to rely on the filter factor totally if it is a very dense filter that you are using. It is a matter of whether the predominant colour of the subject is the same as, or complementary to, the

Colour circle for choosing filters.

Comparative effects of filters:

a:
No filter: original colours of stamps from left to right: yellow, green, red, blue.

b: With yellow filter.

c: With orange filter.

d: With red filter.

e: With green filter.

f: With blue filter.

## XX. Olympische Spiele München 1972

Verkaufspreis 2,- DM

a

## XX. Olympische Spiele München 1972

Verkaufspreis 2,- DM

b

c

## XX. Olympische Spiele München 1972

Verkaufspreis 2,- DM

## XX. Olympische Spiele München 1972

Verkaufspreis 2,- DM

d

## XX. Olympische Spiele München 1972

Verkaufspreis 2,- DM

e

f

## XX. Olympische Spiele München 1972

Verkaufspreis 2,- DM

colour of the filter: in the first instance the factor given should be strictly adhered to, in the second a little leeway should be allowed. Care must be taken in mountainous areas, for the filter will have more effect there than in flat areas: also, a severe over-exposure will cut out the effect of the filter. On those rare occasions when you are not sure, it is best to take the shot several times using different settings.

If your camera has TTL (through-the-lens) metering, you will have no problems whatsoever with filter factors, as the meter will automatically take the density of the filter into account, except in the case of red filters; the procedure with these will be explained in the camera instructions.

If you have a semi- or fully-automatic camera, you will have to adjust the lightmeter before taking the reading: it is a question of treating the filter as a reduction in the sensitivity of the film. Do not of course forget to readjust the setting when you take the filter off!

| ASA Film speed | 25 | 50 | | 100 | | 200 |
|---|---|---|---|---|---|---|
| Filter factor | 8 | 4 | 3 | 2 | 1·5 | 1 |

## FILTERS FOR CORRECTION AND CONTRAST

| Colour | Factor | Effect | Principal uses |
|---|---|---|---|
| Light yellow | 1·5 | Yellow becomes brighter, blue a little darker. | Correction filter for orthopanchromatic film. Emphasizes cloud effects and gives darker shadows in snow. |
| Medium yellow | 2 | Yellow, orange, and red lightened, blues and purples darkened somewhat. | The most important filter for black-and-white photography, having universal application in landscape work: has a more striking effect than the light yellow filter. |
| Dark yellow | 3 | Lightens: orange, red, and yellow. Darkens: blue and purple. | As a correction filter for orthochromatic materials: it acts like a medium-yellow filter, but more so. |

72

| Colour | Factor | Effect | Principal uses |
|---|---|---|---|
| Orange | 3–5 | Lightens: yellow, orange, and red. Darkens: blue strongly, green less so. | Good for landscapes. Gives strong emphasis to cloud effects. Penetrates haze well, giving better clarity over long distances. |
| Light red | 8 | Both blue and green very dark, orange lighter: good clarity at long distance. | Good for landscapes: the sky appears almost black, clouds a radiant white; clarity at long range is even greater than with orange filters. Houses will appear white against a dark sky: can create a night effect in full daylight. |
| Dark red | 16 | Blue becomes black, green is very dark, orange and red light. | Gives an even more dramatic effect than a light-red filter; seldom used because of the high factor. |
| Green-yellow | 2–3 | Dulls red and blue, brightens greens and yellows. | Correction filter for superpanchromatic film in daylight, having much the same effect as a medium-yellow filter; good for predominantly green landscapes, because of its brightening effect, and also for outdoor portraits. |
| Green | 3–4 | Darkens: red and orange, and to a certain extent blue. Lightens: yellow and green. | As for yellow-green filters, but a more striking effect on green landscapes. Good for plant photographs: e.g. foxgloves in a meadow. |
| Blue | 1·5–2 | Darkens red, lightens blue. | Correction filter for superpanchromatic film under artificial light. Gives a good 'suntan' to people out in the open. Mist appears thicker; the sky appears brilliant white, especially in photographs of buildings. |

Filters are often the only means of creating an outstanding landscape. The only way to bring about the desired effect here was to use an orange filter, thus giving the clouds a threatening, stormy look.

## CONTRAST

For simple recognition of what a photograph is presenting, all one needs is the shape: hence the great importance attached to lighting for black-and-white photography. Although it is perfectly possible to use diffuse and front lighting, side lighting and shots into the source of light are much more powerful in their effect. These forms of illumination of a subject emphasize its plasticity and bring out the contours: they also heighten the contrast, and with this the effect of the picture as a whole.

We place such emphasis on contrast simply because black-and-white photographs are based on varying degrees of brightness and the juxtaposition of bright and dark, light and shadow. The greater the difference in the brightness of two surfaces lying side by side, the greater the contrast. The most fascinating and outstanding effect is when pure white and total black border on one another.

If the pictures are to seem natural, the contrast of the subject must not exceed 1:64, as the film materials available cannot register anything higher than this; this means that a spotmeter should not register a difference of more than six aperture stops between the brightest and the darkest parts of the picture.

The subject contrast is created by the contrast given by the strength of the lighting and the subject's own reflecting power. It can be measured with a lightmeter, and it is best to measure both the factors involved separately. To measure the reflecting capability, the lighting must be absolutely even; this can be checked by holding a grey card at various points directly in front of the subject and ensuring that the reading remains constant on the meter. This is the only thing that must be done to obtain an accurate measurement of the differing reflecting powers of the various colours. If a spot metering is subsequently taken, and the difference between the brightest and darkest part is one stop on the aperture setting, the contrast is 1:2; if it is two stops, 1:4; three 1:8, etc. The following table

shows the relationship between aperture difference and contrast:

| Aperture Difference | Contrast |
|:---:|:---:|
| 1 | 1:2 |
| 2 | 1:4 |
| 3 | 1:8 |
| 4 | 1:16 |
| 5 | 1:32 |
| 6 | 1:64 |

This forest photograph gains its effect from the strong contrasts, a result of shooting into the light.

Contrast is at its greatest when the tones are reduced to pure black and white: this is done by multiple copying in the dark-room.

It is easiest to master these techniques under artificial lighting conditions. By varying the lighting you can achieve any combination of contrasts: they are reduced in front lighting, but increase if you take the photograph with the light coming from one side or towards the camera. Changing the intensity of the light, for instance by varying the distance of the light source from the subject or by using greater or lesser strength lamps, has as significant an influence on contrast as the choice of the source of light itself: harder contrast is given by a direct beam of light than by indirect or reflected light. If the strength of main light, secondary light, spots, and background light is well coordinated, the contrast resulting is increased by the difference in brightness between them. If the reflection stands in a proportion of 1:4, the contrast inherent in the lighting must not exceed 1:16, because the total contrast would then overstep the 1:64 mark, which is the most that can be registered on film.

The extent to which the photographer can influence contrast is, of course, limited, although it is easier with black-and-white than with colour film, because the former has a larger contrast range. This means that there are some subjects that, by their very nature, are better suited to black-and-white treatment: this is the case when the shadow

Contrast need not be limited to that between light and dark, but can be used more loosely, as here where we can see the contrast between old and new.

areas of a strong-contrast subject cannot be lightened sufficiently, or if doing so would spoil the atmosphere and feeling of the shot; a third instance would be where the contrasts were so weak that they would make a very poor impression in a colour photograph.

Very long-distance telephoto shots are usually best taken in black-and-white, not only because colour pales from far off and because distance lends a blue tinge to colour film, but also because the contrast would be so weak that a colour photograph would create no impression whatsoever.

## TONE GRADATION

When taking black-and-white photographs, you must come to terms with, and master, subject contrast. This cannot only be done by lightening the shadows using a reflecting diffusion screen, with photofloods or flash; much can also be done by choosing a particular film. The general rule that low-speed film is hard, with a tendency towards softer effects as film speed increases, has lost much of its meaning these days. Most makes of film have been developed to give a similar range of contrast, regardless of speed, in other words a similar variety in tones of grey.

Normal gradation – that given by all medium-speed films – covers the transition from black to white smoothly: a steep gradation is normally only given by very low-speed document films; these show only a limited number of grey tones, with a predominance of black and white. The fastest films are quite the opposite: the steps between different tones are very small, and, in fact, they only register from dark to light grey.

If, then, you want to retain as much definition as possible, you should choose a faster film, which will reduce the contrast. Clearly, if you are willing to sacrifice definition to contrast, a slow film will suit your purpose best; the extreme will be an almost graphic black-and-white effect: this can be achieved by using a very short exposure, and then printing the negative on very hard paper. Filters can be used to increase the contrast still more. Document or line film will give the most unusual results.

## EXPOSURE

Exposure must be as exact as possible, particularly in the shadowed parts of the image, if the full range of greys is to be used to give a true-to-life effect: if in doubt, over-expose rather than under-expose, especially if there is a lot of contrast in the subject. The only exception to this rule is ultra-fast film, which would give such soft pictures that even the hardest paper would not give a satisfactory result.

High-key shots concentrate on tenderness, expressed in light tones, *see* p. 198 for the corresponding lighting technique.

Medium-speed films have the largest margin for experimentation with different exposure times.

## STYLE

It is a current trend to lay great value on fine tone gradation, and to judge a photograph merely by the presence of a large variety of medium tones, forgetting that the black-and-white parts of a subject are just as important; without them, there is a risk that the photograph will become a tedious series of greys against other greys. Do not be afraid to make full use of pure black and pure white, for they are just as important a part of the photographer's palette as the more 'colourful' middle tones. White impresses itself on an observer, whereas black is more passive: it is therefore important to know that you can restore balance in a picture dominated by a large expanse of the one by contrasting it with a small part of the other. Black looks darkest where it lies next to a patch of white, just as white is most brilliant when seen side by side with black. The overall feeling of a photograph is created by the predominant tonality; the effect will be melancholy if the tones used tend to be dark: there is a suggestion of sadness, death, and mourning, although it can also underline the feeling of something secret or uncertain. The opposite effect, given by bright tones, is one of cheerfulness and *joie de vivre*; it is cool and unemotional at the same time. Soft features are the best means of expressing love and tenderness: high-key technique is used to convey this sort of atmosphere, giving pictures composed primarily of lighter greys; the best results are obtained with fast film, which at its best will convey a dream atmosphere. The 'harsh reality' of life is best represented by using hard lighting effects and hard materials.

## GRAIN

Slow films give the sharpest photographs, and also display very little grain. Grain is the remains of the light-sensitive silver bromide crystals in the film emulsion once they have been converted to silver. The more sensitive the film, the larger these grains of silver: they can be used to stress dirt and murkiness and the less savoury sides of life. The effect can be increased by under-exposing a fast film by 1–2 stops, developing it in a high-speed developer and completing the process by making an enlargement of a small part of it.

Colour Plate 5: Carnival in Valletta, Malta. The picture is exclusively composed of large areas of colour.

# COLOUR PHOTOGRAPHS

It may well suffice to see the shape of an object for recognition purposes, and indeed even in black-and-white photography we can distinguish a chrysanthemum from a pansy, or an aster from a rose: we cannot, however, tell if the flower is yellow, red, or pink. If this information is to be conveyed we must, self-evidently, use a colour film. Colour film can also express attitudes and feelings better than black-and-white, so that a creative photographer has a much better chance of awakening feelings of aversion or sympathy in his observers.

Colours can conjure up a great variety of effects: they can be warm or cold, soft or loud, subdued or obtrusive. They can create harmony or discord, and can be placed side by side with like or complementary colours. They can also evoke a sense of direction in the picture; in this way red and orange are excellent foreground colours, because of their brightness; blue will remain passive in the background, or even seem to fly away. The result is that a colour photograph has even more to win or lose from the skill with which it is composed.

Colour Plate 6: Colours appear brightest when contrasted with their complementary colour.

# COMPOSITION

Beginners normally choose bright colours to start with, and take great delight in their excess: then they try to combine as many colours as possible in the same photograph. If they had half a chance, they would try out all the colours there are at once. After all, they may argue, they have put a 'colour' film in the camera, so why shouldn't they take colourful photographs with it. It will not be long before it is realized that too many different colours will disrupt a photograph, because the eye no longer has anywhere to rest. Try to compose the picture using a few large expanses of colour, which you should choose carefully to create a harmonious impression. It is not even necessary to concentrate on bright colours; softer tones can be just as expressive. Variety is not a prerequisite for an effective picture either; some of the best sunsets are merely composed of tones of one colour. Remember that you are taking colour photographs, not colourful pictures; the colours should be carefully chosen to harmonize with each other and then arranged thoughtfully within the picture.

Many people seem to be of the opinion that a photograph is not in colour if there is no red in it; they always try to squeeze a red car or a girl wearing a red dress into the photograph, and feel quite upset if circumstances prevent this. Of course it is possible to take a colour picture just as well without red. Get rid of this bias towards red, and try to cultivate a feeling for other colours.

Another common notion is that you can only take colour photographs when the sun is shining, just

because that is the case on all postcards, calendar photographs, and advertisements. Certainly colours are at their brightest when the sun is out, but shadows are also at their strongest, which can destroy the colour harmony: strong light may also create more contrast than the film can record. The best colour effect is achieved when the limits imposed by the film are adhered to. The maximum contrast ratio for colour negative film is 1:16, while for reversal film it is only 1:8. As well as subject contrast, colour contrast must be taken into consideration: this is greatest when the complementary colours red and cyan, yellow and blue, and green and magenta, are juxtaposed. When such a combination is natural, as in photographs of plants, the effect of the picture is noticeably increased. If, however, you make your own subject, and take it against a background of the complementary colour – even red, if you insist – you run the risk of it swamping the subject and destroying the effect of the photograph. In such a case, it is far better to use a quiet background that tones in with the main colour of the subject. Under certain conditions the whole impression made by a picture can be destroyed if large square expanses of colour are not separated: if the colours 'clash' on top of this, attempts should be made to create a better transition. If very loud or strong colours are involved, the areas should be interlocked in some way so as to soften the effect; this can be done, for instance, with blades of grass or twigs reaching into a blue sky.

A single colour may look different when seen in combination with other colours; it will stand out against a dark background, whereas a light background will make it look darker, and even convey a sense of sadness. A colour composed of two others poses special problems: olive-green, for instance, will look greener on a yellow background, and yellower on a green background.

Colours are at their brightest the darker the surroundings or the background, the extreme case being black. They get darker if the surroundings are light, at the same time becoming more intense. This is not only an important factor in the composition of the photograph, but it has also to be taken into consideration when books and magazines are being composed. Colour photographs with a white border lose much of their brilliance: a black border obviously has the opposite effect.

Although the best light for black-and-white film is given by the sun, this is not necessarily the case with colour: slightly diffused lighting is often better. Outside this is achieved when the sun is shining through light cloud: the colours will not be weakened, but they will appear in pastel tones. Rainy and misty days are also perfectly good for colour photography. So don't leave your camera at home on days like this, but use it to discover the quieter, sadder colours: you can be sure that your photographs will stand out against the mass of sunny-weather shots.

Natural lighting can give as good a high-key effect as studio lights if properly treated.

# 'NATURAL' AND 'UNNATURAL' COLOURS

There are thousands of different colours which are distinguished one from the other in terms of tone, brightness, and density. This very fact makes such tags as sky-blue and leaf-green totally meaningless as far as identification goes. Being the product of light, the attributes of each colour change, depending on the overall composition of the light. At sunset this means that there is a predominant golden hue, whereas sadness and melancholy are conveyed by the blueness of rainy and cloudy days. The same is true of the light reflected off objects: in shadow snow looks blue rather than white because the diffuse light of the sky is reflected in it. If you take a photograph of a girl under a tree, don't blame the film if her face comes out green: the sunlight is filtered through the leaves.

Although such effects may be natural we do not appreciate photographs of blue snow and green faces; our eyes of course do not register such colour shifts in the same way as film does: we are not conscious of them unless they are very marked, which is why we call such colour changes 'tinges'.

This word should only really be used, though, when the whole picture is pervaded by a tinge of yellow, red, blue, or any other one colour: if, however, it is only a patch that is affected, like the blue snow in the shadow, we are not dealing with tinge at all, because the film has recorded the colours 'correctly'. Likewise a scene partly lit by sunlight and partly by artificial light will not show a colour tinge: the imperfections in the result are the price you have to pay for using both sorts of light on a film that will give correct results only with the one.

The first rule, therefore, is always use the right film for the right light. If this is not done, most colour shifts can still be compensated for by using filters, but there is always the danger, if you do this too much, of becoming reliant on them.

When the colour of the light creates a very unusual atmosphere, you should not try to change it. In particular, a very pleasant effect is given by a tendency towards red in the light composition. More likely to need correction are blue and green shifts. This can be done in the composition by introducing the opposite colour, either as a background or just as a small object: the unpleasant effect will be considerably reduced. If the predominant colour arises from the light being filtered through or reflected off something of that colour, you can again avoid using a filter by including a red brick wall in the shot: the eye of the observer will then attribute the colour shift to this, and it will no longer seem unnatural.

You can even take the green out of portraits taken under trees, if you make full use of diffuse light. This can be done by reflecting the sunlight off a reflector covered in grained gold foil.

It is therefore not sufficient to judge light for colour purposes by quantity alone. You must also consider its quality: the colour temperature, the

Low-key shots are primarily dark, *see* p. 199 for technique.

reflections of coloured surfaces, filtering through leaves or coloured canvas. This adds more importance to our earlier maxim, that you should learn to use your eyes consciously. This is the only way that you will be able to judge the predominant colour tinge and take measures to cut it out. Alternatively, you can turn it to good effect in your picture. There is much controversy about which style of photography is the more natural. It is generally the case that a photographer who merely holds his camera steady is after photographs that have a natural effect, while the truly creative photographer, who wishes to convey a meaning through his work, will make use of any light effects available.

By conscious use of the wrong sort of light you can achieve some very strange effects, and if the variety this offers is still not enough for you, there is much that can be done with filters – even with those intended only for use with black-and-white film. All these methods will give photographs where one colour dominates the others; the results can be charming if used carefully. Using one-colour lighting, or pop filters, will give pictures in monochrome, but much more variation can be had by using a mixture of different coloured lights. The combinations are infinite; the motto is: anything goes, as long as it pleases.

A very special effect is given by infra-red colour film: unlike all other colour films, you can rely on this one to give the wrong colour every time! Hence its nickname 'false' or 'crazy' colour film. It is only available in 35 mm. cassettes, or as sheet film for aerial shots. Green comes out purple or red on it, and indeed this is the predominant colour of the whole picture if no filter is used. If, however, you use warm-colour filters intended for black-and-white photography, a wider range of colours will appear, with the maddest results. There is no limit to the use that can be made of this sort of film for experimental photography.

## COLOUR FILMS

Depending on the sort of film used you will get either transparent positive pictures, or a negative in the complementary colours. You make the choice depending on whether you want slides or paper prints.

## REVERSAL FILMS

These produce transparencies upon development, and are intended for projection. It is possible to take colour prints from them, but the results will never be as good as those given by colour negatives: if you try it, better results will be given by slides consisting of light colours than by those where the colour is dark, or where there is a lot of colour contrast. Black-and-white prints can be made only if you first take a negative copy of the slide.

The colour temperature of the light is very important in determining the quality of the colour reproduction, which is why one daylight and two

artificial light films are produced. If you use the wrong sort of light the results will be marred by a strong colour tinge: daylight film used indoors with room lighting will be yellow, whilst artificial-light film used outside will appear blue. Daylight film will give a good response to electronic flash or blue flashbulbs. Artificial light used with the corresponding type of film should be checked to see that the colour temperature is correct: the range is given on the film packet. The 'wrong' film can be used if a correction filter is placed in front of the lens.

The peculiarities of a film depend upon who makes it: you should look for one that gives a good colour gradation under normal conditions, with good density and separation. You want as little grain as possible, to give the maximum detail. Photographic magazines occasionally publish comparisons based on tests, showing which films tend toward red, yellow, green, blue, or violet; some give better results with pastel shades, others with bright colours: it is a matter of personal taste which type you choose from this point of view, but there are generally accepted norms for the other factors tested. So do not base your choice on how much the film costs, but on its quality. Try to stick to the same film once you have found the one you like, and in any case do not change brand too often. As time goes on you will learn its strong points, and above all its weak points, so that you can take them into consideration when setting the camera.

Grain can cause havoc with high-speed reversal films, especially in 35 mm. The highest available speed is 160 ASA: the Ektachrome high-speed film can also be exposed as for a 650 ASA or very rarely a 1250 ASA film, although in the latter case a special developer is called for. Normally 40-64 ASA films will do all you need, giving you good colour density, sharpness, contrast, and exposure margin.

There is very little opportunity to correct exposure faults on a reversal film once the shot has been taken, a technique often used with negative films. This means that the camera must be set exactly, basing the setting on the brightest parts of the subject. A misjudgment of only half a stop can often make or break the picture, particularly in the case of over-exposure. The highlights look 'emaciated', the colours pale and insipid, but a slight under-exposure will give denser colours. Soft reversal films, which give good pastel tones, have a very wide exposure margin, slow films having the narrowest because they can only register limited contrast: this also means that they give the best density. The point must also be made, however, that the exposure margin also depends on the subject contrast: the less strong this is, the greater the exposure margin, and vice versa.

It is normal for the film cost to include processing, and sometimes even mounting; this means that you have to send it to the processor recommended by the manufacturer. Some reversal films can be bought without these strings, so that you can develop them yourself; only rarely do people make use of this opportunity, and they, too, normally end up in a large laboratory.

Slides do not let you delay choosing the part of a view you really want until you get into the darkroom; you must therefore compose the picture exactly before you press the shutter. Otherwise you will have to rearrange the picture in its frame, which

is very unattractive, or spend a lot of money on having an enlargement made.

Slides are not only used for illustrated lectures, but are also best for lithographic or block printing. Reversal film gives much brighter, sharper results than negative film, and on top of this it is cheaper: the disadvantage is that it only gives one-off photographs, with which especial care has to be taken to avoid scratches and fingerprints.

## COLOUR NEGATIVE FILMS

These not only give the basis for making a colour print, but can also be used to make slides or black-and-white prints, although in the latter case the tone gradation may not be absolutely correct; skin colour, for example, comes out too dark. There is a distinction between masked and unmasked negative films, the former having the more complex construction, and being correspondingly more costly, but giving at the same time brighter pictures.

There is a relatively large exposure margin with negative films, the reading being based on the darker areas of the subject, as with black-and-white films; they are usually suited to both day and artificial light, since the colour composition is not finally decided until the darkroom, where use is made of filters. You can, however, only make full use of the film's capabilities if you do the enlarging yourself; you can then give full rein to your fantasy and produce spectacular colour effects. The amateur who gives his negatives to a professional for processing should take note of the following points: as the film is processed automatically, and not manually, the same sort of light should be used on the whole roll: this is why the box has printed on it that the film is daylight-sensitive. If artificial light is used, the same applies as for reversal films: a conversion filter must be put in front of the lens.

This photograph of the moon had to be a relatively short exposure, otherwise it would have appeared as an oval instead of as a disc on the film. In one minute the moon moves a distance equivalent to its own diameter.

# LIGHT – THE PHOTOGRAPHER'S PAINT BRUSH

A mastery of our light source, both in terms of its quantity and of its quality, is necessary if we are to create good photographs. The first is the easier of the two, because we can use a lightmeter.

## THE PHOTO-ELECTRIC LIGHTMETER

These provide the only reliable measurements of the intensity of light. They normally cover an angle of 45 to 50 degrees, which is approximately the angle taken in by a normal lens. There are also special lightmeters, the so-called spot meters, that cover an angle of only a few degrees. The most versatile of all are those that have an aperture to control their angle of view. The advantages of this are quite clear: if, instead of a wide-angle or normal lens, a telephoto lens with a long focal length is being used, the aperture on the meter ensures that the reading taken corresponds to the angle covered by the lens. It also permits semi-close-up metering of the important parts of a particularly contrasty subject without having to change one's position. Obviously the best lightmeters to use in this case are those that indicate the field from which the reading is being taken.

There are two sorts of lightmeter on the market, both of which have their advantages: the CdS and the selenium-cell lightmeters. There are also a great number of cameras that already have a lightmeter built in. The advantage of this is that it means one less accessory to carry around. It can, moreover, be wired up so that the camera settings are made automatically: since the meter is directly linked with the aperture and time settings, the camera is quickly brought into action, particularly when the measurement is reflected in the viewfinder. The procedure is as follows: first you choose either an aperture or a time setting, and then adjust the other setting until the meter needle rests at the half-way point. Semi-automatic cameras have to have one of the settings made before the reading is taken, and the other is set automatically.

The most modern method is to take the reading

directly through the lens. This most often means an integral meter reading, i.e. an average reading taken of the highlights and shadows in the subject. It is the same method as is used in normal hand-held meters.

One method, which seems particularly effective, is that where an integral reading of the whole subject is taken, but in such a way that the sensitivity of the cell is reduced towards the edges. It is normally the case, that the central field of the cell is about 60 per cent, and the less-sensitive area round this about 40 per cent. This method generally gives an even more accurate reading than a normal integral meter. For most subjects both these methods are quite sufficient: but if there is excessive contrast in a subject success can only be had with a selective lightmeter. This is done by taking a reading only from those parts of the subject that are essential to the picture: this can only be done with those cameras able to take a spot reading through the lens. This system of lightmetering is by far the most satisfactory in the hands of an experienced photographer. Cameras that can be switched from one method to the other are by far the most versatile.

## ACCURATE CALCULATION OF EXPOSURE

Possession of a lightmeter is not in itself a passport to correctly exposed shots: you have to be able to use it correctly, in other words interpret its readings accurately. You have to know that the light-meter is 'sensitive' only insofar as it treats every subject as if it were partly composed of black, pure white, and mid-grey, as is of course the case with most subjects. It then takes a mean reading which should lead to a correctly exposed negative or diapositive. If, however, the above condition is not fulfilled, the meter gives a false reading. This means that too long an exposure time will be indicated for a subject that is dark all over, and too short an exposure time for a very bright subject – such as a snow landscape. The result will be an over-exposure in the first case and an under-exposure in the second. It is up to the photographer to interpret the reading given accordingly.

To cater for the possibility that there may be certain faults in the construction of the camera, for example a badly adjusted shutter, it is advisable to calibrate your lightmeter by taking a few test shots: these will equalize any discrepancies, providing the subjects are of moderate contrast.

Let us suppose that you have a 50 ASA colour reversal film in the camera, and that your light-meter indicates aperture $f8$ and $1/125$ sec: set the camera according to the reading for the first shot; then take two more exposures, altering the aperture to $f5.6$ and $f11$ respectively. The photographs you take will have a difference of one stop from the reading suggested by the meter. The exposure time, however, remains unaltered. A more rigorous test would be to take two more photographs, setting the aperture at the half stops. The point hardly needs making that the details should be noted down in a book. Once the film is developed, you will be able to see quite clearly which shot is correctly exposed. If necessary, you can then make a correction to your lightmeter.

If you are carrying out the test with a black-and-white film, it is best to use a low-speed one, since these react most clearly to incorrect exposure.

## MEASUREMENTS USING THE SUBJECT

This is the most frequent form of lightmetering: it is taken from the position of the camera and directed towards the subject of the photograph. Since it involves a mean reading being taken of all the light and dark parts of the subject, it will only give correct results where

Measurement using the subject.

● light and dark areas are spread out over the whole subject in small patches and
● the subject contrast does not exceed the exposure capability of the film being used.

When taking landscape photographs in the open, the effect of a bright sky is overcome by pointing the meter downwards a little and shading the window with one hand.

Subject contrast should not exceed
● 1:64 for black-and-white films
● 1:16 for colour negative films and
● 1:8 for colour reversal films.

This corresponds to a meter-reading difference of 6, 4, and 3 stops respectively. When measuring this contrast difference, only use the light and dark areas, which should still show some detail on the film, and not the black and pure white parts of the subject. If the contrast of the subject exceeds the capability of the film, it will be impossible to produce a correct image of the brightest and darkest parts of the subject unless the shadows are brightened by using artificial or flash light bounced off a reflecting surface. Alternatively, you will have to be satisfied with an exposure based on the important parts of the subject. These are
● the shadows for black-and-white and colour negative film, and
● the highlights for colour reversal film.

This is very easy when, for example, you are taking a photograph of a landscape from the shade of the edge of a wood. If you have a colour reversal film in the camera then you should step out of the shadows to take the reading: if this is not possible, simply take the aperture down a half or a complete stop over and above the reading given by the meter. The

same procedure must be followed in taking shots from a tunnel or an archway.

Objects that do not consist of such large expanses are best dealt with by taking a reading from the brightest part and then opening the aperture a further stop. This will give a correct exposure for the light and medium tones, even if the rest is too dark on the final print. Selective metering of different parts of the picture can be made either from the camera position, using a spot meter, or by using a normal lightmeter from close up. This means taking the reading from about 6 to 10 inches away from the point being measured, making sure not to cast a shadow on it.

Portraits only really require perfect reproduction of skin tones: if a close-up reading is not possible, e.g., because you wish to photograph strangers without being noticed, you can take a substitute reading from your own hand and still obtain good results.

You will achieve the best results by measuring the light and dark parts of the subject separately and then calculating your own mean reading when you are using black-and-white or colour negative films. This is particularly the case when you are taking photographs out of a tunnel. If the subject is predominantly dark, however, it is best to take the reading from the shadow areas. Measure the darkest spot that is to be well defined and close the aperture by two stops, for colour negative films, by three stops for black-and-white films. This will give good definition of the shadows through to the middle tone range. If in doubt take several photographs at different aperture settings. For colour reversal films change the setting by half a stop each time, and by a whole stop for black-and-white and colour negative films. This way you can be sure of getting the best exposure.

## INDIRECT READING

This method involves a diffusion screen being placed before the meter window. This means that the angle of reading is increased to 180°, the emphasis being on the intensity of illumination, not on light reflected from the subject. It is a method used particularly when the subject contrast is very strong; it can also be used to measure the lighting contrast, by taking a reading from various parts of the subject. It comes to the fore when working with artificial light, because one can make sure that foreground and background lighting are absolutely even, and coordinated in the correct proportions.

The method used contrasts with the direct reading because the meter is held immediately in front of the subject and pointed towards the camera. Since light intensity is absolutely independent of the individual colours of the subject, it makes no difference whether the reading is taken in front of a white blouse or a black dress. Exactly the same result will be given in both cases.

Indirect metering with a diffusion screen.

## THE GREY-CARD METHOD

This is an aid to measuring the contrast given by the lighting, used with through-the-lens metering. The card used is neutral grey giving 18 per cent reflection, which is the normal reflection given by indoor subjects. Such cards are available from photographic dealers. The card is held at various points in front of the subject, and a close-up reading is taken of the light reflected from it.

The grey-card method is particularly handy for close-up shots and portraits. An absolutely correct reading is given for colour reproduction. You need only take into consideration that reflecting power is in general slightly less for daylight shots than for shots under artificial-lighting conditions. This means that having taken a reading outside and set it on the camera you should then close the aperture a further half stop.

## EXPOSURE CORRECTION

It is frequently desirable to vary the meter reading somewhat to get good results.

In the case of sunsets or sunrises taken on colour reversal films, the aperture should be shut down by one to two stops. Pictures of rainbows or the reflection of the sun on water call for an aperture reduction of one stop. If your photographs are intended for publication, it is best to cut down the exposure slightly, as this will give more intense colours. A restricted exposure is also the best way of expressing a dusky atmosphere. Dull weather and rain, mist, or snow call for an increase in the aperture of a half to one stop. Also subjects with weak contrasts, like many snow landscapes or aerial photographs call for an increase in exposure. Under the same weather conditions, black-and-white and colour negative films will require a decrease in aperture of one stop: likewise aerial photographs and far-off views need a restricted exposure. Twilight photographs, however, need an over-exposure of one stop, as do all black-and-white shots that are later going to be subjected to fine-grain development. It depends on the developer being used.

## SHOOTING INTO THE LIGHT SOURCE

This is not the easiest of techniques to master: when it is achieved, however, the most attractive effects can result. If only small parts of a subject are affected by the light source, the normal method of through-the-lens metering can be used without any problem. Otherwise, it is a question of how you wish to compose the picture – e.g. a park landscape with a group of trees. If you wish to use the strong contrasts given by the light source to the full, you must base your exposure on the landscape as a whole: the trees will then appear as black silhouettes. If, however, you wish to lay emphasis on shadow definition, you must use the trees as the basis for the exposure. The field will then come out white, and the effect of the photograph being taken into the light source will no longer be apparent. Both these extremes can only be achieved by an exact measurement of the details. By using an in-between value, which you can judge with the aid of the lightmeter, you can reduce the strength of the contrasts by making full use of variations in the exposure margin of the film.

When a photograph is taken directly into the sun it is the sun itself that conveys the feeling behind the shot.

## THE USE OF LIGHT TO CONVEY FEELING

The brighter the lighting used the more realistic and matter-of-fact is the resulting atmosphere. Using half-lighting, with less clearly defined shadows, a veil of mystery and concealment can be

Colour Plate 7: Colours do not have to be particularly bright to give an effective picture. Indeed it is often the case that gentle pastel tones are far more attractive.

suggested. Thus a bar owes its intimate atmosphere, above all, to the low-key lighting. If you return in the daylight, it is hard to imagine such an atmosphere; the effect of bright light is disillusioning. Even the sanctity of an old church appears inseparable from the subdued light transmitted by the colourful stained-glass windows. If you find yourself in a modern church aflood with light, the effect is usually less striking, simply because the brightness seems so dispassionate.

An old saying tells us that where there is light there is shadow: this holds a literal significance for the photographer. Simple front lighting does not give depth to shadows but rather flattens them and takes away from the picture any sort of atmosphere. This is not so with side lighting, footlights, and rear lighting. The effect of footlights is theatrical and unreal: you can achieve quite 'demonic' effects on film.

Oblique lighting gives a lively, friendly atmosphere to pictures; the shadows break up the picture and are as much a characteristic of a hot sunny day as hazy white cumulus clouds in the deep-blue sky. From the long shadows you can picture the sun low in the sky, all of which adds to the picture the tranquil mood of the dying day. Shadows therefore determine the impression made by a picture as much as the well-lit areas.

Diffuse light creates gradual transitions from dark to light and thereby comes over as softer and warmer. Harsh lighting, though, increases contrast and has the opposite effect, producing prints that are clear-cut and hard, uncompromising and unpitying.

Shadow-free illumination is therefore best used to give expression to fragile, gentle, and soft subjects; a venerable ladylike quality can be achieved in portraits of women by using it; babies, using this lighting, appear irresistible, arousing all those feelings we have for them.

Diffuse illumination can also express tedium and melancholy if it is subdued. The whole notion of dull, everyday life can be communicated through it.

On slightly hazy or misty days, a cool autumn morning is enhanced by the sun's rays streaming through the branches of a tree from the front or the side. And who is not acquainted with that pencil of golden rays that the afternoon sun sends through the murky windows of factories and stations? They reflect off the dust and the smoke, and bathe the whole scene in a magical atmosphere, making us forget the bustle and the tedium of a day that has been spent hard at work.

If such an atmosphere is what we want to capture in our photograph, then we have to make do with the available lighting. Any supplementary lighting will destroy all sense of feeling. This means that you will have to buy a high-speed film, despite its reduction in detail and its large grain. The result will

Colour Plate 8: Sunset at Kerteminde, Denmark. Taken with a telephoto lens, the reflection appears as a second sun.

Below: Sunrise over Port Sudan harbour.

The effect of rear lighting on the Odense-Fjord.

nated: in this way the feeling can be maintained as much as possible. Available-light photography denies the use of such mechanical aids as a fundamental principle. It is merely a question of using wide-aperture lenses and high-speed films so that a hand-held shot can still be taken under the worst lighting conditions. When taking the exposure reading, you must be careful that no strong light sources fall within the angle of measurement.

A photograph straight into the light source uses that source itself to convey the feeling behind the shot. Reflections will occur, which will either appear as rays of light or as small halos. They are caused by the fact that the light projected through the lens does not only penetrate the light-sensitive emulsion of the film but also the film backing. A part of the light is then reflected, though much dispersed, so that it hits the light-sensitive emulsion a second time. It is normally still strong enough to darken the emulsion and create these halos.

The use of a soft-focus supplementary lens can, when taking photographs into the source of light, give a very romantic feeling to the photograph. Diffraction screens, also known as 'star-effect screens', create a pattern of light rays in the form of a star around the source of light. A diffraction screen can be made at home with a piece of black cloth or a black nylon stocking. One or more layers

be a picture that, while it may not be technically satisfying, will radiate a wonderful atmosphere, capable of moving an observer far more than a picture of the same subject taken with all the technical refinements of modern lighting systems and yet completely lacking in feeling.

If you do decide to use lamps to brighten the shadows, it is important to adjust them very carefully, so that the shadows are not completely elimi-

Feeling is conveyed by the spread of light rays, caused by taking the photograph straight into the sun. The picture was taken with a fish-eye lens, which is why the horizon is curved.

can be stretched across the lens and held in place with a rubber band. The starry pattern depends on the angle of the weave of the fabric.

To get used to such attachments, you should always start by taking two shots, one with and one without a gadget in front of the lens. By comparing the results you will soon learn the differences. When using single-lens-reflex cameras, you should only put the screen in front of the lens after you have focused the image on the ground-glass screen. Soft-focus photographs need a slightly shorter exposure than normal, whereas a dense diffraction grating will mean that the aperture has to be opened by half a stop.

## COLOUR TEMPERATURE

It is not only the brightness and the direction from which the light is coming that gives a particular sense of feeling to a photograph. A much more important factor is the colour of the light.

Daylight is continually altering; it is different at sunrise and sunset than at midday, and when it is raining or when there is a mist it is different from the light on a cloudy day. The same differences are present in the spectral composition of artificial lighting: household and photographic lamps, flash-bulb and electronic flash, candlelight and fluorescent lighting all give a particular sort of light. Our eye is very quick to get used to the differences and will, for example, always recognize a white piece of paper as white, regardless of the sort of light shining on it. Colour film reacts differently; it is intended for use in a particular type of light, and it only shows the sheet of paper as white when the correct light is used. The concept of colour temperature is used to provide a common scale against which a spectrum range of each type of light can be checked.

This measurement is made by a comparison of the colour of the light that has to be determined with the incandescent colour of the body, which should, in theory, be black. When they coincide, the temperature of the incandescent body is measured and expressed in degrees Kelvin ($^{\circ}$K). These are the same as degrees Celsius but they are taken from absolute zero, i.e. from minus $273^{\circ}$C. To ascertain the colour temperature of the light being used, you can either check on the following table or, with certain reservations, make use of a colour-temperature meter.

# COLOUR-TEMPERATURE TABLE

|  | Colour Temperature in °K | Mired | Decamired |
|---|---|---|---|
| Daylight | 5600 | 178·5 | 18 |
| Artificial light (Tungsten) Type A | 3400 | 294·1 | 29 |
| Artificial light (Tungsten) Type B | 3200 | 312·5 | 31 |
| Candle | 1500 | 666·6 | 67 |
| Household bulb | 2800 | 357·1 | 36 |
| Projector lamp | 3200 | 312·5 | 31 |
| Photoflood Type B | 3200 | 312·5 | 31 |
| Halogen lamp | 3400 | 294·1 | 29 |
| Photoflood Type A | 3400 | 294·1 | 29 |
| Clear flashbulbs | 3800 | 263·1 | 26 |
| Blue photoflood | 4800 | 208·5 | 21 |
| Blue flashbulbs | 5500 | 181·8 | 18 |
| Electronic flash | 5800 | 172·4 | 17 |
| Morning and evening sun | 4000 | 250 | 25 |
| Sun with white clouds (before 11 a.m. and after 3 p.m.) | 5500–5600 | 180 | 18 |
| Sun in a clear blue sky | 5700 | 175 | 18 |
| Sun in haze | 5700–5900 | 170 | 17 |
| Cloudy sky | 6700–7000 | 148 | 15 |
| Midday sun | 7000 | 143 | 14 |
| Low mist without sun | 7500–8400 | 125 | 13 |
| Thick cloud, rain, and mist | 7000–12000 | 143–83 | 14–8 |
| Subject in shadow; clear blue sky | 10000–12000 | 100–83 | 10–8 |
| Blue sky with high cirrus clouds | 12000–14000 | 78 | 8 |
| Clear blue sky | 25000 | 40 | 4 |

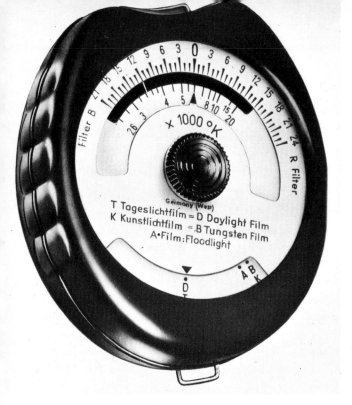

Colour-temperature meter: 'Sixticolor' by Gossen.

Far more than the black-and-white photographer, then, the colour photographer has a vast range of moods and feelings that he can express with his pictures. He can make use of the colour temperature of the light, or use filters to create a balance between the tones involved. Since each make of film is different, this gives him another source of variation.

Soft colours are reticent, pleasing, and soothing, whereas bright, loud colours live up to their aggressive name: they convey jollity, extrovert happiness, and good humour. Pastel shades on the other hand are more timid, and are better for expressing more delicate feelings. They can be combined with a bright spot in the picture to give an immense feeling of tension by underlining the gentleness of the rest of the photograph. This is very much the same thing as in black-and-white photography, where white is brightest when next to black, and black darkest when next to white.

Harmony and order can be expressed by colours that match well, whilst colours that clash create a feeling of disunity, quarrelling, and argument. A total confusion of colours can give a feeling of complete lack of organization, making the picture brim over with vitality and happiness.

Different feelings are inspired by each colour; most tones of green are soothing and pleasant, whereas yellows are decidedly aggressive. Blues are cold and unfriendly. By contrast, reds and oranges are friendly and warm; they can express sympathy, joy, and love. The terms 'warm' and 'cold' are exceptionally relative terms; there are of course scales of warmth within the areas of both cold and warm colours. In the latter we range from yellow-

This table indicates that the more blue there is in the light, the higher the colour temperature. This is an example of physics stating the direct opposite of what our feelings suggest to us, since we usually call red, orange, and yellow tones 'warm', and regard blue as 'cold'. In the context of this book we shell refer to colours as warm and cold in the sense of these feelings.

orange through orange and red to red-violet, orange-red being the warmest of all; in the cold spectral range we are talking of a series from turquoise through blue to blue-violet. If, therefore, we want to convey the contrast between warmth and cold, we are not limited to placing red and blue side by side. All this playing with colours and our reactions to them are relative, which is only to be expected given the vast range of colour tones available.

## FILTERS FOR COLOUR PHOTOGRAPHY

If you wish to reproduce the colours 'correctly' when the emulsion on the film is not sensitive to the colour temperature of the light being used, you will have to make use of filters. Those used for this purpose are pale red or blue and act as equalizing filters.

To simplify the use of these, two concepts have been invented: Mired (from *mi*cro *re*ciprocal *d*egree) and decamired: to establish the value in mireds, divide one million by the colour temperature; if you again divide by ten, you will have the value in decamireds. These decamired values have been included in our table: they are easier to use, since the equalizing filters are marked with a value expressed in decamireds. You use the filter that has the number corresponding to the difference between the colour temperature for which the film was intended, and that of the light actually being used. Red equalizing filters are marked with a plus $(+)$ sign, and blue with a minus $(-)$ sign.

Here is an example: you wish to use an artificial-light $(3,200° K = 31$ decamired) colour film with household lamps at $2,800° K$ $(= 36$ decamired). The difference is $31 - 36 = -5$. You will need a blue equalizing filter number B5. If the number is so high that you do not have a filter strong enough, you can quite easily combine them to give the correct total factor.

Although you can add the decamired values, you must multiply the filter factors to find the adjusted exposure time.

Conversion filters are likewise coloured blue or red, and are used when a type of lighting normally calling for a special film is being used; this would be the case if, for instance, you had a tungsten film in the camera, but wanted to finish off the last few shots in daylight, when you would need a red conversion filter R12 to give the correct colours. Obviously if you want to use a daylight film under artificial-lighting conditions, you would need a blue (B12) conversion filter.

Given this apparently ideal method of filtering, you may think that it is hardly worth while producing films sensitive to different colour temperatures; but the filter has a side-effect: it effectively reduces the sensitivity of the film.

Unlike the above, colour-equalizing filters are available in six different colours. Agfa call them correction filters, and supply them in four densities: 05; 10; 20; and 40. Kodak call them Wratten-CC (colour-compensating) filters, and supply six densities, 05; 10; 20; 30; 40; and 50. These densities are not equivalent, the Agfa being about half as dense as the Kodak for the same number. The filters are made of cellophane and require a special holder.

These filters are generally used to give exact colour reproduction, especially in the following instances:

- when colour shift occurs
- when a colour tinge has to be avoided, such as cast by the leaves of a tree: you would use a filter lying opposite the offending colour on the colour wheel. Alternatively,
- when the emulsion on a film needs a tinge to reproduce the correct colours; professional colour films are provided with a table showing what colour of filters to use under what circumstances.

Colour-equalizing filters.

Correction filters can of course be used artistically, consciously affecting the colour balance of the whole shot by means of any single filter.

## LIGHT AS THE SUBJECT

Here use is made of the ability of film emulsion to store up light impressions, which means that effects can be shown that our eyes cannot see in their entirety; the results are very unusual.

For example, someone can stand in a darkened room and paint pictures or write words in the air with a pocket lamp; a flash is then set off, so that the artist and his work will be seen in the same photograph. Fireworks can be used in the same way: a Roman candle, Bengal Lights, or a Golden Rain can be lit and then swung in the air before the flash is set off.

'Oscillation' photographs are made by a similar process, but make use of the beauty of geometrical forms like those seen on oscilloscopes; it is very difficult to predict the form that the shot will take, because the movement cannot be watched as the camera sees it. The final result will not be seen until the film is developed, so much is left to chance.

You must take the photographs in a completely darkened room, using a torch suspended on a string, so that the beam falls on to the floor. You must remove the glass and the reflector. This is better than reducing the beam by sticking a piece of black cardboard over the glass it enables the shot to be taken from the diagonal as well as from the vertical.

The lamp should hang 3–9 feet above the camera, depending on how wide its swing is to be. Using a 50 ASA film, the aperture should be set at at least $f$5·6, with a B or T time setting. The lamp is then set swinging in circular or elliptical oscillations; wait for the first, irregular movements to pass, and release the shutter; the exposure should last for a minute or more, since the oscillations get smaller as time goes on. The result is a very attractive ornamental pattern. There is no need to restrict yourself to using one lamp: several can be used at once to give an intricate interweaving of patterns. Another possibility is to take several exposures of different patterns on the same film. If your camera will not take double exposures, you can cover the lens with a piece of card before changing the movement of the torch. For this superimposition you can either set the torch off in a different direction, move the camera, or do both.

If the same technique is used with colour film, the effects can be astounding. It means that not only can different patterns be captured, but also different colours. This can be done either by using different-coloured bulbs, or by putting a different-coloured filter in front of the lens each time. This will mean the exposure time having to be increased over that used for an unfiltered shot; the unfiltered shot, incidentally, will record a yellow trace. Shots

Light writing: if names are written in the air with a pocket lamp, the negative must be reversed before printing so that the name will be legible.

Oscillation photographs.

of fireworks, those taken at night and during storms all belong vaguely under this heading, but will be dealt with separately.

## USING ARTIFICIAL LIGHT

Artificial light makes the photographer independent of the sun for his shots, and is used when either the quantity or the quality of the daylight does not meet his requirements. It is used to lighten shadows and to produce special effects. Two sorts of artificial light are involved, continuous and flash; the latter has an additional use in the photographing of movements or phases of movements.

One advantage of artificial light is that it can be matched precisely to the film in terms of colour temperature, because it is not subject to such violent variations as daylight.

## CONTINUOUS LIGHT

The effect of a continuous source of light is easier to observe than flash, and the actual lamps can be arranged to produce any conceivable combination. Professional photographers have known of this advantage for a long time, and use it for portraits, still-life shots, fashion, and advertising, as well as for many other subjects. This will be gone into later in the book. The main disadvantage is the amount of heat that the lamps produce, which must be watched carefully when dealing with plants and animals. Moreover, compared to flash, considerably less light is produced.

For classic studio lighting, 4–5 lamps are needed
● a main light
● a shadow or fill-in light
● an effect light
● 1–2 lights to illuminate the background.
The more lights you use, the more work is involved, and the more likely you are to produce unsatisfactory results because of double shadows. There is no point in exceeding this number of lamps.

Do not forget to find out how many lights you can have on at once without blowing a fuse. There is a simple means of checking this:
In the formula

$$N = U \times I,$$

N is the output of the lamp in watts, U is the voltage, and I is the current in amps. If the voltage stands at 220 V with a 10 amp fuse, we can use our formula to find out that the total output of our lamps must not exceed $220 \times 10 = 2{,}200$ W if we are not to overload the circuit. Since there is variation in the voltage used in houses, it will sometimes be possible to use more lamps, sometimes necessary to use less. To check, you should make the calculation yourself, and even then light the lamps one at a time.

For our purposes household lamps have little use: their output is minimal.

Photoflood bulbs work under overload conditions and thus produce more light. Type A is specially produced for amateurs who are only going

to use artificial lighting now and again. They look like normal bulbs, but have a colour temperature of 3,400°K, and last on average from 3–4 hours. For professional use there is a Type B, which costs more, but lasts correspondingly longer. When coloured blue, the colour temperature reaches 4,800°K and they can be used with daylight film. If they have a reflecting surface on the inside, an additional reflector is not necessary; otherwise, a reflector must always be used, or the light will be scattered all over the place and not produce any real lighting effect.

Depending on the sort of light used, a soft or a hard effect can be had. Strip lights give a very diffused sort of light, which gives a splendid shadow-free effect; unlike the other forms of bulb described above, however, they do not cover the usual light spectrum. This makes no difference for black-and-white, but it will give a strong green tinge to colour film; although as far as our eyes are concerned it is much the same as daylight, and the colour-temperature meter does not register any difference; a purple filter is necessary to compensate.

'Softlite' floods are matt reflectors with only a slight curve and a photoflood bulb without an internal reflector. To prevent any direct light being emitted, a small disc of tin is put in front of the bulb. Over and above this you can add a diffusing screen of plastic, tracing paper, or wire mesh about 4 in. in front of the bulb.

Film-studio lamps give a harsh, direct light, usually provided by tungsten-halogen lamps; these lamps are usually used as the main light.

Stepped-lens floodlamps are expensive pieces of equipment, available in all sizes from 'Baby' to 20 kw. The beam can be varied to cover an angle from 7° to 40°. A rather harsh source of light, it is normally used when the subject is a long distance away. Its versatility can be increased by a range of accessories, such as filters and patterns for background lighting. Diffusion gratings can be used to cut down the hardness of the light. If you replace the fresnel lens by a condensing lens, you will have a spotlight, casting a narrow, high-intensity beam: a marvellous effect light.

Instead of a stepped-lens light or a spot, you can convert a slide projector for the purpose; points to remember are that the bulb must never be inclined at an angle of more than 15°, and that the heat guard filter should be removed as it will impart a pale-green tinge to colour film; perhaps the best of all is the Rollei projector, which can be used with a zoom lens to allow the width of the beam to be altered. This can also be done by making a cone of aluminium foil with a small hole at the point, and placing this over the lens.

If you think that you are going to use studio lighting a lot, then make sure you have enough stands and cable for all the set-ups you are likely to need. Normal lamp stands will only hold light lamps and mirrored bulbs. Solid tripods are suitable for carrying heavy lamps, and are of necessity fitted with castors so that they can be rolled to the desired position.

Since tripods require quite a large amount of ground space, bracket stands are better for use in restricted spaces. These consist of a series of tubes one inside the other, which are spring-loaded so that they will hold steady when fixed between floor and ceiling. A very firm hold is given by rubber suckers on ball and socket joints.

Direct–Indirect flood with aluminium reflector and matt enamel reflector. It can be converted from harsh direct light to a soft indirect light simply by removing the aluminium reflector round the bulb.

ARRI stepped-lens floodlamp.

## FLASH

Flash light is the photographer's personal sun. Since it emits light for only a fraction of a second, it has to be synchronized with the camera shutter so that the light is only emitted while the shutter is open. To this end cameras with a between-the-lens shutter are fitted with an X-contact and occasionally an M-contact, while focal-plane shutters are linked with an X- or an F-contact.

When using flash bulbs or cubes with a between-the-lens shutter, the X-contact is used with a shutter speed of 1/25 or 1/30 sec. If the flash is the main source of light, then the shutter speed is not as important as the length of time for which the flash is effective, which is on average about 1/100 sec. If, however, you are using the flash in conjunction with daylight to capture movement abruptly, or indeed to cut out the effect of the daylight, you should use the M-contact – if you have one – and decrease the shutter speed correspondingly; this will ensure that the shutter is open for the same length of time that the flash is effective. Since only a part of the light is being used, albeit the greater part, the aperture must be increased accordingly. In practice little use is made of this facility, particularly since in conjunction with an electronic flashgun even the shortest exposures can be synchronized with the X-contact.

A focal-plane shutter can only be synchronized with flash bulbs, cubes, or electronic flash when used at a speed where the whole negative is exposed at once; this varies from camera to camera, and from 1/15 to 1/125 sec. In other words, read the instructions given with the camera very carefully! For synchronization in these cases, the X-contact is always used.

If you want to use shorter shutter speeds, you will need to buy flash bulbs that burn for a longer time and emit a constant light: these are used with the F-contact.

If you have not yet bought your flash unit, the first thing to consider is how often you are going to use it. If the answer is 'not often' you will be far better off with a hotshoe flash or flash bulbs than

with the considerably dearer electronic flash, which is only really worth buying if you are going to use it regularly and often. If you do decide on an electronic flash, you should immediately go for a computer flashgun; these have an automatic sensor, which measures the light being reflected from the surface of the subject, and sets the length of flash accordingly; this is done by means of a cable connecting the sensor to the gun. It can be adapted to give normal, indirect and 'free' flash, which allows much greater scope than standard flash.

The higher the flash index, the greater the light output of the bulb. This index is given on the box for each bulb and flashgun. If the index is doubled, the output is not twice that of the other bulb, but approximately four times as great! This fact should be kept in mind when you are comparing prices and indices. You should also remember that the indices are linked to a specific film speed.

If you are using computer flash, which will give the correct exposure automatically, you can use the index to find out the right setting for the aperture from the equation,

$$\text{Aperture} = \frac{\text{Flash Index}}{\text{Distance (in yards)}}$$

In practice, you need to do a lot less arithmetic than seems necessary at first: in each pack of flash bulbs or cubes you will find a table, from which you can read off the aperture required at various distances. Electronic flashguns are usually supplied with an aperture calculator, where all you need to do is set the speed of the film being used on a scale, and then read off the aperture against the list of flash-to-subject distances.

All these values, however, will only work in a

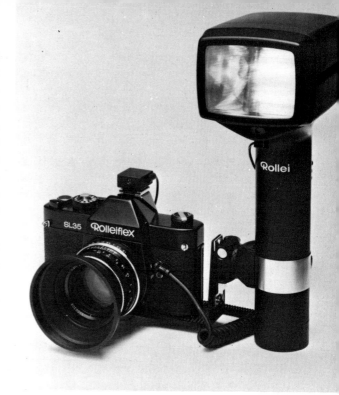

A Rollei E36RE with Vario-Computer; it is attached to a Rolleiflex SL35.

normal room with a fairly bright décor: this means almost all living rooms. If the reflecting power is low, as in large rooms, in the naves of churches, or in the open, you should increase the aperture
● by a whole stop for hotshoe flash
● by half a stop for electronic flash.
Also, if the flash-to-subject distance is less than 5 feet the aperture must be opened a further half or one stop; the same applies for very dark subjects.

If, however, the room is very small and bright, like a bathroom, the aperture must be stopped down instead.

If the flash does not produce enough light to illuminate the subject fully, you should use a faster film. The alternative is to use several flashes set off one after the other, which of course means that the camera must be fixed to the tripod: each flash corresponds to one stop on the aperture. If, for example, an aperture of $f11$ were necessary to give the desired depth of field, and the flash will only light the subject effectively at $f4$, you will need to set off four flashes in succession. This technique is only possible in a room that is completely darkened so that no other light can affect the film. A similar technique is moving flash, which will be discussed later.

A further possibility is to set off several flashes simultaneously: it is possible to link up supplementary tubes to electronic flashguns, but you will only get a higher light output if each is triggered by its own condenser; otherwise the energy stored up will be distributed evenly among all the tubes being used.

Although it is possible to buy multi-adaptors to connect several flash units for simultaneous operation, it is equally possible that such an arrangement will not work. In this case recourse to a photoelectric cell is necessary; the cell is attached to the flashgun on the camera, and when this one is set off the others will be activated without needing any cable.

Difficulties only arise when the flash is not being used to increase the intensity of the light but to produce a special effect; it is very difficult to pre-dict what the effect of each individual flash will be, except in the case of studio-flash set-ups. On top of this, it becomes extremely difficult, if not impossible, to calculate the correct exposure: the formulae given in the box on the right are only valid if all the light is coming from the same direction. For this reason it is better to use constant lighting instead of flash for your special effects.

## MAKING THE BEST USE OF FLASH

The flashgun is mostly just stuck on the camera or on an arm attached to it, which is the easiest method, and indeed the only possible one for snapshots; it does, however, mean that only a direct frontal lighting is possible. Objects appear much less full, and, especially if taken against a wall, seem to be stuck to the shadow.

More effective results can be achieved by using an extension lead to separate the flash and the camera; this means that the subject can now be lit from above, below, the side, or even from behind. Even if you only hold the reflector at arm's length you will notice a marked increase in the plasticity of your subject. If the flash comes down at an angle from above, or from the side, the picture will have more body and the structure and feeling of depth will be improved. At long distance it makes practically no difference whether the flash is coming from the camera or if it is detached, the angle of beam hardly changes; by contrast, over a short distance a reflector held right by the camera will produce a very strong side light. How far upwards and to the side you have to go to give the best feeling of plasticity depends entirely on the flash-to-subject distance. The usual thing is to raise the flash slightly and fix it at an angle of 30° to 45° to the subject.

The danger with very strong side lighting is that the parts left in the shadow will sink into complete darkness. This can only be compensated for by using a corresponding fill-in light. This poses no problems indoors, because the room will reflect a certain amount of light itself, and you can position

Sidelight emphasizes the plasticity of this relief.

your subject to give the right degree of illumination in the shadows. Outside and when taking close-ups you will need a piece of white card to act as a reflecting screen; occasionally a screen covered with silver- or gold-grained paper will suit the conditions better. The fill-in effect is increased

- the greater the reflecting power of the surface being used
- the larger that surface
- the more it is directed towards the subject
- the nearer it is to the subject
- the further away the flash is

Clearly the same effect can be achieved by using a weaker or more distant secondary flash unit as fill-in lighting. Very harsh side lighting gives particular emphasis to the superficial structure of materials; shallow reliefs are given a very strong feeling of body.

The effect of light falling directly from above is not normally very pleasant: likewise footlights shining directly upwards have an unnatural effect; be particularly careful of this when taking portraits.

It is difficult to set up rear lighting, although it is particularly rewarding for the effects it gives. The subject can either be silhouetted, or, if a dark background is being used, it will impart a 'silver lining' to the person or subject being taken. Transparent objects such as glass and liquids will light up. Very impressive are photographs of a model taken in silhouette against a very bright background: this time the flash is placed behind the subject, but shielded from the camera so that it only illuminates the wall.

Tobacco smoke is the enemy of every flash photograph; if the room is full of tobacco smoke the results will be very flat and lifeless, so you should try to 'ventilate' your shots. If, on the other hand, you want to make use of the smoke effect, your best results will be achieved by taking the photograph into the light, against which the smoke will stand out. For this reason you should be careful not to take photographs against windows, aquaria, pictures, furniture, and doors, or you will have unpleasant, bright reflections for your pains. Even worse, if you use computer flash it will base its reading on this bright area, which will result in an under-exposure. You can overcome these reflections by

- opening a door or window so that the reflection is not directed towards the camera
- by changing your own position or that of the flash so that the reflection is no longer a nuisance

Flash photographs are easily recognized from the fact that the background sinks into darkness very rapidly. The brightness will diminish by the square of the distance. In other words, if an object is taken with flash at 6 feet, it will be not half but a quarter as bright as one taken at 3 feet. An object at 9 feet will receive only one-ninth as much light.

As long as the subject does not extend over a great depth, this does not pose much of a problem, but what happens if you want to take a photograph of the family at a celebration? The company have taken their places at the wedding table. Uncle is sitting right at the front, while auntie is at the other end, 9 feet away. If you now stand at a distance of 6 feet, flash-to-uncle and flash-to-auntie distances are 6:15 feet, a ratio of 1:2·5, which means that uncle is going to be perfectly well lit on the picture, but auntie is going to be somewhat under-exposed.

Tobacco smoke illuminated by rear lighting.

reflecting power of the room the effect would be even better. Equalization would also be improved if you stood on a chair and directed the flash not at Uncle, but onto the last third of the table: in this case the entire family would be almost perfectly illuminated! It makes no difference whether you leave the flash on the camera or stand well in front of it, using an extension lead: you could even use a telephoto lens and stand right in the farthest corner of the room. The important thing to recognize is that it is the flash-to-subject distance that matters. If the background is not what you would like, it is a simple matter to let it sink into obscurity: have your model stand as far away from the background, but as close to the flash, as possible.

If, on the contrary, you want maximum illumination of the background, you should increase the flash-to-subject distance correspondingly.

## INDIRECT FLASH

Also known as bounced flash, this is used to give an evenly spread, diffuse light. Its advantages lie in the fact that it softens shadows, cuts down reflections from shiny surfaces, and makes use of the normal room lighting, which is more difficult with direct flash. Christmas trees, for instance, call for indirect flash. The flash index supplied by the manufacturer is no longer valid when this method is used. The technique is to direct the flash towards the ceiling so that the subject is illuminated by reflection. Since this involves a relatively large loss of

This is to be expected, because the decrease in light is in the ratio $1^2 : 2 \cdot 5^2$, i.e. $1 : 6 \cdot 25$.

If, however, you had gone to the other end of the room, it would have been quite a different story. If we assume that the room is large enough to let you stand 24 feet away from Uncle, the ratio is $24 : 33$, or $1 : 1 \cdot 375$; this means that the decrease in light would be in the ratio of $1 : 1 \cdot 375$, i.e. $1 : 1 \cdot 9$. Because of the

light, the aperture has to be opened one or two stops (for the normal room) above the setting indicated by your tables. The reflector should not point towards the ceiling at too steep an angle. The best thing to do is to take the flash unit off the camera and put it on a tripod placed behind you; you are then free to move around as you will. Because the light is reflected evenly, the same aperture will apply wherever you stand. It is important that the ceiling should be white and not coloured, otherwise colour photographs will be tinted with the colour throughout.

## FILL-IN LIGHTING WITH FLASH

Flash is not only a substitute for the sun; it is often used for shadow lighting. This is particularly so when shooting into the light, so that detail can be shown on those parts of the picture that would otherwise be silhouetted. The aperture is set according to the reading given by the lightmeter, and the flash is then placed at a corresponding distance from the subject. Suppose we are taking the photograph in the open, and the reading on the meter is $1/30$ sec. at $f11$. We are using an Osram XM 1B flash bulb with an index of 26 at 50 ASA. To ascertain the correct flash-to-subject distance we must invert the formula given above and divide the index by the aperture. For our example this gives a distance of roughly $7\frac{1}{2}$ feet; since there will be no reflection off walls in the open air, the natural impression of the background will be maintained as the flash light dies out.

## SPECIAL FLASH EFFECTS

Flash and other lighting are not only combined to fill in shadows; a good example of an alternative use is where a sharp picture of a ballerina is overlaid with a certain unsharpness to emphasize the gracefulness of the movement. To do this the camera is placed on the tripod and a shutter speed of $1/8$ or even $1/2$ sec. is used.

Open-shutter flash effects are also capable of being very attractive. They are best taken at night in the open. Again the camera is put on the tripod, and the shutter opened. Several flashes are then set off by hand. Obviously there is no point in doing this if there is nothing happening in the field of view; but it can, for example, be used to show the different stages of movement that a child on a swing goes through. You simply have to make sure that the swing is in a different position each time you set off the flash. Alternatively you can change the position of the camera and take the same scene in different perspectives. You can also use colour film with a different filter for each shot: you may prefer to use coloured filters normally intended for use with black-and-white film, or plastic filters in front of the reflector. By changing the exposure (done by moving the flash unit nearer or further away from the subject), you can emphasize particular phases of the movement and make others drop into the background. There is no end to the possibilities.

Another very pleasing effect is achieved by placing the flash unit inside a lantern. The flash should be wound round with a piece of thin white

paper first to stop its effect being too strong. If you want to capture the expression on a childs face, you should not use too large a flash-to-subject distance. The anticipation and excitement of the child will be emphasized best if you open the lantern slightly and direct and slit towards the face of the child.

Left:
Contrast between a normal photograph and one where the foreground has been 'filled in' with flash.

Right:
The flash was set off in the chinese lantern: when enlarging, care had to be taken that the child's face remained darker than the lantern.

# EVERY DAY IS A DAY FOR PHOTOGRAPHS

The photographer's day begins very early, especially for colour work, because for a few minutes the early morning twilight plays extraordinary tricks with colour; everything is lit on one side by the cold blue light of morning and on the other by the first rays of the sun rising red over the horizon.

## SUNRISES AND SUNSETS

These lend a golden colour to the view, and are therefore in the domain of colour film. If you normally keep a UV absorption filter in front of the lens, you will have to take it off to avoid flare and obtrusive reflections. The reading is taken straight into the sun and the film under-exposed by one or two stops: this will make the sky come out redder than it actually is. You should look for a striking fore- or mid-ground that will interlock in silhouette with the red of the sky. Good subjects are trees or isolated branches. If you simply leave the horizon to cut the photograph into two halves, the result will be very uninspiring.

Shots taken across water are very effective, as the sun's rays are reflected across the surface: to break up the horizon you can use ships' bows or masts or even a ship that is cutting across the sun's reflection. Exceptionally picturesque views are to be had when there are thin clouds in the sky that pick up the glow of the sun. The sun should be as small as possible to give the clearest results. If you close the diaphragm completely, it will be surrounded by a corona of rays, which are longer if a lens with a shorter focal length is used. This effect can be exaggerated by using a diffraction screen.

The lower the sun in the sky the larger it looks, which means that a longer focal length will exhance its appearance still more: it will look even bigger if you take the shot through the branches of a tree having focused the camera on them. This will mean that you will not have a sharp picture of the sun, but it will be bigger, and the unsharpness will not spoil the effect. You can use the same technique with a few blades of grass in the foreground and the sun glowing dark red behind them.

There is not so much colour at sunrise as there is at sunset. Sunsets are best in regions where there is a lot of heavy industry to pollute the air: factory complexes are given a golden hue in the light of the setting sun, and even dirty smokey chimneys assume a sort of beauty.

## MIDDAY

On sunny days, the best time to take photographs is before 11 a.m. and after about 1 or 2 p.m. It is at these times that colour reproduction will be most accurate.

From a photographic point of view, midday is the least satisfying time of day. The light conveys no feeling of plasticity, colours pall because there is a predominance of blue light. It is advisable, therefore, either to miss this time of day, or at least to use a skylight or a haze filter, which will give a warmer feel to the photographs with its gentle pink tint.

If you are far south, however, it may be that you want to represent the shimmering heat on film, in which case this is the best time of day to do so. The colours look pale and the countryside dusty and parched; it thirsts after water and coolness: what little shadow there is offers no shelter to the animals trying to get out of the sun.

Use a telephoto lens for the best results, but not with too long a focal length, or all detail in the scene will be lost.

## AFTER SUNSET

Perhaps the most picturesque time of day, this is when the horizon glows golden or red, while the sky is tinged with violet, against which the clouds stand out strongly. After this there is the 'blue hour' of twilight, which is the best time to take night photographs in the normal sense of the word. The sky is a deep blue, not yet black, and the lines of the buildings stand out well against it. They can either be illuminated by floodlight or you can rely on the inside lighting shining out. If the floodlights are shining up from below, the house may lose much of its character, since the normal shadow effects are changed, and the house looks as if it is made out of sugar candy. This is where colour supersedes black-and-white, especially if you use tungsten film to give a fairy-tale appearance to the dusk landscape.

Interesting, too, is the town with all its neon signs, especially if they are reflected in streets wet with rain. Cars driving past leave a trail of yellow and red light on film; use daylight film to give a warmer feel to the colours. For black-and-white you should use a fast, less-contrasty film, which you can use for hand-held exposures.

Multiple exposures of the same view are very attractive, but are only possible with cameras that are not protected against double exposure. You can superimpose the various signs, combine sharp and unsharp shots, and even jog the camera deliberately for a windscreen-wiper effect. You may need to use quite a lot of film as the result cannot be predicted.

Another possibility is to divide a long exposure time into a series of part exposures. The camera is

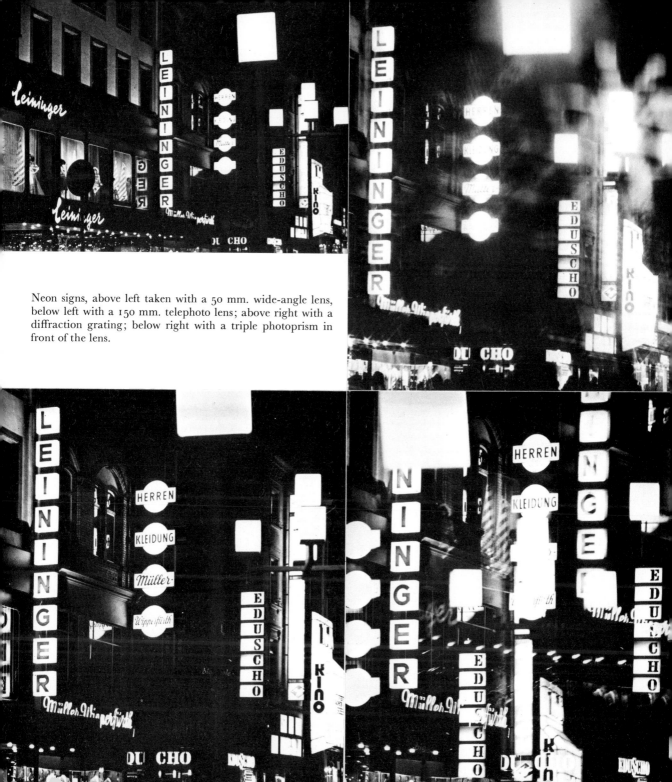

Neon signs, above left taken with a 50 mm. wide-angle lens, below left with a 150 mm. telephoto lens; above right with a diffraction grating; below right with a triple photoprism in front of the lens.

fixed to the tripod and photographs taken of one and the same subject, while the camera is moved to a different place between shots, from side to side or up and down; alternatively you can use a different lens each time to create a 'zoom' effect. The limits to your scope are those of your imagination.

## NIGHT-TIME

This is the time for photographs by moonlight and pictures of the trails of stars or of flashing lights.

Use a telephoto lens for shots of the moon, or it will look ridiculously small. Often you will have to judge the exposure very carefully if you are to have sufficient depth of field to take in the houses near by and the moon, an 'infinite' distance away: you will have to stop down the diaphragm considerably; at the same time the shutter speed must be short enough to show the moon as round, not as an egg-shaped object in the sky: it travels the distance of its own diameter in one minute. This means that you really need a full moon on a night when there has been a recent fall of snow, which will reflect enough light to give detail even in the shaded parts of the scene. The lower the moon is in the sky, the bigger it looks.

You can always cheat if need be; if you take a photograph in bright sunlight using an infra-red filter, the result will look just like a moonlight scene; this is the technique often used in feature films. Keep the exposure brief, and make sure that there are no clouds in the sky, or you will find that they stand out against your pitchblack night sky in a splendid, radiant white. Take the view first with the light falling at as sharp an angle to the subject as possible; you can copy the moon into the print afterwards. This can be done either from a telephoto shot taken separately, or by placing a penny in the appropriate place when you enlarge the picture; do not put it on the paper itself, however; first lay a thick piece of glass over the spot, and put the penny on top of this: this makes the edges less sharp, and the whole gimmick more convincing.

If you want to photograph a starry sky in all its glory, you will again want a cloudless night. Additionally, you do not want any extraneous light from the earth, which means that you should avoid big towns and go out into the country. You will not take pictures of the stars as points of light but as circles around the Pole Star, because of the movement of the earth; the length of the arc depends on the length of exposure.

For this type of photograph you can use a normal lens, but the camera must be on a tripod and pointing towards the Pole Star. At $f8$ using a 50 ASA film, you will need an exposure of about 20–30 minutes. Develop black-and-white film in high-contrast developer for slightly longer than the suggested time.

## FIREWORKS

This is another subject which must be taken well after dusk. Since you know exactly where the action is going to take place, you merely need to set the camera on the tripod, point it in the right direction and set it at B or T, with an aperture of $f5\cdot6-f8$. Rockets will burn a trail into the film emulsion. If several fireworks are set off one after the other, you will only need a short exposure of a few seconds, but if there is only the one, you will have to wait a while to get a good blaze of light on the film. If there is a floodlit building in the foreground, behind which the fireworks are being let off, you must obviously base your exposure on the light reflected by the building. All the better if you can take the photographs across a river so that the trails and patterns are reflected in the water. Use Daylight colour film for best results.

## WIND AND WEATHER

'Every day is a day for photographs', not only when the sun is out, as postcards, calendars, and prospectuses would have us believe. There is much more feeling in a sky that is not a blue mass, but that is filled with threatening, storm-like clouds: there will be a tension between dark and bright patches, casting an ever-varying pattern on the landscape. The approach of the storm is heralded by sudden gusts of wind, which shake the trees. Then sud-denly it is there, with rain and gales, thunder or blizzards. Conditions such as these transform a photograph that would seem a cliché in fine weather.

## MIST

A veil of mist lying over a landscape makes it look calm and peaceful. It will give more depth to forests, mountains, or any strong-featured view, because whereas the foreground may be very sharp, it will gradually disappear into a haze in the distance. This means that long-distance shots are out of the question. You will have to make do with a fairly small subject, such as a path disappearing from view as it passes the nearest tree. This kind of shot is at its most attractive in the autumn, when the leaves are a variety of beautiful shades and have begun to fall from the trees. There are no strong shadows or bright contrasts, and the colours are gentle pastel shades; altogether a magnificent setting for mood pictures conveying a feeling of melancholy. Always take the photographs into the source of light, and focus the camera on those elements of the picture nearest to you. It does not matter if you cannot include the whole view in the depth of field because you have to open the diaphragm quite wide: the unsharpness of the background will only seem to emphasize the effect of the mist. For black-and-white work you should use a fine-grain, fairly slow film, which should be slightly under-exposed and correspondingly over-developed; better than

this is colour reversal film, which will need a slightly longer exposure than that indicated by the exposure meter.

There are of course varying degrees of mist; mist can turn into a thick wet cold fog, chilling everyone to the marrow. It weighs heavy on dust and smoke, and even breathing becomes difficult. Cars edge their way forwards with foglamps on. To capture the essence of a day like this in an industrial town or across a port, try to use a black-and-white film; only this will do full justice to the abstracting effect of the fog. If you use a grainy fast film, the contours of the buildings will be lost, and the unpleasantness of the fog will be emphasized even more. If the fog is not as heavy as you would like for the purposes of your shot, you can make it seem thicker by using a soft-focus lens, or, with black-and-white film, a blue filter. A similar effect will be given by a lens with a slightly longer focal length than normal, as it will condense the whole scene. If you use colour film, you still want as little colour as possible in the shot: a pillar-box, or the indicator lights of a car, or traffic lights will do the job very nicely.

## RAIN

Never try to make rain the excuse for a bad photograph. If it is raining when you take your shot, this

Early morning mist; by including the sun in the picture the view is lent a strange feeling of mystery.

fact should be made quite clear by the finished print, without your having to explain it away.

Wet, empty streets in towns are a good indication of the prevailing weather, or puddles with their surface broken by heavy splashing rain drops. A sea of umbrellas and shiny brightly-coloured raincoats, perhaps, or best of all a dark background against which the falling rain will stand out in lines, especially if lit by the sun breaking through the clouds.

You should look for somewhere dry to stand and take your picture; if there are no doorways around you can always use an umbrella. This not only protects the camera, it also gives clearer pictures, since drops of rain falling on the lens will have much the same effect as a hair in front of your eye: you can see through it, but it will make everything seem out of focus. Black-and-white and colour negative films both need a slight under-exposure, whereas colour reversal will need a little more light. The black-and-white film will subsequently require a high-contrast development.

Many subjects are most striking if taken on a dull rainy day; slums and houses falling down, rubbish dumps, and everything that radiates need and wretchedness are most unphotogenic if it is a bright sunny day. Bright sunlight of course makes everything look romantic and picturesque. Only rainy weather can express the seeming hopelessness of such a scene.

Even bright neon signs in the centre of a town look their best in a shower of rain, when they are reflected in the streets.

A landscape can be enhanced if you are lucky enough to be able to include a bright rainbow in the sky. Rainbows are always found opposite the sun, and are caused by the prismatic effect of the rain-drops as they refract the sun's light. This is why houses in the mid-distance also appear very bright, especially if, like the rainbow, they stand out against a thick heavy blanket of grey clouds. The lower the sun in the sky, the higher the arc of the rainbow. The natural colour of such a shot is most attractive, and will require a brief exposure if the effect is to be preserved.

Rainy weather makes colours paler, making it advisable to use a skylight filter; if, however, you want to preserve the true colours of the view, you must not use any filter whatsoever, but rather use a film that gives good blues and greens, to enhance the effect of the scene. Watermeadows in particular will benefit from this and will appear very moist and lush.

## STORMS

There is a very particular mood about a photograph that shows a storm blowing up in the distance: white house fronts shine in the sunlight against a dark backcloth of rain clouds. Base your exposure on the bright foreground; this will mean that the clouds will be under-exposed, and so look even more menacing. Storm clouds over water or a broad landscape are also extremely photogenic.

It is almost impossible to 'freeze' lightning during the day, and if you succeed it will be more by luck than good judgement. At night, however, it is nowhere near as difficult. Set the camera up on its

tripod by an open window, set the aperture at $f5\cdot6$ and open the shutter. If the storm is travelling clearly in one direction, an exposure of several minutes is likely to show several strikes of lightning. The long exposure combined with the light intensity if lightning will mean that trees and buildings will be sufficiently illuminated to provide the necessary foreground.

This shot was taken through a window streaming with raindrops, and the camera focused on the water. You could produce a similar photograph by spraying the window with a garden hose.

Colour Plates 9 and 10: The wide-angle lens gives a wide general view, while the telephoto lens concentrates the picture, and makes the crags seem much more overwhelming: the photograph is of the Meteora monastery in Greece.

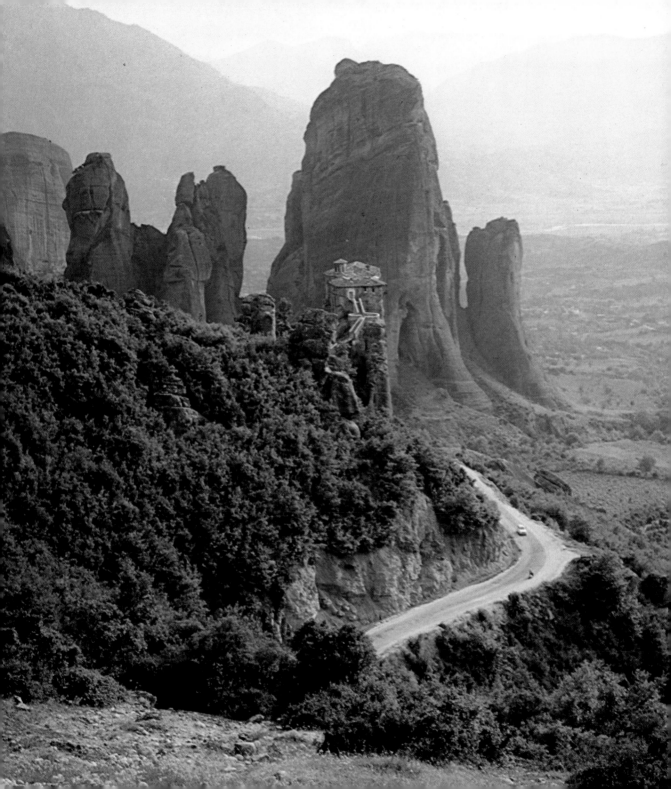

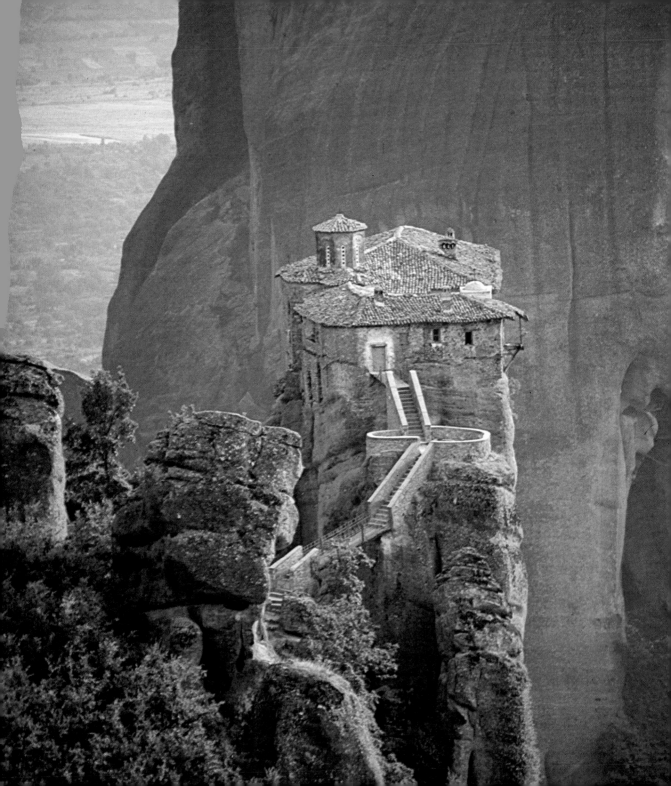

## WIND

Clearly you can never photograph wind itself, but only its consequences. It can, however, play an important part in the composition of a picture; frocks and hair blown about show one of the more obvious side-effects, while a landscape may be made to look all the more barren and open if you include some trees all leaning in the same direction: a result of the wind in the region. The power of the wind can be guessed near water by the clouds of spray and the fullness of the sails, and in the town it is shown by coats being blown about, umbrellas being turned inside out, or people leaning forward into the gale.

## ICE AND SNOW

If you want to photograph snowflakes as they float down to earth and form a blanket over it, you will need to have a dark background to see them properly. If it is a heavy snowfall you will have to focus a fair distance off if you do not want a white cloud on your film. The same principles are true here as for rainy-weather shots, but you should always try

Colour Plate 10: Detail from Plate 9.

By comparison with the two sailors it is possible to judge the height of the waves. Life is given to the photograph by the diagonal composition and the blurred water spray.

to use a time exposure from a tripod so that the snow will have a chance of registering on the film.

If you are using black-and-white film you only ever need to take one good shot of snow falling, which will then last you for ever. The negative must be perfectly clear and unscratched, with the snowflakes standing out in a strong black; it can then be

sandwiched together with other winter landscapes for enlargement purposes. This is in fact the best way to make a 'Landscape with Snow' print, because the flakes will even stand out against the brighter parts of the main view, which will give the whole shot more appeal.

Snowflakes are amazing structures; each one has a different crystal shape, the shape depending on the temperature at which it was formed. To take a photograph of them you should let a few fall on to a glass dish, which should certainly be no warmer than the outside temperature, and preferably colder. Then you take a macrophotograph. Regardless of whether you shine the light through them, or whether you use dark-field illumination, you will end up with the most delightful pictures, each one with its own charm.

Snow forms a splendid white cloak covering the landscape; if you want a good photograph of this, you will have to wait for a sunny day, because the snow will look dull and uninteresting on a grey day: at best it will look like cotton wool, but it will have no sparkle. Take the shot into the light, or with the light shining from the side, for the best effects, so that the contours of the ground can be seen quite clearly; this will not be the case if the sun is standing high in the sky. In the shade snow looks blue; do not try to compensate for this on colour film by using a skylight filter, or else you will impair the brightness of the snow. Lightmeters are fooled by such a large expanse of white, and indicate too small an aperture, which means that you will have to increase this for colour slides. For black-and-white, however, you should use a fine-grain slow film and under-expose it slightly; it can later be

An uninspiring photograph: twigs covered with snow.

over-developed somewhat, and then printed on hard or extra-hard paper to give very strong contrasts. This will really make the snow sparkle! A yellow filter is used to give more body to the contours of the scene and to emphasize the light-and-shade effect.

Ice is a typical subject suitable for shooting against the light. This is not only true of icicles, but also of the patterns formed by frost on windowpanes: their structure is only shown to its best

advantage under these conditions. For the best results the photograph should be taken early in the morning, when the blue light of the night is giving way to the golden rays of the rising sun. Needless to say it is also possible to synthesize this effect by using artificial light with corresponding filters over the lamps.

A good photographer will not only have his camera at the ready for family celebrations and other special occasions, but will be on the look out for likely subjects the whole year through. This is the only way to learn to observe consciously, and to find out all the things worthy of a photograph, which most people will miss. Everyone who takes photographs necessarily becomes more aware of his or her surroundings. Every day is most certainly a day for a photograph!

This picture is taken with the light shining from the side; a medium-yellow filter helps to give more depth to the hollows in the landscape.

Icicles are only at their best when taken against the light; this technique is also the best way to take pictures of most winter and snow landscapes.

It is normal to take twilight photographs in the hour before night falls: this shot, however, was taken under a full moon. The light reflected by the heavy clouds and the snow was sufficient to light the other parts of the scene.

# PICTURES OF LANDSCAPES

The vast variety of subjects makes it very difficult to give a brief outline to landscape photography in general. Before going on to give some positive tips, I would like to start by telling you how it is *not* done; it is not a case of driving out to a nice view, pointing the camera towards it, and pressing the shutter; nor is it sufficient to drive on a bit, wind down the window, and take another shot. You might as well save yourself the trouble, for the results will not even be up to the standard of cheap postcards you can buy at tourist kiosks.

You have to take exceptional trouble over landscapes, and cannot convey the charm of a scene in a haphazard shot. Take your time and keep your eyes skinned for the right view; having found it avoid taking it from the nearest level ground, but look around to see if there is a better position, which may only be a matter of a few paces from where you are; the results will be well worth the small effort involved.

On train and bus excursions you may not get the chance to choose the position for your photograph, and will just have to wait. The only thing is that you will need superfast reactions, or you will press the shutter too late and miss the view you had been waiting for. You must use the snapshot method and set the camera shutter speed, aperture, and distance beforehand. Do not lean against the side of a moving vehicle, or the vibrations will be transmitted to the camera. For the same reason, you should use a fast shutter speed, say 1/250, or even better, 1/500 sec.

If you are to include the typical as well as the exceptional, it is necessary to do more than just find the best place to stand and the best part of the view to include; you must also pick the right time of day. You must remember that a landscape is something living, in a state of constant change, affected by such factors as the position of the sun in the sky, the weather conditions and, of course, the season of the year. It is a well-known fact that the sun does not grace us with its smile every day, it is less widely appreciated that the sun is not indispensable for a good photograph. It is often the case that wind and rough weather will give a much better shot than the sun. Be selective and do not release the shutter if you

know that you will get a better picture by coming back at another time of day or when the weather changes. Carefully-chosen shots will stand out against the mass of snapshots and fine-weather photographs.

If you are using black-and-white film you will have to get used to colour filters. Yellow and orange are those most commonly used in landscape work as they bring out cloud effects very clearly, but filters are also needed to show different tonal areas of green. In summer, for instance, the green of trees in a wood is often too dark on film; to lighten the tone a yellow-green or a light-green filter should be used. Over long-distances you will find a red filter especially useful as it is capable of penetrating a fairly thick haze.

## MOUNTAINS

A classic subject, mountains add variety and a feeling of immensity to a photograph: looking at them is like looking at an open picture book; glistening lakes and dark forests, over there a small brook meandering across a watermeadow; perhaps an idyllic mountain village. And then, towering behind it, the sheer slopes, glaciers, and snowbound passes.

Even when there is such an abundance of subject matter, it is necessary to follow certain rules if you are to take good photographs; it is in these very mountains that the difference between the actual landscape and the landscape photograph strikes the eye most clearly. It does not require any special skill to make a banal photograph out of the most inspiring landscape. The height and the sheer faces of the mountains may be badly brought out in the photograph, and the same may happen to a bottomless abyss. Why is this? The simple answer is that no impression of size is given. All that you need to achieve this is a house or some object whose size can easily be imagined, so that it will form a point for comparison. The observer will then appreciate the true dimensions of the steep, towering mountains in the background.

Houses by themselves are not enough to do this; if you use a normal or a wide-angle lens, the proportions will be wrong: the house will look huge in the foreground and the mountains will shrink into the background. A point of comparison is only worth having if the proportions are going to be correct, which means using a lens with a long focal length, and the longer the better. You will then have to find a place to stand that is far enough away from the subject to get it all into the frame. By using a telephoto lens, you will also condense the content of the picture, which is clearly going to be desirable.

Mountains are always in season from the photographer's point of view: this means that to get a complete view of them, pictures must be taken at all times of year; this requires a full knowledge of the seasons and their effects.

For example, when the snow thaws, look out for a brook swollen into a gushing torrent. Be careful not to freeze the water again by using too fast a shutter speed, but likewise do not set it so slow that the water is striated. For normal purposes $1/125$ sec. should be about right, but if the water is slow flow-

ing increase it to 1/60 sec: a waterfall calls for 1/500 sec. on average.

## PANORAMAS

The following prerequisites must be fulfilled for a broad panorama: it must be a clear day, with the sun falling over the landscape from the side, to give body to the features. Do not try to take the whole panorama in one shot, but use a telephoto lens (a medium-sized one will do) to extract the most important points. A very large print is then made of the shot; detail is maintained by using slow, fine-grain film.

This picture was taken at 1/60 sec. The water retains an appearance of flowing, without dissolving into an absolute blur.

Very deep landscapes easily become flat towards the background: an orange or a red filter will counteract this to a certain extent. If you are using colour, you will need a hazefilter to remove the blue haze.

Often a subject is enhanced by the use of an unusual format: if you take a photograph of a mountain with a river in the foreground, you should choose a long narrow print, and cut out all extraneous material above and below the main subject; the same applies with panoramic views of towns. If one picture is not enough, you can build the complete view from several shots, making sure to make a smooth transition between the prints. Having set the camera on the tripod, check that it is level so that the verticals will be truly vertical on each picture, and take these with about a 5° overlap.

If you are unable to wait for a clear day, you can use a red filter to counteract the effect of any mist or haze. Better still, you can use an infra-red film.

Panoramas are built up out of several individual shots. For demonstration purposes we have left a small gap between the prints here: normally, however, they would be joined without any visible seams.

## THE EFFECT OF DEPTH

Even if neither of these steps can be taken, your photographs do not necessarily have to be flat and lifeless. Life is given to them by using a dark foreground, such as a precipice or a gnarled pine tree. This not only increases the contrast, it also gives

A pergola used to give a frame effect.

The depth of this photograph is brought about by two separate elements. Firstly the frame formed by the trees, and secondly the contrast between the dark foreground and the light middle and background.

depth to the view. The foreground should always be emphasized in such cases, even when it is a frame formed by an archway or a pergola, or the branches of a tree. Attention should be paid to the distribution of the tones used; lighter tones are limited to the more distant parts of the picture, dark tones to the foreground. Our perception of space is fundamentally influenced by a light perspective like this. It is accepted that nearby objects will be clearer and more brightly coloured, whereas farther away they will be paler and more washed out. This is a well-known fact, which can be proven simply by looking at something a long way off.

If you want to emphasize the depth of a landscape, you must still make use of this aspect of perspective; on a clear day you can use a pale-blue filter to create an artificial haze and produce the required effect. Normally, however, it will suffice to stand in the shadow and take your view from there out into the distance. This will give a more concrete feeling of space than a landscape brightly and evenly lit by the sun. This can be made even more graphic with black-and-white film, if the foreground is made completely black with the lighter background behind it.

What is expressed in black-and-white photography as a light-dark contrast comes out in colour work as 'colour direction'; thus red and orange are very much foreground colours, thrusting themselves forwards, whilst blue keeps very much to the background. If you are not careful, and invert the colour relationships, you risk distorting the whole perspective and space impression of the photograph. If mountain climbers seem to like taking pictures of their friends wearing red pullovers, it is not just because they like red, but because it will give more depth to the scene. If you want to show how steep an ascent was, always take the shot upwards, never downwards, and try to make subjects in the foreground stand out against the blue of the sky as much as possible. Otherwise they will look as though they are stuck to the rock, and any sense of daring will be lost.

It is better to shoot into the light than to use side light to give more depth. This is not only achieved because the shadows will 'run' towards the observer, but also by the optical separation of the individual elements of the picture by the gentle borders of light that are formed round them. The shapelessness of distant mountains in landscapes is also overcome by this technique: the light separates them and makes them stand out against each other.

# FLAT COUNTRY

There is no need for this to be boring, even though it may be less full of variety than mountainous regions. There are all types of flat country, but few areas are totally devoid of scenic interest, whether the scene be from the desert lands of Arizona or from the rolling green countryside of an English shire.

You should never underestimate the importance of the horizon in your photographs; if it stands high in the picture it stresses closeness: the effect is at its strongest when the horizon is almost forced out of the picture. If, however, you get down on your knees to have the horizon low in the picture, you will lay emphasis on the sky and its advancing clouds: you will add a touch of infinity to your

The power of the earth over us is conveyed by excluding the horizon.

By holding the camera very low, you can achieve a low horizon in the picture. This makes the photograph seem wider.

Left:
A shot into the light will not only add an air of mystery to the view, but will also help to separate the more hazy hills in the background.

Telephoto detail from Colour Plate 11.

## THE SEA

A picture of the sea relies on its great expanse to give it life; this does not mean that it is easy to take a good photograph of it, since the huge surface can all too easily become tedious and banal. The last thing you want is good weather: this will destroy the character of the sea; best of all is the sort of day where it lies there in leaden stillness, with oppressive layers of cloud above it, and just one ray of sunlight shining through and glinting on the surface of the water. On the horizon, which must be perfectly level in the photograph, there is a steamer, very small in the distance, making its way slowly towards a distant port.

The face of the sea alters with the weather; one minute it looks like a mirror, soon afterwards a squall is whipping up great crests on the waves, and the breakers thunder on the quay walls spraying them with foam. To capture the exhilaration you need just the right shutter speed, which will be 1/250–1/500 sec. Single big waves should be taken with a fairly large scale of reproduction in mind,

photograph. It is much more effective if you do not merely have a straight line for the horizon, but make it more attractive by breaking it up with a tree, a church spire, a windmill, or something similar. It is generally true to say that if it lies in the centre of the picture the result will not be very good; if, however, you *want* to show how monotonous and boring a landscape is there is no better way of doing it.

Colour Plate 11: Two shots taken from almost exactly the same spot.
Although the colour shot portrays the colour of a mountain spring well, the photograph on the left is better proportioned. Both photos were taken with a Rollei SL66, the one on the right with a 50 mm. wide-angle lens, the one on the left with a 150 mm. telephoto.

but even then you cannot express their awesomeness all that well, as it is impossible to judge either their size or their force. The magic spell behind the storm is only to be seen if the breakers are shown crashing over the bows of a ship.

The coast offers a great variety of subjects for landscape work; there are picturesque bays and steep shores with golden sands or bright pebbles. The gulls walk over the deserted sandcastles decorated with mussel shells, where earlier in the day holidaymakers lay tanning themselves in the sun as their children splashed around in the water. You can take shots into the sun without any need to fill in the shadows: the sand and the sea reflect enough light to do this. Then there are the lighthouses, the dykes, the breakwaters, and the sandflats. The ripple marks left by the sea glisten in the setting sun: if you want to get them all in focus over a large distance you will need a camera with a manoeuvrable lens mounting.

Without any point of comparison even huge waves look quite harmless: only when they are crashing down on the decks of a supertanker can the fury of the sea be properly seen.

Colour Plate 12: There is a certain melancholy appeal in photographs of calm water. The simpler the composition of the shot, the better the impression conveyed.

The appeal of this photograph is created by the inclusion of the pontoon and the posts in the foreground.

Delightful photographs can be taken of small fishing villages with their colourfully painted cottages and the people in bright local costume. All this grouped round an idyllic harbour full of yachts and old ketches: a mass of confused masts, nets, and hawsers. Their effect can be condensed by using a telephoto lens; you will have to use a tripod, however, as you will need to open the diaphragm completely for a good depth of field. Try to find fishermen mending their nets or getting their boats ready for the next trip out. Always get close up to the subject so that a full-size photograph will be the result; if you try to include it in a general view, the effect will be lost. You might even try taking the shot through a net or a lobster basket. The weather-beaten faces are very photogenic, and do not forget to see if there is a good photograph to be taken of a creel.

The big ports usually have even more to offer. If you go on a tour of the harbour you will get to see all the sights first hand: wharves, silos, container ports, a jungle of steel cranes and loading rigs, and of course ships of all shapes and sizes from every country. The biggest problem is finding a suitable foreground; look out for a small boat which can be used as a contrast with the port as a whole; or you

Under the seaweed lying rotting in the sun you will find a microcosm of small animals sheltering to avoid being dehydrated. In the rock pools you will find mussels and starfish, small crabs and shellfish; a strange world admirably suited to close-up and macrophotography. If you are not equipped for this at the time, you can gather a few of the creatures and take them home. There you can put them in the aquarium and take all the shots you want; there is plenty of scope for the imagination.

A telephoto lens not only produces a more compact picture, it also increases the haze and gives the picture a fuller atmosphere. In this photograph the eye is drawn above all to the seagull whose flight has been stopped just at the right place.

can take a shot through a lifebelt or a ship's rail. Do not worry if the foreground is not sharply in focus: this will give a feeling of depth to the photograph. You can include even more if you take your pictures from the shore, for example, thick hawsers round huge bollards; the biggest advantage is that you can get much closer to the ships than is possible from the harbour tour boat. If you take the shot from the bows with a wide-angle lens, they will look particularly stylish.

Do not forget to use an ultra-violet absorbing filter when taking photographs by the sea. Apart from keeping ultra-violet rays (which also abound in mountainous areas) away from the film, they are a good protection for the lens from sea spray. Never put your camera down on the beach: if you get sand in the works it will be ruined. Even the case or a gadget bag will not offer sufficient protection. When you are not actually taking photographs you should put all your equipment in a plastic bag and seal it with a wire. In the evening you should always clean the camera and the lens with a fine sable brush.

A freighter can be made to look like a luxury yacht by means of a wide-angle lens.

# WOODLAND

Trees and woods are good subjects in the spring, with the sprouting leaf buds, and a host of shades and nuances of green. If these are to be distinguished on black-and-white film, you should use a green-yellow or, better still, a green filter.

In summer you should try to lighten the greens which will otherwise seem too dark. This means using a polarizing filter with colour film, to cut out the blue light of the sky reflected from the leaves and give them back their true colour.

Then in autumn all the colours change, except for the evergreens, which stand out with the dark greens against the golden larch and all the deciduous trees, which range in colour from bright yellow through russet and brown to deep reds. Such splendour may not last for very long; a high wind will soon remove the leaves from the trees and pile them high on the ground ready to become next year's humus. All that is left then are the bare branches and twigs: only now can you see the skeleton of a tree and study it in depth; it is best to seek out trees standing alone for this.

The woods do not lose their charm in winter, for then they are decked with snow; there is little colour left, and the scene is almost entirely composed of blacks and whites. The fir trees look like white cones, their branches drooping low with the weight of the snow. Hoar frost makes a very good photograph, but it does not last long, so you must always have your camera ready. Try to take the branches when the sun is making the frost glisten. Use black-and-white film for the most beautiful results: it should be under-exposed and over-developed, and then printed on very hard paper.

You can never photograph a wood in its entirety; the best you can hope for is a tight group of trees, which will convey a similar feeling. It is very difficult to judge the correct exposure, as it is always very dark, and there is more contrast than you might think. Take the photographs into the light or try to include the sun's rays falling through the leaves to form patches of light on the forest floor. If there is a light mist the rays are specially beautiful as they stand out against the background.

Apart from living trees, you can watch out for the felled trunks waiting in piles to be taken away. Nature lovers will see all sorts of things by the side of the track: forest flowers, mosses and ferns, toadstools and berries, beetles, and all kinds of small animals; you will, however, have to be a skilled nature photographer if you want to include wild animals and birds in your pictures.

# HOLIDAYS

A camera is naturally an important part of any photographer's luggage: firstly because he wants to show his friends where he has been, and secondly the photographs will serve as a personal record of his holiday experiences.

Before leaving, check that everything is working properly, and do not forget to take plenty of film with you: it may not be so easy to come by where you are going. In any case it is always better to take too much film than too little.

In some countries you need permission to take photographs, and even once you have this, you may find that you cannot take all that you might like to; it is often the case that bridges, stations, ports and industrial zones are considered to be of strategic importance. This means that you can no more take photographs of them than of military installations. In developing countries photographs of beggars and slums are seen as a sign of discrimination, and there are many Moslems who will not let you take their picture. The consulates and – if they exist – the municipal tourist offices will give you all the information you need about local customs and views on this subject.

In tourist offices you will be given a wide range of information, pamphlets, and prospectuses. Read them thoroughly, as well as any guide books you can find on the country being visited. Depending on your interests, find out about the history, art, and culture of the country, its flora and fauna, and the people, and their customs in general. This will not only increase your anticipation, but it will also give you a rough idea of what you want to see, so that you can make plans.

If you are going by plane you should take all your equipment, not just the camera, as hand luggage; if your film is subjected to X-rays it will almost certainly be ruined. The best times to take photographs from the plane are just before take off and just after landing, when the plane is not too far from the ground, and the landscape is still distinct. Higher up the only real subjects are the huge cloud-banks: the earth will seem bluish, but otherwise colourless and pale. Only when the sun is very high will you get a better view, but remember that colour is less effective than black-and-white: use a slow film slightly under-exposed, and then over-develop it accordingly; IR black-and-white film will give some good effects. Make sure that the vibrations of the engines are not transmitted to the camera, which means that it should not be pressed against the window, nor should you lean your elbow on the seat rest.

When you arrive at your destination do not walk straight past the postcard stands. You may well find that they will be the inspiration of some of your own shots. Almost everything will be worth taking a photograph of, the landscapes, strange and exotic plants, historical sites, or perhaps the bustle of a bazaar; then there are the people, who differ from those at home in race, dress, and manners; you may find people doing jobs not known in your own country.

But above all you must not forget yourself, for it may well be that you would like to see yourself in a few of the pictures in later years; perhaps at a memorable stage in the journey, or when bargaining with a native or mounting a camel.

Also worth a photograph are festive tables in foreign restaurants bedecked with strange dishes

For clear results such as this, black-and-white is far better than colour, because more expression can be given to contrasts.

worthy of Petronius. Allow those who had to stay at home participate in your experiences, and remember to include a bit of lightheartedness. If you want to take a photograph of your girlfriend on a particularly uninspiring stretch of beach, draw a funny face in the sand, and take the photograph with your girlfriend beside it, holding a colourful parasol. The more imaginative your photographs, the more entertaining your holiday yarns will be when you get back home!

# IN THE TOWN

A town has many faces for the photographer: the city, the area round the railway station, the old town, the affluent suburbs, and the tenement blocks. In the industrial zones heavy lorries thunder along, pneumatic tools drum out their message, while smoke and filth belch out of the chimneys.

Then there are the special attractions: the botanical and zoological gardens, natural history and other museums, memorials, and picture galleries.

But first and foremost come the people who throng the streets and make them pulse with life; there is all the bustle of the shopping centres and street markets, the traffic, the rush and tear of railway stations and the underground. Then there is the atmosphere of international sea and airports. Huge crowds can be found in sports stadiums, at political meetings, and at demonstrations. A tremendous feeling for the more pleasant side of life is unleashed at fairs and carnivals.

Streets festooned with bunting at international festivals also change the face of a town, as do the lights at Christmas time. The whole town takes on a festive air.

You can look out the quieter parts: the parks and gardens; people strolling around, a young couple kissing on the street corner; russet leaves falling in

Even at the annual fair you will find static subjects.

the autumn; perhaps an elderly couple sitting quietly on a park bench.

As evening falls over the town, the lights start to go on. Colour is added by the neon signs.

## GENERAL VIEWS

Taken from a piece of flat ground or across a river, the skyline of a town, with its church steeples and high-rise buildings, can be very attractive. It is often difficult to find a suitable foreground to balance such photographs and the sky, though blue, may seem monotonous. You can then use a long thin format for your picture, cutting out everything that you feel is superfluous to the shot: an enlargement will be necessary for this. If there is a storm brewing, however, you can bring the skyline down almost to the bottom of the picture and let the threatening clouds loom up above it. The town cowers at the mercy of the forces of nature.

The best general views of a place are normally to be taken from a nearby high spot, using a telephoto lens if necessary. It is better, if you want to get as much detail into the shot as possible, to take the picture with the sun to the side than with it behind you. Colour photographs will be best just after a shower has cleared the air. Slight haze can be dispersed on black-and-white film with a red or orange filter. Infra-red film can be used even in a heavy mist to produce pictures rich in contrast.

Never overlook a chance to take a shot from the roof of a high building or a church: the result will be very impressive and far from everyday. Do not, however, be tempted to take photographs simply because they cover a large area; they are rarely as good as those where the view has been limited. If you do not include the skyline in the shot, the roofs and gables will form a bright mosaic. A feeling of height can be conveyed by using a short-focal-length lens. The picture will be more impressive if a tower or a turret is included in the foreground. If this is not possible, at least try to include part of a balcony, perhaps with somebody on it.

Two photographs of New York, one a bird's eye view, the other taken through the suspension cables of a bridge.

# ARCHITECTURE

As time passes, you get so used to your surroundings that you are no longer really aware of them; until you start walking around with your camera looking for things to photograph. The search will increase your power of observation and bring to light many things that you did not even know existed. A lot depends on the time of day: perhaps a façade is no longer in the shade, or perhaps it is just that the light is no longer falling on it from the front, but from the side. Cornices and walls gain more depth, and façades are brought to life. Sometimes you will only have a few moments to take a photograph before the effect fades. You do not have to leave it to chance as it is always possible to plan a shot in advance. Get a street plan, and mark north on it: as the streets lie in different directions, each will have its own most photogenic time of day when the light falls on it from the best angle. If you know the position of the buildings you want to photograph, it is a simple matter to work out the best time to do it.

The feeling of depth in this picture is given by the light falling on the house from the side.

Inn signs are essentially graphic subjects, and should be taken in black-and-white.

There is no need to limit yourself to a whole street, façade, or building. Many details have more to say if they are isolated from their surroundings, for example, a tower, a brightly-coloured roof pattern, or a finely-carved stone portal; perhaps a window with wrought-iron bars, or even a simple door knocker.

Try to cut out everything that is not necessary to the picture, such as tram wires, traffic signs, and parking meters; they do not go very well with an idyllic half-timbered house. First of all you must get used to the laws of perspective, so that you will spot any lines that will upset the balance of the photograph.

## PERSPECTIVE

An impression of perspective is created by:
● 'parallel' lines running together
● the reduction in height and
● the reduction in breadth of objects in proportion to depth.

In other words it is a distortion of reality, since the true proportions are not maintained. Although we are perfectly well aware that this perspective distortion is only apparent, we accept it as real and find it perfectly natural, since our sense of space is conditioned by it.

One often hears that it is possible to alter perspective depending on whether one uses a wide-angle, normal, or telephoto lens: this is not the case, as a simple experiment will show:

Without changing our standpoint, we take a photograph with each of the lenses mentioned above, in succession. Obviously each time a different part of the view will appear on the film, because each lens has a different angle of field. Then we make enlargements, taking only the part of the scene that appears on the telephoto shot. If we then compare the photographs, there will be no difference between them, except in sharpness. The proportions of the objects in the pictures are the same, so it follows that the perspective is unchanged.

For the next test we take the photographs from different positions, so that the subject – a church, for instance – appears the same size on the negative each time. Comparison of the prints will this time show that the proportions are different, and so, therefore, is the perspective.

The conclusion to be drawn from these tests is that it is erroneous to talk of wide-angle, normal, and teleperspective: it is not the lens that changes the perspective, but the point from which the photograph is taken. In other words there are only near and distant perspectives. The choice of lens only affects the scale of reproduction; a wide-angle lens

Two photographs from the same place – with wide-angle and telephoto lenses – then a selective enlargement from the wide-angle shot for comparison with the telephoto print: the perspective remains the same.

takes in a lot, but it is reduced in size, whereas a telephoto will cover a smaller field, but the scale will be larger. The impression will be rather like that of looking through a telescope.

As you approach an object with a wide-angle lens it becomes bigger, perhaps exaggeratedly so by comparison with objects farther away. On top of this, parallel lines will seem to converge very strongly as they move into the distance, which gives a great feeling of depth to the photograph. This means that you can emphasize certain elements of the scene by making them appear larger than others out of proportion; they will dominate the picture and catch the eye.

Long-distance perspective, on the other hand, maintains relative size much better, which means that it is to be preferred if you wish to keep the proportions in your photographs as near natural as possible. Since the parallels converge gradually as they work deeper into the picture, the content of the picture is condensed, and there is a stronger reduction in height perspective: in other words a telephoto print will not have much feeling of depth to it.

You can alter the perspective by changing your position. Look particularly at the flag pole and the tower; the top photograph is taken with a normal lens, the bottom one with a telephoto.

Colour Plate 13: Autumn is the time to take the most colourful forest photographs; it is also the time when shooting into the light can produce the most magical effects.

The laws of perspective govern all lines: horizontals, verticals, and diagonals. If a line seems out of place, it is because we know, for example, that house walls are parallel, and our brain is correcting a visual impression. We can, though, make these parallel lines run together when we look at a row of houses, by conscious effort. The camera has no brain and can only register what it sees. Converging parallels are only exceptionally unpleasant if they are but faintly suggested; they will then make the house look as though it is tipping over backwards. To avoid this, the camera must never be tilted upwards, but always held parallel to the wall. The best way of achieving this is to take the photograph from an upper storey of a building opposite. If you are using black-and-white film, you can always correct the verticals in the enlarging process. The other way to do it is to stand far enough away from the subject to include the whole thing without needing to tilt the camera upwards. You can later make a selective enlargement. This is not possible if you are taking transparencies; then the only solution to these lines is to use a PC lens, although this is not as efficient as a plate camera, where the various parts can be manoeuvred. The large format also offers an incomparable range of detail, which is essential to a good architectural photograph.

Colour Plate 14: Holiday photographs comprise anything and everything: picturesque landscapes, souvenir pictures, and people in foreign countries who like looking at people with cameras.

It is, of course, possible to put converging parallels to good effect. They are the best way of conveying the height of a tower or a skyscraper, and can be well used when the top of the building is cut off by the top of the picture: the subject then seems to grow beyond the limits of the frame.

It is just as natural for us to recognize parallels that converge in a curve, for exactly the same reason, i.e. that our brain corrects what we see in the picture. And yet with a little imagination we can see perfectly well why two parallel lines converging must seem to curve.

Imagine a set of rails stretching in a straight line from one horizon to the other. If the perspective were actually expressed in straight lines, then the rails would meet at our feet in a sharp angle. Since this obviously does not happen, there is only one explanation: the perspective narrowing is not straight, but curved. We can take this even further, and conclude that parallels can never appear straight to us, even when we look down on them from above, because even then they are a part of this arc. This is why lines of perspective in photographs are not straight, but curved.

These observations are necessary because we always base our judgement of photographs on our normal visual sense. If they depart from this, it is all too easy to label them overdone or even unnatural. This is to forget that the way we see things is only one of many possibilities for coping with a series of insufficiencies. Once you are aware of how this process works, you will be able to foresee these unnatural effects and counter them by holding the camera in a particular way or by choosing a particular lens.

With central perspective all straight lines meet in a point at infinity.

Most lenses give pictures with central perspective, which means that all the parallels move towards a single point in the distance, apparently in straight lines. But as we have already shown, because we are only taking in a particular angle of field, we appreciate these lines as they must be in reality, i.e. curved.

Fish-eye and swivelling lenses give a completely different picture: central perspective is the result of projection onto a flat surface, whereas fish-eye lenses give a spherical perspective, which as the name suggests is much the same as the reflection in a Christmas-tree bauble. All straight lines except those at the centre of the photograph appear curved, the effect being exaggerated at the edges of the image. Things near the middle of the picture appear large, whilst at the edges they would look much smaller. Panoramic cameras, and cameras that produce a panoramic picture made up of several individual shots, show the image like a reflection from a mirrored pillar. Horizontal and diagonal lines are curved, whilst verticals remain straight. Since this corresponds to a projection on to a cylinder, it has been termed cylindrical perspective. How it comes about is easily explained.

Imagine yourself in front of a row of terraced houses: the street is absolutely straight. You stand opposite the centre of the row with your camera and take one shot to the left, one central, and one to the right. The whole of the street has now been taken on three horizontal-format photographs. On the first one the houses will seem to get smaller in a line from left to right, on the second the lines will be parallel to the edges of the print, and in the third the houses will again get smaller, this time from right to left. If you then put the photographs together to form a whole, you will find that the lines will form a sharp angle; if instead of three horizontal shots you had taken a lot of vertical photographs the transition would have been much smoother, and the curvature would have been much clearer.

We can look at a photograph taken with a

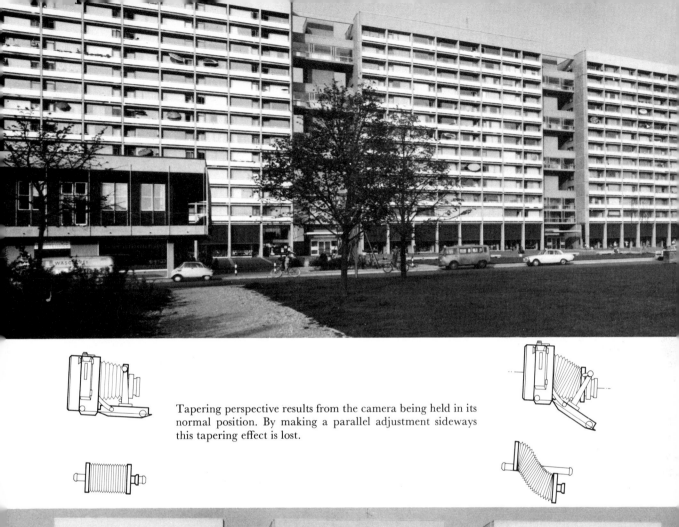

Tapering perspective results from the camera being held in its
normal position. By making a parallel adjustment sideways
this tapering effect is lost.

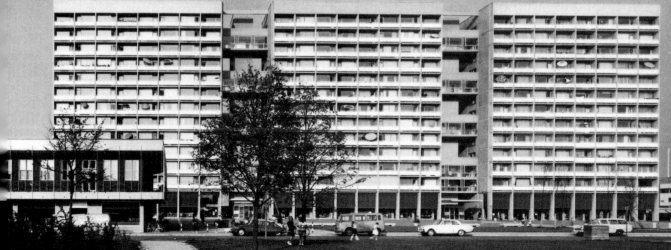

Avoiding distorted verticals. With the camera in its normal
position (left), the lines can be seen to converge; a parallel
adjustment in the vertical plane corrects this.

panoramic camera much as though it were an endless series of individual shots joined together.

## CHURCHES

Pictures of churches are well worth taking, along with those of other stylized structures, such as castles, châteaux, windmills, fountains, and monuments; there is a great variety in style and period. Take the pictures inside and out; the leaded windows lit by the sun are much brighter than you might expect. There are the main altars and those inside chapels, the chancel and the tombs. A photograph of the nave in its entirety can be overawing. You can contrast baroque churches, agleam with gold ornamentation and cherubs, with modern religious institutions made of reinforced concrete and stained glass: their very plainness can be exceptionally striking. Use the same principles for taking church interiors as were applied to architectural photography: good lighting, a concentration on detail, and control of distorted lines. The 'moving flash' technique can be used to get all-round illumination.

All this makes it relatively easy to capture the atmosphere of a church. It is a fine subject for available-light photography; you will require a very sensitive, high-speed film, a wide aperture and a lens with a fairly long focal length. Focus on an important part of the picture, such as a statue of a saint illuminated by the light of a candle, or an old lady praying. Everything else will fade into unsharpness and darkness.

Spherical perspective through a fish-eye supplementary lens placed in front of the main lens. Any straight lines other than those in the centre of the picture appear curved.

## MOVING FLASH

This is a technique that is used primarily in churches, caverns full of stalactites, or in any large enclosed spaces. It is used when one flash would not provide enough light for the shot and when a simple multiple flash arrangement would still not illuminate the farthest parts of the space.

One all important point to remember with moving flash is that there must be no extraneous light that will affect the film. Since dark windows are not very attractive the normal technique is to leave the camera on the stand overnight after a successful flash shot, and to make a further exposure the next morning. This obviously means that you should take steps to ensure that the camera will not be moved or jogged while you are away; this would result in a double image and mean that all your work was in vain. The best cameras to use are those that do not have a stop to prevent double exposure, since then it is merely a question of releasing the shutter again.

The procedure is as follows: after fixing the camera to the tripod you set the shutter speed at B or T, and then (in order to get the required depth of focus) you set the aperture to at least $f8$ or $f11$. You can calculate the flash-to-subject distance from the formulae given earlier. You then flash the light at each part of the room in turn from the appropriate distance. If this is very great, or if the subject has a large surface area, you can fire off several flashes in succession at the same point. If a lot of flashes are called for, it is a safe bet to set off an extra one for every three calculated. At the same time you should change your position on each occasion to ensure even illumination without shadows; nothing will look worse than a lot of shadows running into each other in all directions. Always make sure that the camera is well shielded from any light coming from the side of the flash-gun.

## MUSEUMS

Pictures in museums present precisely the same problems. Firstly there must be a neutral, uniform background, for which the bare museum walls are usually suitable; smaller pieces can be isolated from what is around them by holding a piece of cardboard behind them. No other objects on display should be allowed to penetrate into the field of view. Glass cabinets can only be countered by a polarizing filter, which will help to dispel disruptive glare.

Frequently one can make do with the available diffuse light, particularly when it falls from above, lighting the exhibition room evenly. Reliefs, though, require more direct light falling on them to give them form and vitality. This can be achieved with flash, but you must ensure a sufficient distance between the reflector and the subject to avoid a decline in brightness from one side of the relief to the other. Sculptures, carvings, and other forms of plastic art need the same technique as portraits, which is the same as for costumes in a folk museum or for bones in the natural-history section. It will rarely be possible in a museum to fiddle about with cables and lighting units as the subject demands. In any case special permission must be obtained from the museum authorities: if this is not forthcoming, then it is better to forget about the photograph.

Photography is normally forbidden in art-galleries, as there is usually an exclusive contract with a professional photographer, whose work is on sale at the entrance. These are almost certainly better than one's own efforts might be: it is often more difficult to photograph paintings than it at first appears. Two lamps are necessary to ensure absolutely even illumination. It is extremely difficult to avoid reflections and glare. For oil paintings, circumstances often require polarizing filters for the lighting units and another for the camera lens.

Bought photographs usually only show the picture itself, although it was created by the artist with the intention of housing it in a suitable frame, which would underline the total effect. You should, therefore, whenever attempting such photographs yourself, on no account omit to include the frame.

Skylights in a museum transmit the necessary diffuse lighting for interior shots.

167

Lanes of traffic are best seen and photographed from above.

135 mm lens. Flash will naturally have a flattening effect, as well as disturbing both actors and audience; this means that you will have to make do with the stage lighting, remembering, of course, that it is not nearly as even as it appears to be from the auditorium. In fact there are normally quite considerable 'holes' between the beams from the lamps. These can be seen if you hold a red filter to your eye. This does not pose any real problems with black-and-white film, since you can use high-speed stock; to make sure you can always over-expose it slightly and reduce the developing time accordingly: this will help to equalize the effect of the stark contrasts. You will normally find that the stage lighting is sufficient for colour film too, as long as you base the exposure on the brightest areas to avoid the colours being washed out.

The rules for variety shows are the same as for the theatre. In the circus the best place to go, if you can, is the ring itself. Again flash is forbidden because it might disturb the animals or the acrobats.

You must always ask for permission to take photographs before doing so, but once you have been granted it, do not try to save money by being stingy with film.

## THEATRE, CIRCUS, AND SHOWS

The best seat in the theatre for a photographer is not in the orchestra pit or the stalls, but in the first row on one side; this will give a fuller picture, and at the same time cut down the large spaces between the actors that would be seen from directly in front of the stage. Use a miniature camera with a 90–

## TRAFFIC

Like all the others, this is an urban photographic subject: streets and tramways, bridges and junctions – from the simple crossing to the clover leaf or even a spaghetti junction: the product of modern technology, the image of our time.

168

Congested traffic is best taken with a telephoto lens because of the condensing effect this has. Such a photograph gains its effect from the repetition of the shapes of cars and their even spacing. Traffic coming into a crossing is best taken from a tall building. Car ferries being loaded form an interesting subject. Impressions of a very different kind are given by photographs taken from a moving car. And remember that if you are involved in an accident, a few photographs will be more telling than the fullest eye-witness account. Your photographs may well be the deciding factor for the judge or for the insurance company.

Stations are full of opportunity for the amateur photographer; some people are dashing after their train, others are waiting; there are the immense arches of the station itself, the suburban lines, the diesel trains and the streamlined trans-European expresses. You can use a telephoto lens to condense the forest of signals and the tangle of cables. Just after a snow shower or simply taken into the light, the rails themselves are a marvellous subject. Take the shot from a bridge or from a nearby high building.

You might even be lucky enough to find a steam-engine still in operation, although they will normally be mobile museums rather than anything else. If you want to concentrate on the steam, take the shot into the light and on a cold day for the fullest effect.

## REPORTAGE

This is the art of conveying in pictures incidents, backgrounds, and connexions in a story: the photographs can be timeless or fixed in time, as you wish. In the first instance, they are called features, in the second it is a case of recording the events of the day, that make the news; naturally enough these soon date. Such photographs are rarely taken by a chance eyewitness of an event. Normally you will have to do a fair amount of research to decide what features of a problem your photographs should illustrate: then, and only then, do you go out with your camera.

If the photographs are to appear together, always start with a good one, so that it will be a kind of advertisement for the rest: then neither the general shots nor the more incisive probings of the camera will fail to gain attention. Everyone of course will look at the pictures with different eyes. The final photograph should underline the message that the whole series is trying to convey.

The pictures should not have to speak for themselves, but should be accompanied by a brief text, which may also cover the transition from one photograph to the next. Such a text is necessary to avoid misinterpretation. It should contain the names, facts, and dates, which the photograph cannot express in pictorial form.

The narrower the subject being dealt with, the more concentrated your treatment of it should be; it may be that you will have covered everything in as few as 2–5 pictures. The broader the subject, the more photographs you will need, but you should

try not to present more than 15, or else it will seem long-winded and will be less effective. This means that it is best to show only those photographs that have the most to say. Because they are tied to an article, many photographs will have a much greater effect than if they were looked at for their own sake. If the subject is too broad, you run the risk of treating it too superficially.

The best equipment is a miniature or a $6 \times 6$ camera with interchangeable lenses and as many other accessories as you can afford. Perhaps the best is a Nikonos camera, which can not only be used underwater, but will prove more resistant in rain or snow than a 'normal' camera, and will even stand up to being sprayed with mud by passing cars.

# PICTURES AT HOME

The home provides more subjects for photographs than is often realized. These begin with the members of the family who can be photographed in a great number of ways: doing the housework, practising a hobby, reading, eating, or drinking. Then there are the various celebrations: the children's birthdays, the carnival parties, when the home is decked out with garlands, Chinese lanterns, and paper streamers, right up to the cheerful present-laden table under the bright Christmas-tree lights.

Our feathered and four-legged friends are also worth photographing: budgerigars and canaries, hamsters and poodles, or indeed anything else the family may possess. Not to forget those inside the vivarium or aquarium, the house plants, and bunches of flowers. Should you wish to take close-ups of flowers, it is best to do so in the home, where quiet can be found and where there is no wind to make all efforts in vain. On top of this there are photographs from television, photographs using stroboscopic effects, or reproductions of children's drawings, stamps, and above all of interesting newspaper items, which will, in time, build up into a comprehensive microfilm library.

## LODGINGS

Lodgings likewise offer many subjects. These photographs become particularly interesting if you have moved home a lot. They are then a reminder of how you used to be set up. It is self-evident that you should clear up the room before taking the picture so that there is not too much clutter lying around. It may even be necessary in some cases to shift the furniture a little in the interests of good composition. It may also prove advantageous to place flowers or house plants, perhaps even a sculpture, in the foreground. They do not have to be sharply in focus. In any case they break up the foreground and the eye can wander into the interior of the room.

171

The greatest difficulty you are liable to experience is that you will not be able to go back far enough, and that the best you can do is retreat into a corner and take what you can from there, which means that a wide-angle lens may well come in handy. Be careful that you do not hold the camera at a tilt, as photographs of interiors need to have all the lines dead straight and the corners parallel to those of the print.

Another criterion is the way the room is lit. If the sun is streaming in it is very easy to overstep the contrast limit of the film material, so it is often best to photograph interiors on dull days. This means that the available light will rarely be sufficient, even if the windows are very large and reach right down to the floor. There is likely to be a sharp reduction in light at the other side of the room and you will have to compensate for this. This is not the easiest of things to do while at the same time avoiding crossed shadows, and the best way out is to use bounced flash, directing the reflector towards the ceiling; the advantage of this is that there will be no reflections off the polished surfaces in the room. The room lighting should also be switched on unless you are trying to create some spectacular lighting effect.

If you want to take a photograph from inside of something outside, it is absolutely essential to brighten the foreground, or else you will get a good picture of what is inside with a dazzling garden, or, alternatively, the outside will be correctly exposed with a very dull foreground. An alternative to indirect flash is a blue photoflood replacing the normal bulb under the lampshade. As these bulbs

still retain a faint yellow tinge in the light they emit, the overall impression will be the same as with a conventional bulb only brighter.

## PHOTOGRAPHS OF OBJECTS

Photographs of furniture, bits of jewellery, and other man-made objects, toys, utensils, and technical apparatus do not become more effective if you try to embellish them somehow, but, rather, succeed if you emphasize their impersonality and their inanimate nature; the photograph is there for informative purposes only. If you want to get over the perspective problems posed by articles of furniture, you will have to use a studio camera of one sort or the other, but with most other subjects any camera will do. The only thing that requires particular attention is the plasticity of the object, which must be clearly expressed on film; the photograph should also show the material and the contour of the surface of the article in the picture.

This means that you should not only be able to see the grain of wood clearly, but also be able to judge if the surface is rough, matt, or polished. The best way of doing this is by using a filter similar in colour to the basic shade of the wood: this means a green filter for a grey-green wood, or an orange or pink filter for the red woods. The effect will be seen if you simply hold the filter in front of your eye. Reflections can be cut down by using a polarizing filter, but you should not do this too much when photographing highly-polished pieces of furniture,

or all the work spent polishing it will have been in vain and the surface will look quite dull. In the same way you want to avoid making a porcelain figurine look as if it were made out of Plaster of Paris; and remember that a diamond should sparkle and not look like a pebble off the beach. In the same way you should bear in mind that silver, copper, and tin all have a different shine to them.

Surface shine and points of light not only help to give fullness and body to an object, but also give an idea, in black-and-white, of what the item is made of. One light is rarely enough, and it will often be a long time before you have set up the lighting so that everything is just how you want it. To give an overall reflection from the surface, diffuse lighting will have the best effect.

By using the manoeuvring capability of a studio camera, this shot was taken so that perspective did not make the glasses look thinner towards the bottom.

A good photograph of an object requires not so much artistic direction as the feeling of a craftsman: the articles being placed on the right base or background and given body so that the photograph will stand comparison with the real thing; this is difficult and the skill involved should not be underestimated.

If it is a question of giving emphasis to a structured surface, the best thing to do is use sidelighting. Otto Croy has shown in an interesting series of comparisons using coins as a subject how the direction from which the light comes can have a bearing on the shot. If the light falls from the left the coins look perfectly natural, but if it comes from the right, the light plays tricks, and everything looks the wrong way round because the shadows fall in the wrong direction. If you light the coin from above, you will get plenty of reflection but will loose all definition and sense of depth.

Fine chasing needs to be lit with as little shadow as possible, whereas glass has its best brought out if the photograph is taken into the light and against a dark background, especially if the surface is cut. This makes metering well nigh impossible, and it is necessary to take several shots at different apertures.

Most subjects call for a fairly dark foreground to draw the eye on to the main subject further back.

There are two alternatives for the background: it can either be darker or lighter than the main subject; it is generally better if it is lighter, as this will create a feeling of depth and space. For colour shots, it is best not to use the complement of the subject colour as a background, as a two-tone composition is far more attractive. You can either use a coloured backcloth or a white one with light of the appropriate colour projected on to it. Designs will liven up a large expanse of background and can be projected on to it quite easily, although you can have too much of a good thing, as experience will show.

The line where floor and wall meet can look very unpleasant on film: its effect can be overcome if you

- hold the camera high enough to use the floor as a background, if the subject allows, or
- use a backcloth (available in 50 colours). The roll is hung on the wall and then drawn on to the floor with the subject on top of it; the wall will then run smoothly into the floor without any kinks or lines.

To avoid shadows there has to be sufficient distance between subject and background, and an arrangement of lights that will make the shadow fall outside the field of view and not on to the background. Small objects can be photographed on a sheet of frosted glass, which is supported about 20in. above a sheet of white card. If the card is now brightly lit, it will reflect enough light upwards to eliminate all shadow. If you want a black background, the best material to use is velvet, which will likewise absorb any shadow falling on it. If the object is rather larger, you can use a black backcloth, although if there is sufficient distance behind the subject the decreasing intensity of the light will have much the same effect. If the room is too small to allow a great enough distance, the object can be taken against an open window in the dark.

Diffuse lighting is the best to use for very shiny objects. This is done by constructing a light tent out of tracing paper. This consists of a large cube with a hole for the camera to look through. You then

arrange a series of lights round the 'tent' all pointing toward the middle of it; the result will be a diffuse and absolutely shadow-free illumination of the subject.

The same method is used for photographing objects in a glass case, except that this time the tracing paper is wound round the sides.

## USE OF THE POLARIZING FILTER

These filters are another means of cutting down reflection and glare, since, unless they come off metal surfaces, both are made up of polarized light.

Normal light vibrates in all directions, whilst polarized light is restricted to one plane. Think of it as a very dense grating, consisting of a series of rods standing very close together. This structure is built up from organic molecules, which are very large. If you hold the filter so that the lines are in the same plane as the vibrations of the light being reflected, the light will pass through without hindrance: as you rotate the filter, however, the amount that passes will be cut down, until it is totally absorbed at 90°. All that can now pass is normal light, reflections and glare having been lost. The effect can be monitored through the viewfinder of a single-lens-reflex camera if you turn the filter in front of the lens. If you are using a rangefinder, you must turn the filter in front of your eye until the correct degree of rotation is found, and then put it on the lens in the same position.

It is easy to find the best place to take the photograph from; since, depending on the material, only an angle of 35–40° consists of polarized light, you should always stand to one side of the reflecting surface, and never face-on. You can choose to what extent you wish to eliminate the glare by turning the filter to a greater or a lesser degree; a great variety of different shots is possible. Full-colour saturation is achieved when all reflection is disposed of. Since the polarizing filter eliminates a proportion of visible light, the exposure time must be increased above that indicated by the meter reading. The filter factor must be used in its entirety, regardless of whether the reflection is completely lost or only partly so. This method of glare reduction can be used in photographs of all objects, but not in reproductions, since the steep camera angle would distort the perspective.

Polarized-light photography is a specialized field in itself; one filter is placed in front of the light source, and another in front of the lens; this is a technique particularly used in close-up work and macro- and microphotography. The filters are called the polarizer and analyzer respectively. They enable you to cut out reflections from metallic surfaces, and also to explore the possibilities of dark- and light-ground illumination. If the gratings in the two filters run parallel, you will have light-ground illumination, and if they cross, dark-ground illumination. You are also entering the field of stress optics. It is possible to see stress patterns in colour in models made of transparent plastic, which enable the manufacturer to see which parts need extra reinforcement. Very attractive patterns can be made with two layers of very thin

How a polarizing filter works. Non-polarized light vibrates in all directions, but polarized light only in one. If you place a second filter behind the first with the 'lines' at 90° to those of the first, no light at all will pass through it.

Shop window taken with and without a polarizing filter. The reflections disappear completely, and the models can be seen clearly.

Colour Plate 15: Souvenirs of foreign towns: one large photograph of a single detail of the town may express more about the town than an overall panorama; and festivals – this is a float of flowers – offer an opportunity to take a whole series of shots.

cellophane. The arrangement of the colours depends on the number of layers, and the relationship of the cellophane and the two filters. The results can be used to give a background of any colour you want.

## VIGNETTES

These have a concentrating effect, since they completely cut out everything but the main subject from the shot. They are made by placing a piece of card in front of the lens, having previously cut out of it a hole to correspond very roughly to the shape of the subject.

This is a technique much used in advertising, and is most effective when the edges of the hole do not appear sharp on the negative; to do this, you must fit the vignette on to the lens hood or a bellows extension, and then bring the subject into focus. This gives you more scope, and also allows you to vary the brightness of the vignette according to the background; if this is bright, then the vignette should be dark, and if dark, the vignette should be lit in such a way as to make it stand out; a lens with a long focal length should be used, and an aperture no smaller than $f8$.

Colour Plate 16: Old towns with their narrow picturesque streets are often best taken from a tower.

In many instances, however, it is preferable to have the vignette sharp on the negative; this is normally the case when the hole is not irregular, but takes the form of something like a keyhole. This gives the impression of a secretive glance. Here a lens with a short focal length is used and the aperture opened as wide as possible. The vignette is then stuck on to the end of an extra-long lens hood, for the further it is from the lens, the sharper it will be in focus.

## THE GREASED LENS

This is another means of concentrating the eye on the main subject, but this time the outer field is not completely obscured. A bellows compendium is used to hold a glass disc at about the focal length of the lens, which should if possible be a portrait lens. The edge of this disc is smeared with Vaseline, but the middle is left clear. You can see the effect through the viewfinder of a single-lens reflex. There is a gentle transition from the sharpness of the main subject in the centre to the unsharpness of the outer field. This cuts out everything that is not essential to the picture, and lets the eye concentrate on what is important.

This method can be used in photographs of inanimate objects as well as in fashion and portrait work. The important thing is not to stop down the lens too much.

177

## GHOST PHOTOGRAPHS

These are very informative in that they not only show the outward appearance of an object, but at the same time – by means of double exposure – offer an indication of 'what makes it tick' inside; such photographs are primarily used for technical equipment.

First of all the inside of the subject is taken against a black background, using indirect or soft flood-lighting to give shadow-free illumination; the exposure is that given by the meter; only if the inner parts are darker than the casing should you use half (or less) the value given in the reading, otherwise it will be too dark in the picture.

For the second exposure, the casing is placed in exactly the right place, which means that you have first to mark the position on the ground-glass screen; if you are using a rangefinder, you will have to make the marks on the base or the background so that they will not be seen in the finished result. You then change the background for a light one and take the picture with the settings indicated by the meter; very dark casings should be over-exposed by 1–2 stops.

## REPRODUCTIONS

A very important rôle is played in modern photography by reproductions. Scripts, stamps, old photographs where the negative has been lost, etchings, or quite simply interesting news cuttings are all likely subjects for the amateur who wants to try his hand; a small collection will soon build up into a personal microfilm library.

The sort of film you use depends very much on the subject. The following table can be used as a guide:

| | Original | Film |
|---|---|---|
| 1) | Black on white line originals: print, graphics, diagrams, technical drawings, woodcuts, etc. | Medium-format and technical document film, which can be developed to give prints or trans-parencies. |
| 2) | Black-and-white half-tone originals: These have medium tones as well as pure black and white: etchings, old and yellowed photographs, magazine articles with illustrations, etc. | Slow, hard black-and-white films, either ortho- or ortho-panchromatic. Document films developed as prints or transparencies: direct slide film. |
| 3) | Coloured originals: watercolours, children's drawings, colour prints, etc. | Slow orthopanchromatic black-and-white film, and colour-reversal film. |

178

The next step is to arrange the lighting; either two or four lamps are needed, arranged on both sides of the original: they should be set at the same height, and be directed towards the base at the same angle. To check for even illumination substitute a piece of plain white paper for the original, and hold a pencil vertically in the middle. The shadows should be of equal strength and length and lie opposite each other. If this is the case, you can put the item to be copied back in place: to make sure that it lies flat, you can stick it down with a non-abrasive tape or even a piece of glass.

The camera has to be fitted with extension rings or a bellows attachment; the best camera for the job is a single-lens-reflex with a box viewfinder. It is also possible to use supplementary lenses. Make absolutely sure that the film and the original are parallel, and that the camera is pointing at the exact centre of the original, or else the result will be trapezoid. Special reproduction apparatus is available, but it is also possible to use smaller stands that can be bought for originals of the sizes A4, A5, and A6. These stands hold the camera level so that there will be no bizarre perspective effects, they can also be used for automatic focusing. To ensure that the film does not pick up any reflections from the glass holding the paper down, cut a round hole in a large piece of black card and place it over the lens: if, when you look through the viewfinder, you can see reflections of the lamps, a new position must be found for them.

The meter reading is taken vertically downwards, preferably using the grey-card method; do not forget to make any adjustments necessary because of lens extension, or filters if they are being used. Then

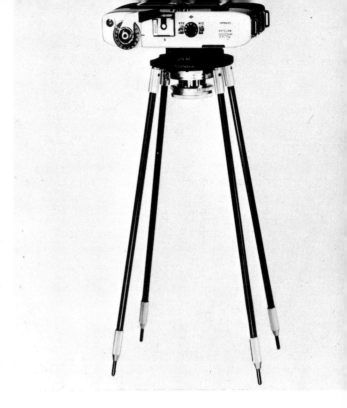

Camera stand for reproduction work.

stop down to *f*8 or *f*11, and release the shutter with a cable release.

A series of test shots has to be made with document film, as these have no indication of speed; take the shots at half-stop intervals; this is especially important if the film is to be reversed to give transparencies.

179

Leitz 'Docuflex' reproduction apparatus.

an old yellowing print whose negative has gone astray, the best medium is document film using a blue filter. Spots and stains can be eliminated by using a red or orange filter. If they are very weak, a dark yellow filter will suffice, and if they are very strong, infra-red film will have to be used before they will disappear. If you have a tungsten colour film in the camera, the colour temperature of the lighting must correspond to the sensitivity of the film emulsion if you wish to avoid having to use filters.

## TAKING PHOTOGRAPHS THROUGH A KALEIDOSCOPE

A kaleidoscope is constructed with three mirrors, joined together to form a triangular, open-ended box. The subject is placed at one end, the camera at the other. The most frequent subjects are items of print. The results are very attractive mosaics and puzzle photographs: you can have great fun trying to guess which is the original, and which is the reflection.

The mirror box is set up on end to take the photograph; apart from exceptional cases, lighting is achieved by shining it up through the subject paper.

Filters may be used to give higher quality and better contrast. Reproductions of colour originals taken in daylight need a light- to medium-yellow filter to correct the tone values. If an artificial light source is being used, no filter will be needed, unless you want to bring out the print on a pale-coloured stamp, in which case the filter must be of the complementary colour. If you want to make a copy of

# TABLE-TOP PHOTOGRAPHS

Whereas up to now we have been talking of subjects with a vaguely technical application, table-top photography is the art of making things 'live' and is based on pure fantasy. Tin soldiers join battle to the sound of the battle trumpets and war cries. Dolls and soft toys, indeed even household items can be given a personality and even human features with all their strengths and weaknesses. Figures from fairy tales and fables can be brought to life. The impossible becomes a tangible reality. This is a world of fantasy, which becomes all the more delightful the less real and the more ludicrous the subjects.

Reproduction photo: Detail from a bank note.

Kaleidoscopic effect: normal glass mirrors give a double image, which is why metallic-mirrored surfaces are normally used; otherwise a polarizing filter is needed to cut down the double-image effect.

## STILL-LIFE PHOTOGRAPHS

These hail from the days when the photographer looked to conventional art for his inspiration. It follows that one is trying to achieve a result as like a painting as possible, which effectively limits one to using colour film.

Although the subject is built up specially for the shot, we are not encroaching on the fantasy world of table-top photography. Subjects are normally vases, jugs, glasses, statuettes, and carvings, as well as the more traditional flower arrangements, fruit bowls, etc. The background can be neutral, but more often consists of a drawing, woodcut, or painting. A typical still-life would be a Japanese ink drawing behind a vase, forming part of an ikebana arrangement made up of single flowers and twigs. It is, however, equally possible to make up a still-life out of objects that normally have nothing to do with each other. All you are attempting to do is create a harmonious composition: this can be a good exercise in cultivating a feeling for lighting.

## PICTURES TAKEN FROM THE TELEVISION SCREEN

Since the advent of television it has been possible to take photographs of your film idols in the comfort of your own home: in black-and-white and colour. On no account must any additional lighting (including flash) be used, or the shot will be ruined. The room should be as dark as possible to avoid reflections on the surface of the screen.

Since there is no question of depth of field, the aperture can be fully opened. Film titles will help you with the focusing on the ground-glass screen, but if you are using a rangefinder camera, you will have to measure the distance exactly.

The camera has to be placed on the tripod for the shot, and a minimum shutter speed of 1/25 sec. used; anything faster and you will get some surprises on the film; because the television picture is built up of lines, fast shutter speeds will show horizontal or diagonal lines across the picture, or you may even find part of it missing completely. We need not dwell on this point, however, since the meter reading is bound to show a fairly slow speed. To take the reading, you should go close enough to the screen to stop the dark area around the set affecting the meter. Watch the needle for a while and use a mean reading: this will normally do for the whole programme. Concentrate on slow-moving scenes where a shutter speed of 1/4–1/15 sec. will not mean an unsharp photograph. Anything slower than this cannot be expected to give a good result.

For black-and-white work you will want a medium-speed film of around 100 ASA; 50 or 64 ASA is quite sufficient for colour shots. Only use daylight colour film, never tungsten. You may find that a purple or a green filter necessary if you are not to have a blue or green tinge over your pictures. No definitive guide can be given here for choosing a filter, since each programme has its own particular standard of colour reproduction. Perhaps the best one to start your experiments with is an equalizing filter R4. Colour negative film need never need filters, as you can play with the colour composition in the darkroom later.

Photograph taken from a television-screen picture.

# TAKING PHOTOGRAPHS OF PEOPLE

Human beings are the most frequently-used photographic subject, according to the censuses published by various institutions.

## FAMILY PHOTOGRAPHS

These are the most popular. They form a document of your life and the life of those who mean something to you. Think how nice it is to possess a collection of such photographs, ranging from your great grandparents' time to that of your own children; it is a heritage well worth passing on to

Portraits can gain immensely from even a slightly unusual format.

future generations of the family. Each photograph should be presented with place and date written underneath it. The years go by so quickly that it is easy to forget exactly when the individual shots were taken.

## BABIES

By far the easiest of subjects, especially when taken with their mother, so that they feel protected and unafraid; this does not mean that you should go right up to them with the camera: try to get by with the available light, if necessary by using a faster film. Direct flash will be blinding and frightening for the baby, and it is better to use indirect flash, which is both less upsetting and gives a softer, shadow-free illumination. Photographs of babies should be as light as possible, since dark tones and shadows spoil the image of a baby as a tender, delicate being.

The baby should fill the frame, whether this is

done on the negative, or left until the darkroom. Don't just take it on its potty, in its cot, or with its bottle; nor on a big cushion so that it sinks down past its ears. Take great care with its face and how the hands are held. Its expressions will not only change constantly, but the features themselves are in a constant state of development during the first months of its life. This means that you should take as many pictures as possible at this time at regular intervals. Be generous with the film; it is better to take ten shots too many than one too few. The pleasure will be the greatest from a series of photographs.

At about 8–9 months the first period of growing is over, and a new stage is reached.

## CHILD PHOTOGRAPHY

This is where the problems start, because the children are constantly active and jumping around. In fact this is really the time for the mother to start taking the pictures, since she sees more of them than her husband does.

When the child is playing along with you, even a posed shot can look natural.

Left: Many photographs of babies and children are only interesting as part of a series.

Do not limit your shots to children eating or with chocolate all over their faces, but concentrate on them when they are playing, and try to get down to their level rather than standing above them. Get right down on your knees for a true 'child's eye view', which will give much more convincing results. Again, be generous with the film: the children will start by adopting poses, and it will be a little while before they lose interest in having their photograph taken; and it is only then that really natural photographs can be taken. For this reason it is important not to try to influence the child when you are taking the shot; let them concentrate on their games. This will give natural, unforced pictures; you can use the snapshot technique with a high-speed film so that you are ready for every situation as it arises.

Make a record of your child's first drawings on the blackboard, and later of its attempts to use crayons and fingerpaints, as well as sandcastles and Lego constructions.

## FAMILY CELEBRATIONS

These often provide the best source for snapshots, as long as you are not too obvious about it and do not self-consciously wait for photogenic situations to arise. It is best to wait until the conversation

A low and unobtrusive viewpoint allows the photographer this 'natural' shot.

round the table has got into full swing, when nobody is paying any attention to the camera; at the right moment all you have to do is release the shutter. Try to avoid flash by using a fast film; this will make your workings less conspicuous and disrupt the atmosphere less.

Very often it will not be possible to get away without using flash: if this is the case, it is hardly worth using the snapshot technique, unless you are going to concentrate on a particular group of people. Conventional flash will not illuminate the people at the back of the table if you try to squeeze them all in; you will have to use bounced flash or 'teleflash' (see section 'Making the best use of flash').

More variety is possible if there is dancing or if party games are played. You will get the best view from about 6–12 ft. away. Stop down the lens to limit depth of focus to this range; once you have done this you will not need to alter the distance setting again during the evening. If necessary get on a stool, or climb up on to the table. Groups of people are best photographed from above.

At birthdays and weddings there are always people who are more important than the rest, so obviously you are always going to return to them for shots; the result will be a series within a series; it should concentrate on the most important moments: the 'I do' in the church, the placing of the ring, signing the register, etc. The vicar and the registrar must obviously give their permission first. In the registry office it is best to use indirect flash, and in the church you will have to increase the aperture, because of the lack of reflected light in the building, a factor that is allowed for in exposure tables.

## GROUP PHOTOGRAPHS

It is normal to take these at parties of all sorts, and the same has been true since the time of our grandfathers. They are either taken on the steps in front of a church or in a restaurant; often the back row stands, the front row kneels, while the middle row are provided with chairs to sit on.

If the group is not this large, you can make it less stiff and impersonal by letting the subjects relax, or by standing them in an uneven line, with heads poking out on all sides. All you need to watch is that none of the faces is partly or totally obscured by another. The expressions that result are an indication of how much fun this is.

If the photograph has a different purpose, for instance to mark the retirement of a colleague, there is still no need to bow to convention; a suitable variation would be to take individual portraits of the people and then to put them together later as a photomontage. Make sure that the shadows are all on the same side; if you can draw as well, you can produce some quite original effects.

## SELF-PORTRAITS

If you are to appear as part of a group portrait, you will have to use an automatic shutter release; these are often built in to cameras, although they are also available as optional accessories. It consists of a cable release fitted with a clockwork attachment, which sets off the shutter after about 10–15 seconds.

Better still are long-distance shutter releases; their advantage is that you are no longer the slave of the clockwork, and can choose the precise moment yourself. It is even possible nowadays to release the shutter by radio control.

## SOUVENIR PHOTOGRAPHS

Posed photographs are all much of a muchness; the people to be photographed are stuck in front of a tree or a monument looking stiff and gauche, not knowing where to look or where to put their hands. Then they either look mournful or grin like the Cheshire cat, all specially for the picture; it could not be more unnatural!

How much more pleasant it is if you can get a little life into the picture; snapshots are quite easy to take, especially with the short exposure times offered on modern cameras and by fast films. So get close to the subject! Why take 15 steps backward if 3 are enough? Make the people stand out in the photograph: you only need larger distances if you want to include the landscape in the picture, and here too you will need to 'direct' the poses unobtrusively so that the group will be in the best position. If the people in the photograph are made to come out very small, the centre of attention will no longer be them, but the landscape behind them.

# STRANGERS

Strangers occasionally feel that being photographed is an intrusion on their privacy, and will correspondingly react somewhat violently. You should therefore start by asking if they mind having their picture taken, especially if folk costume or original work is to appear in the photograph; you should then follow it up by sending them a copy. Alternatively just start a conversation, which will make the photograph seem less like a personal insult. It is, however, sometimes more advisable to take snapshots using the 'candid camera' technique. Since nowadays even people in the middle of the jungle know what a camera looks like and what it does, you must try to outsmart your 'victim'. A long focal length will come in handy here, since it will cover a longer distance. The biggest aid of all, though, is a box viewfinder on a single-lens-reflex camera, which allows you to take photographs

A natural expression is essential for a good portrait.

It is not necessary to include the whole face in a portrait: the pensive expression in this picture was achieved by making a selective enlargement of the negative and then guillotining the edges.

Photographs from your travels. A shopkeeper in Nassau, in the Bahamas.

'blind': you can lean against a wall quite harmlessly, apparently gazing into the distance, whereas in reality you are setting up the picture in the viewfinder; then, at the right moment, you can release the shutter. It is also possible to use this method to shoot round a corner, but this is rarely necessary. You can be even more subtle by taking the shot backwards under your arm, looking into the viewer from above. The biggest confidence trick of the lot is to start explaining to someone how the camera works, and 'accidentally' press the shutter release.

# PORTRAITS

These are primarily head-and-shoulder photographs, or those that only show the face. Only in an extended sense does the collective term include those pictures that show the whole person and the surroundings as well. Although most portraits are done at home or in a studio, they can just as well be taken in the open air. Black-and-white film is much better suited to this purpose than colour, since even the slightest colour discrepancies can make themselves disturbingly obtrusive.

You should not be too close with the camera, as features may lose their correct proportion: nose and cheekbones become too big, and the ears come out too small. It is therefore desirable to use a portrait lens; this means a 90 mm. lens for a 35 mm. camera, or one with a focal distance of 120 mm. for a 6 × 6 camera. If only a normal lens is available, then the portrait will not fill the frame completely, although this can be corrected in the enlargement.

Do not force your model to adopt a beauty-contest smile – such pictures have a stiff artificial effect. It helps to carry on a normal conversation to dispel all camera-shyness. Natural photographs can only be created in a relaxed atmosphere. You must exude confidence and relaxation, so act accordingly and slip your directions in to the conversation.

Clothing should be subdued, since a brightly-coloured or obtrusively-patterned garment distracts too much from the face. If it is a matter of showing off a new piece of gold jewelry, it can be brought out best on tanned bare skin. The edge of

Even lighting of the face is given by a lightly-overcast sky in outside portraits, as with this peasant woman from Fuerteventura.

the clothing should not appear in the picture in this case. If the skin is unevenly tanned, make-up and powder must be used in the appropriate places, or the 'patchiness' will appear ugly in the print. The background should be of one colour and just light enough to allow the hair to stand out.

The way the head is held is also of importance; if the face looks straight at the camera the result is liable to look rather flat, which means that it is easy

to make round faces look rather like the full moon; they appear less full if taken in semi-profile. The proportions are kept as they are if the head is held upright, but it is sometimes advisable to play down a large nose or chin or a receding forehead. If the head is bent down slightly, the chin will appear smaller, but the forehead and nose will be more pronounced; it follows that if the head is leant backwards, the forehead and nose will be less prominent, but the chin will look bigger. Depending on how you arrange the position of the head, you can either flatter or caricature a person. Remember that each profile looks different; this has partly to do with hairstyle, but also with the fact that no one has an absolutely symmetrical face. This is why everyone talks of their 'good side'.

The camera should be held at the same height as the head; if you point it downwards the neck will look stubby, to the extreme where it looks as though the head is set directly on the torso; if you feel it is part of your duty to make a neck look longer, you should take the photograph from one side with the camera pointing up slightly.

Lighting is of prime significance; a thinner overall appearance will be given if the light is directed on to that side of the face turned away from the camera, i.e. the one that looks narrower to the camera; if you shine the light on the side nearer you, the model will look as though she's got mumps. Diffused and indirect lighting will give soft lines to the face, at the same time hiding wrinkles and imperfections in the skin. A soft-focus lens is an even more powerful 'beauty treatment'; direct lighting can be used to good effect if it is desired to emphasize the wrinkles that have set in over many long years. The effects possible with lighting are therefore very wide; with it you can either flatter a face or turn it into a demonic grimace.

Particular attention must be devoted to the shadows; these should not stick to the background, nor should those cast by several lamps be allowed to create distracting patterns at their intersections. The eyes should not disappear into darkness, nor should the shadow cast by the nose be too hard, or allowed to fall across the lips.

Always focus on the eyes, and take note of where they are pointing: if they are looking straight at the camera, the result will be an impression that the picture is watching you. Make sure that the flash does not blind your model, or she will blink involuntarily, which will produce a most unpleasant effect; since this cannot be controlled, remember that two photographs are better than one.

A picture of two people does not constitute a double portrait; unless it is possible to make two individual portraits with the aid of a pair of scissors, the two must form a photographic unit. This is the case if their shoulders overlap, and their heads are half turned towards each other. With three people the heads should be arranged so as to form an unequal triangle, with none of the sides parallel to any edge of the picture. When you get

A shower turned full on. If, contrary to expectations, the water were to come out cold, surprise might replace the expression of pleasure!

on to four people, you are in the sphere of group photography again.

More information can be conveyed about a person if not only the head is taken, but if the shoulders and the usual surroundings are also included. This can give a key to the nature, thoughts, and feelings, the likes and dislikes, or the profession of the person photographed.

## ARTIFICIAL LIGHT FOR PORTRAITS

Continuous lighting is far preferable to flash for portraits, using an average of 4–5 lamps. A good source for the main light is a floodlight with a Fresnel lens, or a photoflood with a reflector. It should be placed at a 45° angle to, and slightly above, the subject.

A second light is then needed to lighten the background and shadows: this is best achieved by a soft light with an umbrella reflector. Set up in the air, it should be set at roughly the same point as the camera. The only effective alternative to this method of softening the shadows produced by the main light is a ring flash unit. Of course the secondary lighting should not be too strong or the shadows will be lost completely, which would give the same results as direct front lighting, and all sense of form would be lost.

Dark faces need quite a long exposure.

The effect light is the third to be set up; the best sort for this purpose is a spotlight shining down from behind, but not letting its beam fall directly on to the lens of the camera: this can be shielded by a piece of cardboard round the lamp. This will give a silken sheen to the hair, and will also accentuate the cheek turned away from the main light.

The last lights are those used to illuminate the background: if the lighting is to be regular you will need two photofloods. If, however, you want a concentration of light on one side, one bulb will be sufficient. If this is directed towards the opposite side to the spot, the effect will be the bright side of the hair shining out against the dark background, which is very attractive.

Always remember to set up the lights individually not all at the same time; you should always be satisfied with the effect of the first one before going on to the next. This is the only way you can control the effect of each individual light.

The more lights you use, the more work you give yourself and the less satisfactory the results. There is little sense in exceeding the number suggested of 4–5. Once you have got fully accustomed to this standard lighting set-up, however, there is nothing at all to stop you trying out new effects.

Just as with natural light, the contrast of the subject should not exceed the range of which the film is capable. The differences in brightness can not be seen with the naked eye, a meter must be used. As far as possible, subject and background should be subject to the same lighting contrast. This means that the indirect or grey-card readings should be the same for both.

## HIGH-KEY TECHNIQUE

This gives tender prints in predominantly light shades of grey: it is a particularly feminine technique, which makes it ideal for portraits of children and women with blond(!) hair. Check that face, hair, and clothes all give a roughly similar meter reading from close up, and avoid harsh shadows at all costs. For this reason soft lighting is used exclusively, including an umbrella to diffuse the light from the main light. Dark tones are only permissible for eyes, eyebrows, and eyelashes, and of course for the nostrils. The background should be pure white, and lit so strongly that it is effectively exposed at an aperture two stops greater than that actually used, the aperture used being based on subject brightness.

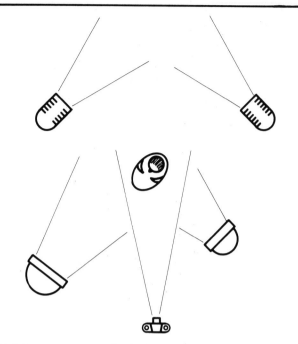

Lighting arrangement for high-key photographs. For a shot taken in the studio *see* p. 79.

## LOW-KEY TECHNIQUE

A great feeling of tension is created with this technique by its hard highlight and shadow contrasts. It is very masculine, expressing hardness and decision, with no taste for compromise.

The background here must be black, and the illumination is given by a hard side light, perhaps directed slightly downwards. If the resulting shadows are too dark, a second light can be used with an umbrella reflector. The main condition is that only the most important features of the subject should be lit, while everything else sinks into mystery and darkness.

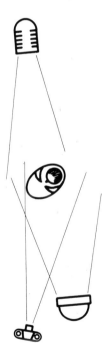

Lighting arrangement for low-key shots. *See* p. 84 for an example.

## USING PHOTOPRISMS

Multiple prisms can be used to give a special effect by producing a simultaneous multiple image of the same subject on the film; they are available as three-, five-, or six-fold prisms, the last of these consisting of a central facet surrounded by five others. The three-fold prism has no central facet, and it consists of three faces either arranged in radial or parallel fashion. They are all mounted so that they can be turned round and the variations in the image checked on the viewing screen.

These trick lenses, for that is all they are, are most often used for portrait work, but they are also quite suitable for plants and architecture. The background should comprise several colours, and tend to be dark rather than light. Depending on the angle of the prism and the distance you stand away from the subject, you will be able to alter the effect of the prism. The images can be made to overlap, or they can stand by themselves, each delegated a part of the picture. The reflex unit allows the effect to be monitored precisely. An increase in exposure is not necessary. For further experiments, try combining a photoprism with a colour filter made up of different coloured segments.

199

## PICTURES TAKEN THROUGH WINDOW-PANES

An alienation effect is achieved here because of the structure of the glass interfering with the rays passing through it: it acts as a series of small lenses and distorts the contours of the subject. Depending on the degree of flatness of the glass, a large number of different pictures can be taken of one subject. The nearer the camera is moved to the window, the less effect the irregularities will have.

For such a picture to be successful, the expanses of each colour must be quite large; a colourful hat or bright lipstick will improve a portrait. You should strive for simplicity in composition to give a good result.

Colour photographs should be taken with front lighting, but black-and-white will be more successful if the picture is shot into the light, thus giving a silhouette effect against the sheet of glass.

## 'SHADOW' PHOTOGRAPHS

The same principle is used here as for the 'keyhole' vignette effect. Instead of a keyhole, however, half the lens is covered with a strip of paper, which is shifted to the other side once the photograph has been taken. It follows that the subject must also change his position. In this way, you can take a picture of yourself playing both colours at chess, or carrying on a conversation with yourself. The only proviso is that the camera must be able to take double exposures.

If this is not the case, the 'open flash' method must be used: the room must have no trace of light, and the subject can wander around while the photographer lets off a series of flashes.

## MIRROR PHOTOGRAPHS

This is a way of producing a multiple picture of one person, but has nothing in common with the above method. To set the distance you must remember that the measurement in question is camera–mirror–subject, not just camera–mirror. This is why many pictures of mirrors have to leave the frame out of focus: this very fact can often make the photograph particularly attractive – especially if the frame is made of wrought iron.

The mirrors will give endless fun; if the model is placed between them, there will appear an infinite series of images. To take the shot the camera is placed directly on the edge of one of the mirrors. If the mirrors are put together at an angle of 90°, you can take a photograph of the rear of the subject whilst its front and side will appear in the mirrors. The sharper the angle the greater the multiplicity of images created.

Mirrors do not have to be flat. The sort seen in fairgrounds can be used to produce the most grotesque distortions of people. This technique is used especially when photographing texts that are subsequently to be copied into a picture. Ideal

mirrors are made with the glazing sheets from print dryers, or with sheets of metallized plastic, which are available in different colours.

## PEOPLE AT WORK

Such photographs call for a good power of observation so that the right moment may be captured. If you do not understand the work being done, you should consult someone who does before taking the shot. In this way you will never make the mistake of having someone hold a tool in a particular way just because you think it looks more photogenic like that. An expert will immediately see that the shot has been posed. You will take pictures like this best at your own place of work, because you will know both the people and the work involved.

## GLAMOUR AND NUDE PHOTOGRAPHY

These both have something in common: they both attempt to portray the beauty of the female body. The main difference lies in whether or not the model is wearing clothes. The subject should appear sensuous without stooping to pornography. The dividing line is narrow and easily overstepped, which is why so very few good examples are seen in magazines.

Glamour photography requires that the clothing should in no way conceal the model's attractiveness, for example, a low-cut bikini, a soft underskirt, a close-fitting pullover, or a buttoned-up blouse. Clearly the model must be very pretty, and able to look relaxed. The byword for such photographs is 'joie de vivre' – the model can look pert, give a roguish smile, or risk a cheeky look in her eye. Make-up must be flawless, with none at all on the face for decorative purposes. Wind-blown long hair can have a magnificent effect. The body must be in top form: any looseness about it will spoil the effect. The curves of the body must be well proportioned. The photographer can improve on nature before the shot by the pose, and afterwards by retouching. If the hips are too broad, they can be made to look slimmer if photographed in profile, the model turning her torso to face the camera. The breasts should be photographed in profile, with the camera pointing upwards slightly. Careful lighting and use of shadow can create a certain magic and conjure up more than there actually is. The shoulder blades should not be held back too much or the breasts will appear broad and flat: it is better if the shoulders are hunched slightly and the body bent towards the camera. The stomach should be held in, but not to such an extent that a cavity is made under the ribs.

By taking the legs in quarter-profile, they will appear slimmer, and any tendency towards knock-knees or bow-leggedness will not be visible. The legs should not be held stiff, but very slightly bent at the knee; holding the camera low will make them appear slimmer: they can also be made more attractive if the model stands on tip toe, but take care that the feet do not point directly at the camera.

The weight of the body should be put on the side away from the camera, and the body curves should not be over-emphasized. Arms should never be held alongside the body, but should always be slightly bent: they can be held at a sharp angle but never so as to form a right-angle. In this way the elbow on the far side of the body can be used to create a feeling of space. Take care with nude photography that there are no unsightly bikini marks. Make-up and powder can be used to get over this. A tanned skin is more effective in a colour shot than white. Darkroom work can be used in black-and-white photography to leave only the curves and the softest lines in the picture. Someone came very near the truth when he said that this is the photography of the female landscape.

Nude and glamour photography can also be taken outdoors, but the scenery must be as simple as possible to avoid distraction from the main subject. The model must be more relaxed than ever, and her pose natural and easy, not stiff and cramped.

Cheekiness, brightness and humour: essential features of a good glamour shot. Obviously great importance is attached to the sexuality radiated by the model.

## BACKGROUND PROJECTION

Used in the form of rear projection or ordinary projection, this offers many possibilities. Ordinary projection involves a slide being projected onto a screen and the model standing in front of the image but outside the projector beam, to avoid a shadow falling across the picture. Since this gives but little scope for variation, it is used less often than rear projection. In this latter method the slide is projected on to a transparent surface, so that the image and the subject can be photographed simultaneously on the other side. A suitable screen is transparent paper stretched on a wooden frame. Better still, although dearer, are the screens that let the picture shine through clearly whilst absorbing light from the other side.

As a rule the picture will be distorted by the image of the projector filament in the centre. This can generally be overcome by shifting the camera to one side or the other so that it does not show too much. The surest way to anull its effects is by placing the subject in front of it.

The best slides to use for a background are those that were taken with side lighting: of course they must be very sharp, and not too strong in contrasts – tending rather towards medium tones if the shot is to appear natural. The shadow of the main subject should be aligned with those on the slide.

Lighting depends very much on the brightness of the background image, and a direct reading should be taken from the position of the camera. Shadows and brightness must be the same for the subject as on the slide, and as little extraneous light as pos-

sible should fall onto the screen. The space between model and screen should be fairly large, and darkened: this can be done by shielding the screen from the lamps with cardboard. Problems arise when a person has to appear full-figure against a scene.

This will involve a full scenic decor that fits in with the picture and runs into it. The model can be shown by a fence, seated on a tree-trunk, or on a large rock to increase the effect.

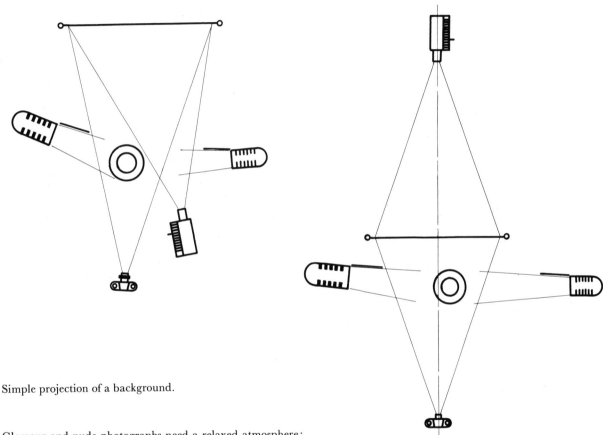

Simple projection of a background.

Glamour and nude photographs need a relaxed atmosphere: both photographer and model should enjoy their respective rôles. In this way the pose will not seem stiff and awkward. The effect of this shot relies on the border of light round the body, given by rear lighting.

Rear projection of a background.

205

## SUPERIMPOSITION

This involves the projection of a slide on to a single colour object, the slide normally being of a picture, ornament, or piece of writing. It is a technique used most of all in publicity and in book covers, although the amateur will find it useful for the title slide of an illustrated talk.

By superimposing a map on the back of a 'mermaid', for example, a certain attraction is lent to the place concerned, which the map alone could not give. If you use three-dimensional objects as a screen you will find that interesting contour effects and overlaps can be created.

The lighting must be so arranged that the shadow cast by the projector beam is reduced in strength, but at the same time it must not be so strong as to weaken the projected image itself.

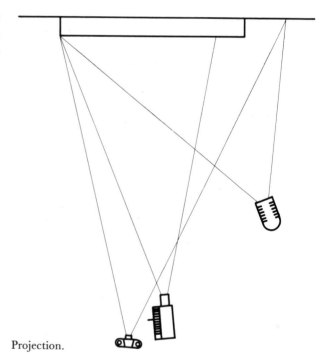

Projection.

# PHOTOGRAPHING MOVEMENT

Motion very often goes beyond merely being a subsidiary attribute of a subject, to the point of being the main reason for taking the picture in the first place; obviously special emphasis must be devoted to conveying it well. The method you choose will depend on your creative intent and on the subject; much of the essence of this has already been mentioned in the chapter on exposure.

## BLUR

This effect is primarily used when the subject in motion does not look much different from when it is standing still, as is the case with trains and cars. If you take a photograph of a moving car, for instance, but using a very short exposure time so that the motion is frozen, you might just as well have taken the picture before the car left the kerb.

If you use blur in such a way that the surroundings and the street remain clear and sharp, but the car loses detail, the form of presentation simply becomes a symbol of speed itself: you need only be careful not to make the car totally unrecognizable, which would happen if the exposure time were too short. You must adjust the shutter speed to each subject, which means practising in the early stages with shots taken at a variety of shutter speeds. In this way you will learn to represent the concept of speed; if you choose to pan the camera, the car is the main interest, rather than its speed.

## MOMENTARY EVENTS

Changing the composition of a photograph will do much to alter its message; another way of indicating speed is achieved by photographing a car or a motor-bike leaning to one side as it takes a bend. The effect can be emphasized by tilting the camera slightly in the same direction; if you place the subject in the middle of the picture you will introduce

Waterskier taken into the light: the figure is silhouetted, while the drops of water sparkle in the sun.

even more tension is created, because the high-point of the action has not been reached; if it is coming out of the middle it looks as if the race is already run.

A perfectly sharp picture of certain subjects may be the best way to bring them alive, without there being any feeling of 'frozen' movement. This is particularly the case where the motion is not indicated merely in terms of time, as with a car or bike on a bend; it is especially true of planes and boats. If something is in mid air, it follows that it must be moving, just as a motor-boat is shown to be moving by the spray thrown up behind it and by the churning wake; the same is true of water-skiers. All you need to show that a sailing boat is moving is a little wind in the sails or in the spinnaker. If you still decide to blur the image you will not be emphasizing the movement, but the speed.

When taking pictures of animals or people in movement, especially of sportsmen, the essential feature is the stance, which means that the action should be caught at its high point, or at the instant that characterizes it.

This is most important when taking pictures of pedestrians, so that the legs appear natural. The characteristic stage of the movement is the moment when the front foot is just coming to rest on the ground again. A second before and the subject will look as though he is on parade; anything else will

the peaceful, well-balanced atmosphere inherent in this style of composition: the last thing you want at a race meeting! You will thereby lose most of the sense of drama offered by the shot. If you visually weight the photograph down on one side by placing the main subject there, you will increase the tension. Another way of doing this is to use a telephoto lens; if the direction of motion is into the picture

Colour Plate 17: Church interiors – this one is in Mosta – are normally taken using a tripod. To maintain the natural atmosphere, it is best to use daylight.

produce even less pleasant results: the person doing the walking will look as though he has lost his balance and is about to fall rather than walk!

The position of an animal's legs must be taken with care, particularly if it is moving diagonally across the angle of view. If the shot is taken at the wrong time it will look as though its front legs are doing the splits.

If you blur a photograph of pedestrians you will, unlike a photograph capturing the movement sharply, express the bustle of everyday life. The high point of a sporting action is reached when, for instance, a pole-vaulter is just leaving the pole, or when a rider is hanging over a fence as if balanced above it. An unusual angle will make the picture seem more dramatic: don't take the rider side on from the grandstand, but crouch down so that horse and rider seem to be coming straight for you. The pole-vaulter is best taken from the bottom of the pole so that he does not take up the whole frame, but, instead, looks as if he is just about to go through the top of the photograph: this will also give a better sense of the height involved.

## PANNING THE CAMERA

Those sports where speed comes first again call for blur; if the camera is panned the main subject should appear as sharp as possible; this is quite easy when a vehicle is involved: not so with sportsmen, for several movements frequently overlap. The torso may well be dashing forward in a straight line, but the arms and legs are describing circles, or making rather rapid movements backwards and forwards. In such cases you must try to find a shutter speed that will freeze them to give the degree of sharpness necessary for recognition – but no more; you will also have to follow the rhythm of the movement with the camera. This means a variety of things: you will have to follow a hurdler taking into account the arc of his jump. A child chasing a ball as it bounces away can be given a playful dance-like appearance if a sickle-like camera movement is made. If you photograph a circle dance from above, the lens itself is the point about which the camera must be turned.

There is another point to consider with colour film. There is not merely a contrast between sharp and blurred: a moving subject will have its constituent colours overlapping, an effect that can be particularly attractive.

Colour Plate 18: A feeling of depth is given to this picture of a ferry by the use of the lifting rig as a frame and by the colour composition: warm colours in the foreground, a passive blue behind.

## ZOOMING

A variable or zoom lens give a special sort of blur: if the focal length is changed as the exposure is being made, a series of lines will seem to lead from a central point to the edge of the picture. It is better if the adjustment is not made throughout the exposure, but only towards the end. This will give a sharp picture in the centre, with the zoom lines on both sides of it. This effect can be used in photographs of non-moving objects, architecture, portraits, and plants, but it really comes to the fore when used in conjunction with movement. The shot should be taken face on, with the subject in the centre of the picture. The zoom effect will convey the impression of motion.

Right: Shots using a zoom lens.
Above: With a smooth zoom action.
Below: The focal distance is altered step by step in conjunction with a multiple exposure of the negative.

Left: Even a flash only burning for a fraction of a second was not enough to produce a sharp picture throughout; it is this very fact that gives life to the photograph.

## PHOTOGRAPHS FROM A MOVING CAR

A special kind of blur is given if you take a photograph from a moving car with a relatively slow shutter speed. Vehicles moving at the same speed in the same direction will be sharp, while everything else seems to fly past. It is even more interesting if you can include a car coming from the opposite direction. Another alternative is to take the shot not through the front windscreen, but through the back, to include the following traffic. In this case it is best to use a normal or a wide-angle lens, and if possible not to try it in open countryside. The occasional tree, but best of all houses or spinneys, will produce more interesting results. Avoid including too much sky in the shot, or wait until evening when the street lighting can be used to good advantage. The same technique can be used at the fairground in photographs of merry-go-rounds or switchbacks.

## ULTRA-FAST MOVEMENT

Movements that are so fast that they can no longer be followed by the naked eye must be captured with full definition; true, it would be more natural to reproduce the blur actually seen by the eye, but the best and most interesting use of such photographs lies in the fact that they freeze an action not normally seen clearly by the eye.

Even the shortest exposure settings on most cameras do not usually suffice for such shots, which include birds in flight, water drops falling, or some scientific work: electronic flash must be used.

## SEQUENCES

If you want to photograph a movement as it unfolds, you can use one of several techniques. You can attach a small bulb to the moving parts, so that light traces are left on the film – this can only be done in the dark – while a flash is let off to illuminate the subject itself; alternatively this can be left until last, once the subject has come to a stop.

You can also take multiple exposures using several flashes with the shutter left open (*see* 'Special Flash Effects'). Because of the technical skill needed amateurs will rarely get the chance to use strobe lights; but a motor-driven camera can be used to split up movements in much the same way as strobe. If you print these shots one on top of the other, or make a 'sandwich print' (*see* 'Ice and Snow'), you will achieve a result normally only possible with multiple exposures of one negative.

## SPORT

First-class sport is normally the territory of the professional photographers, since they alone can gain easy access to large sports grounds. Amateurs can at best hope for a good place in the grandstand, and even with the longest focal distances one cannot

expect enthralling sport shots. The daily press normally only print photographs of a win, or of decisive moments in a game. Such pictures are often unspectacular from a photographic point of view, but many excellent pictures taken by members of the public are turned down because they are of the 'also rans'. This is not only a symptom of how short-lived sporting achievements and records are, but also of how little it matters whether one was there to witness it personally. The world at large is only interested in the winner, and then only if he is world class: it is of course preferable if the standard was so near even that only a hundredth or a thousandth of a second separated first and second place.

Such details are not important for a truly good sports photograph; one is not solely interested in the sporting élite, and this is where the amateur can take part. He can go along to the smaller clubs, which do not interest the public and where he will be a welcome visitor. The athletes will be pleased to have souvenir photographs, or studies that will help them to improve their form and adjust their practice and training. A golfer will often be willing to chip the ball to give a splendid cloud of dust merely for the photograph. This is how the amateur will get exciting shots, because the main interest is in the sport, not in the person. You do not even need to know the rules of the game. A natural instinct for good photographic situations can be developed for sport photographs, and indeed has to be, because the right moment for the shot will arrive and there is no time for preparation; if you hesitate you will lose your chance.

You will need a miniature camera with a variety of interchangeable lenses, especially those with

Kayak slalom.

long focal lengths. A 6 × 6 camera will also suit the purpose, as long as it is similarly capable of fast action. It is best if you can have two, or even three cameras with lenses of different focal lengths attached, since there is rarely sufficient time to change the lens. All you have to do is pick up the right camera, which of course you have to know intimately, including such points as which direction you have to turn the focusing ring for greater and lesser distances.

The sporting scene is in a continuous state of flux: high points come and go, each one creating new tension. It would be fatal to miss such a moment just because you are trying to save on materials. If you are to produce good sport photographs you must be prepared to pay out – sometimes a great deal – for a large quantity of film. Often you will find that only one of your 36 exposures is usable, but sometimes there will be three or more, one of which may be your best ever!

To resume: movements can be taken in two ways. They can be blurred or frozen, with 100 per cent sharpness. The latter method is the more often used; it requires fast to very fast film in the camera, so that very short exposure times are possible in conjunction with small apertures, to give a good depth of field.

A good sports photograph captures the spirit of competition and the personal application involved; it shows concentration, strength, and timing, and the joy and satisfaction after a victory. But that is only one side: there is also the exhaustion, the disappointment, and the sadness of defeat. That is sport photography as well.

Only rear lighting will give the full effect of snow spray.

# NATURE PHOTOGRAPHS

When someone speaks of nature photography they normally mean pictures of plants and animals and no more, which excludes most of what should be considered as a part of this category. Just think of the marvellous aspects of nature, of sunrises and sunsets, of the force unleashed by a bolt of lightning, the wind whistling through a tunnel, or the sad charm of a rainbow. Then there are the four seasons with their various qualities. The forces of nature do not have to be photographed directly, but can be implied by what they leave behind. Tell-tale signs of a storm are trees that have been uprooted and snapped like matchsticks, whereas a burst dyke is an indication of an exceptionally high spring tide. Better than any other photograph attempting to convey the effects of an earthquake or a volcanic eruption will be those showing the smoking ruins and the horror in peoples' faces. Man is shown as entirely subject to the forces of nature despite his technological advances.

Even landscape photography is nature photography, despite the fact that our landscapes are stamped with the die of man's culture. There are still some places, though, that seem untouched: brooks that have not yet been levelled out, and murmur as they meander through a valley; silent and extensive woods; the sandflats by the coast, and the peaks and steep ridges of the mountains. Tourism is so highly developed now that we can even visit the age-old landscapes of the past: the eternal world of ice with massive glaciers and drifting icebergs; the deserts, steppes, pampas, and savannas, and even the jungle.

A narcissus held against the sky and taken through a six-fold prism. The images are pale because the background is so light. If the shot had been taken against the dark night-sky, using flash, all the narcissi would have been as bright as the original.

## ROCKS

Rocks and stones have extraordinarily interesting stories to tell, about their creation and decay, and about a cycle not unlike that of water, but which lasts much, much longer. It is the story of how mountains turn to gravel and sand, or are even ground down to dust. There are mountains that started in life as living coral reefs, and there are fossil prints of plants and animals which died long ago. If ultra-violet instead of ordinary light is used, organic remains can be traced by their fluorescence. Some stones have to be wet before they reveal their colouring and pattern in all its beauty. Others, like marble, petrified trees, and agate, have to be ground and polished to show the same effect. The charms of crystals are discovered when rays from rear-lighting are shone through them: flash will do little for them. Normal photographic lamps can be used, but if the stones are very small you will need microscope lamps, magnifying glasses, and shaving mirrors.

## PLANTS

These are an easy subject so long as they take the form of trees and bushes or views across parks and well-tended gardens. The minute you start trying to fit a flower exactly on to the negative, you have problems, for you are entering the sphere of macro-photography with all its difficulties. Some flowers look better in bunches than alone: they should be put in a suitable vase, one that harmonizes with the background; on no account should the edge of a table cut across the picture. Glass vases should be emptied and dried thoroughly to avoid refraction problems with the water.

Photofloods give out a great deal of heat and are therefore not normally suitable. If you want to take a series of shots around a bud bursting into blossom the heat radiated can be used, together with a strong salt solution in the water, to speed up the process. Take care that all the photographs are taken from the same point. Use a tripod and calculate the area and position of the full blossom so that you do not have to move the tripod later on if the flower expands out of the picture. Outside, even the slightest gust of air will spoil a picture. Not only might the camera be moved, but the flower will be blown out of the limits of the depth of field. This means that you must wait a moment until all movement has died down. Using the snapshot technique will simplify matters. A single-lens-reflex camera can be set up for the shot and held to the eye. You should then lean forward very slowly and release the shutter when the flower comes into focus. A piece of cardboard can be used as a windshield if necessary; sometimes not placed to one side but curved round the back of the plant. If this casts a shadow, a sky-light filter must be used to prevent a blue haze being imparted to the photograph; alternatively you can use flash, or even reflect sunlight on to the subject by means of a mirror. The important thing is clarity; by virtue of the format used, most unnecessary parts of the plant are kept out of the picture, and you yourself should go further and

clear away all withered leaves, blades of grass, and dead twigs that obstruct the view. The best effect of all is achieved by completely isolating the flower from its surroundings; this can only be done, however, by holding the camera very low.

A disorganized background can be disposed of by interposing a piece of card; if this is painted blue it will look as if the photograph were taken against the sky.

Obviously you should only photograph fresh flowers. Use rear lighting if you are taken by the fine hairs on a plant's leaves: each hair will be distinct against the light, giving the photograph an irresistible charm. Much atmosphere can be created by letting the light shine through a flower's petals from behind. A photograph of a flower will often be improved if you only include part of it rather than the whole thing. This poses no problems whatsoever with single flowers, such as the poppy; more complex flowers will need to have a few petals removed first.

## CLOSE-UPS AND MACROPHOTOGRAPHS

These rely for much of their effect on the fact that they show details not seen by the naked eye. To get an idea of the actual size, you must know the scale of reproduction: if an object 10 in. high appears 1 in. high on the negative, the scale is 1:10; if both heights are similar, the ratio is 1:1. This ratio also defines the sort of photograph: from 1:10 to a maximum of 1:1, they are called close-ups – this means that the majority are reductions reaching at best 'actual size' reproductions; up to 50:1 photographs are known as macrophotographs, and from then on as microphotographs.

Unlike close-ups, macrophotographs can present considerable problems: the depth of field is squeezed into a very small space, perhaps only millimetres wide, or even less. You cannot, therefore, expect sharp definition throughout a shot, and must confine your interest to one part, and accept that everything else will have to be out of focus. The scale of reproduction should not be chosen to be as small as possible, but to suit the subject. This is especially true of black-and-white shots. A selective enlargement will often turn out better than a print taken with too large a scale of reproduction.

A miniature camera is best for taking close-up slides. For this will give you a full-format picture on a smaller scale than is possible with medium- or large-format cameras. Along with a series of other advantages, this brings with it a potentially greater depth of field. It is not possible to enlarge it by using a lens with a shorter focal length, nor will there be any difference between a picture taken with a wide-angle lens and one taken with a telephoto lens if the reproduction scale is the same. The only difference will be in perspective, the image being more tangible and solid the shorter the focal length; for example, a wide-angle lens will give the best photographs of rockeries, whereas a telephoto will be chosen when you have to stand as far away as possible from the subject, as, for instance, in the case of a butterfly. If you tried to get right on top of such creatures with a normal lens they would have flown away before you got anywhere near taking the shot.

Another criterion that must be emphasized under this heading is the avoidance of blur caused by the subject moving. The greater the magnification being used, the worse any camera shake or movement on the part of the subject will appear. This makes the use of a tripod almost indispensable for macrophotography. If at all possible set the camera up ready, and then move the subject in till it is in focus. There are easy ways of doing this: flower stems can be set in plasticine and placed wherever you want them; recently a wire with a crocodile clip soldered to it has been produced, primarily for wireless technicians' use, but also handy for this purpose. Subjects that hang vertically downwards can be attached to a hemisphere, which is placed in a ring so that its position can be adjusted. Not so good is a ball-and-socket joint, which will swing the subject right out of the field of view if only slightly moved. For pond life you will need a small tank.

Supplementary lenses increase the possibilities of close-ups: for pictures of toadstools the camera must be held as low as possible.

## SUPPLEMENTARY LENSES

For close-ups these lenses fixed in front of the camera lens are quite sufficient: they decrease the focal length of the lens, their own power being measured in dioptres.

Supplementary lenses are cheap, and they do not need an increased exposure time, as they use the setting given by the meter. The longer the focal length of the lens, the more they increase the magnification factor. It is also possible to combine more than one supplementary lens, in which case the stronger is put on to the camera first, and the aperture opened to at least f8 to maintain a good depth of field.

Each lens is supplied with a table for calculating the distance given at each camera setting, as well as the magnification scale. This distance is then measured from the centre of the supplementary lens when used with rangefinder cameras, taking care to allow for parallax, which increases as you approach the subject. If the viewfinder is above the lens, parallax can be equalized by raising the camera higher and pointing it downwards; you must then leave a considerable space above the subject in the viewfinder, and imagine what lies below. An analogous situation arises if the camera is being held vertically, except that this time the parallax is equalized from the side. With practice you will soon get the hang of what to do.

A viewing frame is easily made out of wire and will be useful in that it shows the distance and the field covered; you simply approach the subject until it fills the frame and then release the shutter.

Clearly the easiest way of all is to use a single-lens-reflex camera: then you have no parallax or reproduction-scale problems; even setting the distance is easier, because you can follow the focus in the viewfinder. This means that the total power of the supplementary lens (or combination thereof) can be increased – up to a maximum of 5 dioptres – over that possible with a rangefinder: even this, however, will not give a scale of more than 1:1.

## EXTENSION RINGS OR BELLOWS?

These are used for macro work as well as for close-ups. They can only be fitted to single-lens-reflex cameras, or others that have been adapted with a reflecting chamber. They are put between the camera and the lens so as to increase the extension of the lens, which means that you can get nearer to the subject. A side effect of this is that the aperture has to be altered, and the exposure time correspondingly adjusted. The longer the focusing extension of the lens, the longer the exposure required. The adjustments are either engraved on the bellows' scale, or can be read off the table supplied with it.

If you are not using a macro lens, your pictures will be sharper if you reverse the lens so that the face normally pointing at the subject is now pointing at the film. The reason behind this is that lenses are made for normal purposes, which involves the width of the picture being less than that of the object; if the reproduction scale is greater than 1:1 this is no longer true. By turning the lens round the

correct relationship is restored and the sharpness is improved. To do this you will need a reversing ring to put between the lens and the extension rings (or bellows). The exposure time is now increased according to the magnification factor of the lens. If this information is not provided with the lens instructions, the manufacturer will supply it if you write to him.

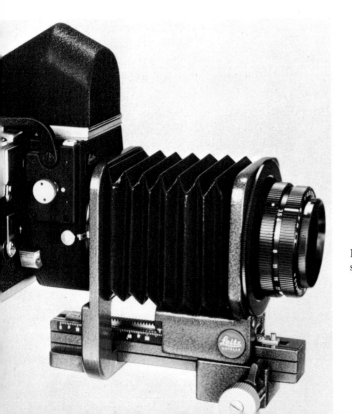

Rangefinder camera with reflex chamber and bellows extension.

# CLOSE-UP FORMULAE

A) With supplementary lenses:
1) Strength of lens

$$D = \frac{100}{f}$$

2) Total strength of lens
   with supplementary lens attached

$$D_n = D_1 + D_2 + \ldots$$

3) Total focal length of
   this combination

$$f_n - \frac{100}{D_n} \text{ (mm.)}$$

B) With bellows or ring extension:
1) Reproduction scale

$$v = \frac{B}{G}; \ v = \frac{b}{g}; \ v = \frac{f}{g-f}$$

2) Width of image

$$b = (v + 1)f \text{ (mm.)}$$

3) Width of object

$$g = \frac{b}{v}; \ g = \left(\frac{1}{v} + 1\right) f \text{ [mm.]}$$

4) Increase factor for
   exposure time
   a) with lens in normal position

$$y = \frac{b^2}{f^2}$$

   b) with lens reversed

$$y = \left(\frac{1}{p} + v\right)^2$$

5) Depth of field

$$+ = 2z \times \left(\frac{v + 1}{v^2}\right)$$

Key:
B – size of image in mm.; b – width of image in mm.; D – dioptres; $D_1$ – strength of first supplementary lens in dioptres; $D_2$ – dioptre strength of second supplementary lens; D – total dioptre strength of lens combination; f – focal length of camera lens in mm.; $f_n$ – total focal length of lens combination in mm.; G – size of subject in mm.; g – width of subject in mm.; p – magnification factor of lens; t – depth of field in mm.; v – reproduction scale; x – aperture; y – factor of exposure time increase; z – diameter of discs of confusion in mm.

## LIGHTING

This is not always easy, especially for extreme close-up and magnification work; there are various means of increasing the concentration of a household lamp: it can be shone through a magnifying glass or a spherical glass vessel filled with water, or have its light reflected on to the subject with a shaving mirror. The beam of a projector can also be used if shone through a cone of aluminium foil; if used in conjunction with a magnifying glass, the intensity will be so strong that you will need to soften the shadows by using small reflector screens.

These methods can only be used if you are sure that the build-up of heat involved will not affect the subject adversely: stamps are liable to wrinkle, leafbuds will start to sprout, and flowers will blossom; plants will even wilt if in full blossom already. Small living creatures cannot be subjected to such treatment.

Electronic flash will overcome these difficulties, but will pose others of its own. Because of the short distance involved it is liable to cast a shadow of the camera or the lens over the subject; if you use it from the side to try to overcome this, the illumination will be so strong that some parts of the picture will be lost in the shadow of the rest. The only alternative is a ring flash, which fits round the lens in a circle: this will light the subject without causing excessive shadow.

With a non-living subject you can use a light tent to get rid of unwanted shadow: an opaque piece of card large enough to fill the whole picture is placed on a sheet of glass, and the object placed

on top of it. A 'tent' made out of white paper with a base diameter about 1 in. larger than the piece of cardboard is then put over the subject and the camera placed so that it looks through a whole cut

Using a light tent for close-up work.

in the top of the paper cone. Illumination is effected by a lamp positioned under the piece of cardboard. An even better 'tent' for very small subjects can be made from the pointed end of an eggshell: the

224

parabolic shape ensures a more even light dispersion.

There are two other interesting possibilities offered, in the shape of light- and dark-field lighting. In the former instance a piece of opal glass is lit from below; a subject on top of the glass will appear in silhouette against a bright background.

Arrangement for dark-field illumination.

Arrangement for light-field illumination.

*Opal glass*

*Diffusion screen*

Very delicate subjects stand out particularly well with this method, which is also the best to use for such things as insect wings or objects embedded in amber.

If at the same time you include top lighting as well, definition will be given to those parts otherwise appearing as black silhouettes, and the physical dimensions of the object will be conveyed. If

225

the light below the glass screen is brighter than the one above, shadows will be avoided, and the object will appear to be floating in mid air.

For dark-field illumination you need a matt-black base: a transparent glass sheet is placed about 6–8 in. above it with the subject on it. The lamps are arranged underneath, outside the field of view, and shaded so that their light only falls on the subject. This gives a mysterious appearance to hairs and other delicate objects, which stand out bright against the dark background.

## PETS

Anybody who keeps animals will naturally want to photograph them: a camera fitted with a lens of

fairly long focal length is advisable to keep proportions correct, especially in the case of portraits. The same rules apply for portraits of pets as for portraits of people. As far as possible try not to photograph animals from above, but from their eye-level. Dogs look their best when they have just been trimmed, with their coat well brushed and shiny. A black coat absorbs an awful lot of light, which means you should use your meter carefully; additional flash lighting is suggested.

It is much more difficult to get cats to do what you want them to do than is the case with dogs, but once you get to know them it becomes easier. It is best to catch them while eating or using their scratching post.

An aviary could not be less suited to bird photography; what is really needed is a special photography cage. The rear and front walls of such a cage are made of glass, the other two of mosquito net. The glass sides are placed at an angle, so that if the bird flies into them it will slide down without getting hurt. A few twigs or roots should be put inside for perches. If you put the cage out in the open you can use a 'natural' background. Remember that birds with untidy ruffled feathers are not very photogenic, so it is best to wait until just after the moult before taking pictures of them.

Animal portraits are taken according to the same rules as those applying to portraits of humans.

## AQUARIA

It is much more difficult for anyone who wants to photograph his fish in the aquarium. The most important thing is crystal-clear water, although if a chemical has been added to turn it amber or turquoise this will not affect black-and-white film, and any colour tinge can be eliminated on colour film by using a filter of the opposite colour. The glass sides of the tank must not have any scratches and must be polished to a shine inside and out. Even very small quantities of algae will veil pictures. The camera should be held parallel to the side of the tank and not at an angle, or else you are liable to pick up patterns and coloured borders because of refraction. If reflections are to be avoided, the room in which the aquarium stands should be in darkness. The camera should be covered with a piece of black cardboard, so that only the lens pokes out, and you yourself should not wear a white shirt, but rather a dark pullover; if you are going to be very particular you could even wear dark gloves.

The most natural lighting is achieved by using strong flash over the top of the aquarium. At the same time a smaller flash is set off from one side, whilst opposite this there is a reflecting screen made of grained aluminium foil. If this arrangement is not possible then the flash will have to be set off from the same side as the camera. It is important to remember that the angle of incidence equals the angle of reflection. This means that the flash must be set off far enough to one side to ensure that the beam will not be reflected into the lens.

Because of their small size, most creatures living in aquaria are photographed in close-up, occasionally even by macrophotography. This means that the best camera to use is a single-lens reflex. A longer focal length than normal is advisable if you are to maintain a reasonable distance between yourself and the fish. It is better to photograph the fish in a small photographic tank than to use the collective tank. The former is made of specially polished optical glass, glued together without a frame. Its special feature is a further sheet of glass, which fits inside exactly and runs parallel to the front and rear walls. It can be moved so that it is possible to limit the area within which the fish can swim; this of course helps control the depth of field. Before taking the photograph you should wait until the fish have accustomed themselves to their new surroundings. A good background can be built up by putting water-weed and other plants behind the partition sheet of glass, especially if the whole is backed by a piece of black or blue cardboard.

## PHOTOGRAPHS IN THE ZOO

Zoos attract countless amateur photographers, but despite the many animals that are there, it is not sufficient just to release the shutter. It is a matter of trying to capture the animals in a typical position or stance. They do not hold their facial expressions or display their mannerisms for very long at once. The better your knowledge of the subject, the more sure you are of good results. The right moment to release the shutter can often be seen by studying

movements of intention; such movements are often made by animals to indicate what they are going to do next. Birds, for example, bend their knees before flying off, and horses lay their ears back before they bite.

If you want to try to attract the animals nearer to you in order to photograph them, you may experience a great deal of difficulty. The only way you will do it is by great patience. It is, of course, possible to get round this difficulty by using a telephoto lens.

It is reasonably easy to get over the difficulty of obstructions such as fences, and unattractive backgrounds; chicken-wire disappears as if by magic when you go up close to it; you can get rid of an unsuitable background by pointing the camera towards the ground slightly: alternatively if you open the aperture enough there will be no definition that far away. If the animal you are taking is lit by a sunbeam the background will be very dark. Small mammals, shy nocturnal animals, and birds can be put in a glass cage; they should be fitted out to resemble the animal's natural habitat as closely as possible. This also avoids difficulties with the background. Put the camera right against the glass to avoid reflections. If you hold the camera at an angle, you should use a polarizing filter; the same rules apply for flash as for aquarium photographs.

## ANIMAL PHOTOGRAPHY IN THE OPEN

Not only amateurs go to the zoo to take photographs, but also experienced naturalists; however, the best documentary shots are to be had in the wild. The easiest to take are those of snails, caterpillars, and insects. Slow-moving animals and those that will not fly away can be treated like flowers for photographic purposes: the camera is set up ready, preferably with a ring flash; then lean forward slowly until the subject is in focus and release the shutter. More timid insects call for a lens with a longer focal length. Be careful not to frighten the insect off with your shadow. It is possible to attract them by placing a little sugar water or a drop of honey in a flower (making sure it is hidden from the camera). With a bit of luck you will even be able to catch the insect in flight. Butterflies are attracted by apple juice: the most photogenic moment to aim for is when they lay their wings flat. Unfortunately it is only possible to take macrophotographs of these wings from a dead specimen: you will, however, see the most magnificent pattern of tiny scales.

Photographs of butterflies easing out of their cocoons, or dragonflies shedding their larval skin, are very impressive, and one reason for this is that one rarely sees the process as it happens in nature. A photographer who wishes to try to capture these moments can set the shot up at home. Once you have collected the cocoons and the larvae and taken them home, it is simply a matter of patience and attention.

Again, with birds it is best to start experimenting

at home. Set up a feeding table outside the window and put a twig on it for a perch. Next set up camera and flash on the tripod. Soon the birds will get so used to it that they will lose their shyness. Arrange the shot so that only the twig appears in the picture, excluding the table.

For sheer sentimental charm there is little that will beat a bird's nest, although there are considerable problems involved since the young are endangered when the shot is taken. The available light is rarely sufficient, which means that flash must be used. To increase its effective distance, the flash bulb can be built into a parabolic reflector such as that used in car headlamps. The flash index will be altered by this, and will have to be found by test shots, using a series of aperture settings over the same distance. The index is given by multiplying the distance by the aperture giving the best results.

For serious ornithological photography a canvas hide is absolutely essential. It is constructed in such a way that its position can be changed without dismantling. The normal procedure is to set it up quite far away from where you want it, and to move it up gradually over a period of hours or even days. Brooding birds at the nest will then slowly get accustomed to its presence. Bird photography is relatively easy near lakes, especially at the time of migration. Birds in town parks are used to human presence, which dispenses with the need for overlong lenses.

Birds in flight belong to the advanced school of photography. They can be taken as they land on the bird table or when they return to the nest. A light box will be of great value; alternatively good photographs of flight can be taken with a photo-

Rear lighting is the only way to give a good sparkle to dewdrops on a spider's web.

graphic cage; electronic flash is usually called for as daylight is rarely sufficient.

Interesting subjects are also provided by snakes, lizards, toads, frogs, and salamanders. Again, you should wait for something to happen, such as a snake or a lizard flicking its tongue out: frogs are at their best when in the full resonance of a croak, when sticking out their tongues to catch insects, or

229

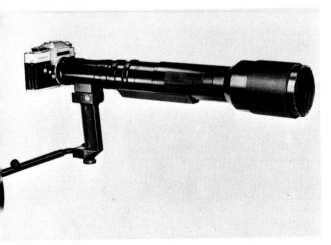

trap. This consists of a small board with an electronic contact on it; the contact sets off a flash when the animal treads on it and completes the circuit. Forresters or gamekeepers will be only too pleased to give advice on shy or large animals. Most photographs of these will have to be taken under bad lighting conditions, either early in the morning or in the twilight. Apart from telephoto lenses, therefore, you will need high-speed colour and black-and-white film in your gadget bag, along with telephoto lenses that are fitted with a fast-focusing attachment, permitting a sharp setting at each turn of the hand.

Single-lens-reflex camera with shoulder rest and 560 mm. telephoto lens with fast-focusing attachment.

when in the middle of a leap. In the last instance, particularly, you should not try to save on film.

Here, too, a telephoto lens is used: if, however, you want to take photographs of the animal's love-life you will need to put on a frogman's suit in spring, and, having put your camera in its watertight casing, step in to the cold water with them. If this is too much for you, you can always watch the life-cycle in a cold-water aquarium; this goes for newts as well as frogs.

Hares, squirrels, and other small mammals call for the same treatment as birds. If you know the paths used by hedgehogs and mice, you can let them take their own photographs by setting up a camera

## UNDERWATER PHOTOGRAPHY

A totally new world is revealed to the photographer under water. You will need at least a watertight housing for the camera and the ability to use a snorkel, although it is better to learn how to use full-scale breathing apparatus: this not only means that you can dive deeper, but also that you can devote more time to your subjects.

Visibility under water is roughly similar to that in a heavy mist on land; this fact must not be conveyed by dull, lifeless photographs. Contrast can be increased with black-and-white if the film is underexposed by up to three stops and subsequently correspondingly over-developed. The same effect can be achieved by using a yellow or an orange filter. They can, of course, only be used at those depths down to which light rays of that colour can penetrate. At greater depth they will no longer be effective unless used in conjunction with flash.

The film used predominantly is colour reversal because of the vast range of colours there are under water. These almost always have to be used with flash. This is not only because natural light may not be sufficient, but because different colours are filtered out at different depths. About 20 ft. down red has gone, at 50 ft. there is no more orange, and violet is fading, and from about 80–160 ft. there is no yellow either; all that is left is a grey-blue twilight, which gets darker the deeper you go. By using flash, however, you can restore the true colours.

This filtering effect of water is not only effective in terms of depth, but also over distances in the horizontal plane. A general view gradually fades

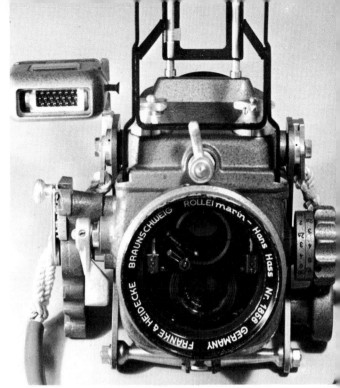

Rolleimarine watertight casing for twin-lens reflex Rollei 3·5 F. The Sixtomat exposure meter is attached in a Hugyfot casing.

into a dull blue; if you wish to reduce this predominance of blue, it is normal to remove the blue coating of flashbulbs except up to distances of about three feet. Underwater electronic flash is used for long-distance work in conjunction with colour-equalizing filters.

The exposure tables given for use with flashbulbs and electronic flash guns are no longer applicable

231

under water. The following values must be used, based on a 64 ASA film with M-contact flash at 1/125 sec.

| Apparent under-water distance in ft. | Aperture with: XM 1B or PF 1B | XM 5B or PF 5B |
|---|---|---|
| 3·0 | 8 | 11 |
| 4·5 | 5·6–8 | 8–11 |
| 6·0 | 5·6 | 8 |
| 7·5 | 3·5 | 4–5·6 |
| 9·0 | – | 3·5 |

| Close-up | Aperture with XM 1B or PF 1B |
|---|---|
| Rolleimar I | 8–11 |
| Rolleimar II | 16 |
| Rolleimar III | 22 |

The values given are approximate, and must be altered according to circumstances. Cracks in the rock, caves, and sand all require an aperture smaller by ½–1 stop: consequently, dark subjects need a correspondingly wider aperture. In murky lakes it will often prove necessary to increase the value by 1–1½ stops.

The person new to underwater photography should start by photographing his friends, and perhaps some of the non-moving life around, for example, coral, mussels, snails, and starfish. Once used to this it is possible to progress on to fish; first the more slow-moving bottom fish and then the faster species. You can use a sea urchin as bait, cutting it up and waiting for small fish to be attracted by the scent of the blood. If you can get pictures naturally, though, the effect is far greater. You can only move into the special area of nature photography one step at a time.

The easiest shots underwater are those of divers: seen near or inside a wrecked ship they look like something from a science-fiction story.

Close-ups are an important part of underwater photography:
this is a tube worm, which reveals its beauty even in black-and-
white, although colour would normally be chosen.

# GLOSSARY OF PHOTOGRAPHIC TERMS

**Achromatism,** *see* Colour correction.

**Angle of image.** This should be measured from the diagonal of the picture, but is often given based on the side measurements.

**Animal photography,** *see* p. 226 ff.

**Anti-glare coating.** To avoid reflections as much as possible, all modern lenses and some high-quality filters are coated with a thin blue layer. Recent developments have produced extremely effective multiple-layer coatings, available under various trade names. They give more contrast and colour brilliance, as well as better colour reproduction, than the simpler sort, and are correspondingly dearer.

Calculation of the angle of image:

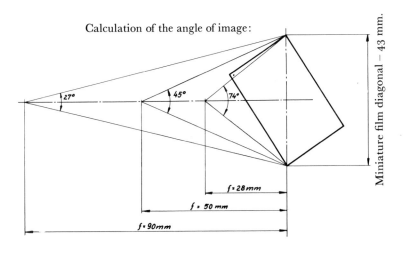

Miniature film diagonal – 43 mm.

f = 28 mm

f = 50 mm

f = 90mm

235

**Aperture.** Controls the intensity of the light falling on the film while the shutter controls the length of time the exposure lasts. Aperture also controls depth of field.

**Aperture calculator.** Found on electronic flash-guns, it gives the aperture setting needed for a particular combination of film sensitivity and flash-to-subject distance.

**Aperture, fixed-hole.** This is a strip of tin with holes of exactly the right size punched in it. Usually attached to cheaper cameras, such apertures do not allow intermediate settings.

**Aperture, international settings.** 1·4, 2, 2·8, 4, 5·6, 8, 11, 16, 22, 32.

**Apertures, notched.** On these the adjusting ring is notched at each setting, and sometimes for in-between settings: silent adjustment is therefore impossible.

**Aperture, preset.** To use this, the desired setting is made: the distance is then set by means of the reflex viewfinder. Before the shutter opens the diaphragm stops down automatically without any need for further adjustment.

**Aperture ratio.** This gives the intensity of a lens.

**Aperture, setting the,** *see* p. 32.

**Aperture time relationship.** Ensures perfect exposure of the film. Aperture and time settings are so arranged that a change of one stop on the former corresponds to the time being halved or doubled. No calculation is therefore necessary to find an alternative exposure. By using this relationship you can take sharp or blurred motion shots, and use a large or narrow depth of field.

**Apochromatism,** *see* Colour correction.

**Aquarium photography,** *see* p. 227.

**Architectural photography,** *see* p. 157.

**ASA (American Standard Association).** Measure of film sensitivity, given on every packet alongside the DIN number, *see* p. 68.

**Available-light photography,** *see* pp. 98, 166.

Yachts are normally taken from deck-level on the horizontal plane. A completely different result can be obtained by climbing the mast and using a fish-eye lens.

**B**

**Babies,** *see* p. 185.

**Background composition,** *see* p. 57.

**Background illumination.** This is as important as illumination of the subject itself when using artificial light.

**Background paper.** Available in over 50 colours, the rolls are hung on the ceiling and draped in an arc on to the floor: this device hides the join of the floor and wall.

**Background projection.** Here the background is created by the projection of the desired slide, a technique used principally in fashion and publicity photography.

**Backlighting.** When photographs are taken into the source of light, *see* also p. 96.

**Bellows attachment.** Leather bellows fitted between camera and lens and used for close-ups and in particular macro-photographs. If suitable lenses are used can produce 1:1 photos at infinity; also allows cheaper lenses to be fitted, instead of telephotos.

**Brightening lamp.** Used to lighten shadows, *see* p. 117.

**Bright-field lighting.** A technique of lighting the background strongly enough to eliminate shadows, leaving the subject 'suspended' in mid-air. If only the background is lit, a silhouette effect occurs.

**Cable release.** Allows shots to be taken from the tripod without shaking the camera.

**Camera, choosing the,** *see* p. 25.

    **holding the,** *see* p. 43.

    **panning the,** *see* p. 209.

    **types,** *see* p. 14.

    **using,** *see* p. 31.

**Camera, aerial.** Take medium- and large-format photographs, and are equipped with special aerial lenses.

**Camera, fully automatic.** Equipped with a lightmeter, which automatically sets aperture and shutter speed.

An aerial camera, the Linhof Aero-Technika 45.

**Camera, ground-glass-screen.** These range from some medium-format models over $6 \times 9$ cm. to all large-format cameras and the sort that Grandpa used. Not to be confused with reflex cameras, although these too make use of a frosted screen in their viewing system.

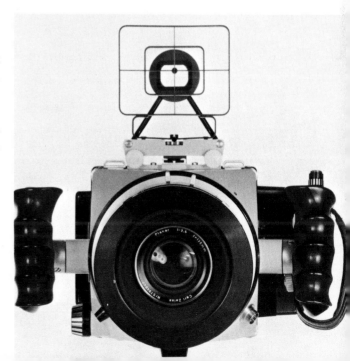

**Camera, instant picture,** *see* Camera, Polaroid.

**Camera, large-format.** Studio or Patten cameras using a runner or Optical Bank system of manoeuvring, and sheet film of not less than $9 \times 12$ cm.

**Camera, medium-format.** These produce pictures ranging in size from $3 \times 4$ to $6 \times 9$ cm.

**Camera, miniature.** Gives photographs of the following sizes: (mm.) $14 \times 21$, $18 \times 24$, $24 \times 24$, $24 \times 36$, or $28 \times 28$.

**Camera obscura,** *see* p. 9.

**Camera, optical-bank.** These are studio cameras that are built to allow maximum manoeuvrability in all directions.

**Camera, panoramic.** These cameras are fitted with a swivelling lens, which exposes the film in strips rather like a focal-plane shutter. The angle of field can be up to $140°$, but the result is in cylindrical perspective.

**Camera, pocket.** (micro cameras) Give negatives $8 \times 11$ or $13 \times 17$ cm.

**Camera, Polaroid.** These are special cameras that produce a positive print shortly after the shot has been taken: they only take Polaroid films.

**Camera, reflex.** Cameras fitted with a reflex viewfinder.

**Camera, semi-automatic.** These are fitted with a lightmeter: either the aperture or the shutter speed is preset, and the other factor is set automatically, according to the light conditions.

**Camera, single-lens-reflex.** These project the image on to a viewing screen through the lens, by means of an interposed mirror. Almost exactly the

Colour Plate 19: A Sudanese musician playing in the open at night. Computer flash was used to get exactly the right exposure.

same picture is seen by the eye as will later appear on film, and there is no parallax problem. Such cameras, which are usually also fitted with a focal-plane shutter, are universal and have a large range of interchangeable accessories.

**Camera, studio.** Plate cameras fitted with tubular runners or the Optical Bank system, both being large format.

**Camera, super wide-angle.** These cover an angle of more than 80° and should not be confused with panoramic cameras and those used with a fish-eye lens.

**Camera supports, shoulder and chest.** These are an aid to holding the camera still, and are used particularly where long lenses are involved.

Colour Plate 20: Movement can be represented by photo-graphing something typical of it, as here with the spinnakers of the yachts, and the slightly blurred rotors of the helicopter.

**Camera technique,** *see* p. 35.

**Camera, tubular-slide.** These are large-format cameras, which are not as manoeuvrable as those using the Optical Bank system.

**Car rest.** Fitted by a sucker to the car window to provide better camera support in the moving vehicle: more used in motion filming than in still photography.

**Celebrations, photographs at,** *see* pp. 116, 189.

**Centre contact.** A contact fitted in the shoe of all modern cameras for use with flash: it eliminates the need for a synchronizing cable.

Charging units for lead and nickel-cadmium cells. Older models have to be plugged in to the AC mains for up to 14 hours, but the newer style can charge the battery in 2–3 hours.

**Children,** *see* p. 187.

**Close-focus attachments.** Have an advantage over supplementary lenses in that they eliminate parallax even on rangefinder cameras, allowing the distance to be set through the viewfinder.

**Close-ups.** These have a reproduction scale of from 1:10 to 1:1.

**Colour contrast,** *see* p. 84.

**Colour correction of lenses.** When white light passes through a converging lens it is split into its component colours: the reason is that each colour is refracted by the glass to a different extent. And this means that they will no longer meet in a point, but that each colour will produce its own image a minute distance away from the others, causing, since only one of these colour images is truly in focus, a series of coloured borders. This effect, known as colour aberration, would not only spoil colour photographs, but would also reduce clarity of black-and-white shots. All lenses must therefore be colour corrected, a process that is called achro-matic or apochromatic correction depending on the colours involved. Achromatic lenses are yellow-green corrected, apochromatic lenses cover the red and blue area of the spectrum.

**Colour photographs,** *see* p. 85.

**Colours, effect of,** *see* pp. 81, 102.

**Colour sensitivity.** The ability to see colours as they should be and not as they really are.

**Colour temperature.** The temperature of light, measured in °K.

**Colour tinge.** The name given to colour photographs where there is a predominance of one particular colour.

**Complementary colours.** Those on the other side of the colour circle: red opposite cyan, blue opposite yellow, green opposite magenta. In juxtaposition they give the greatest contrast.

**Composition,** *see* pp. 58, 78, 81, 121 ff.

**Condenser screens for reflex viewers.** To give all-over brightness to the image a Fresnel or field lens is used. Very finely frosted glass is good for macrophotographs, as well as for microphotographs, although the latter respond better to a screen divided into millimetre squares with a clear spot in the middle. For normal photographs it is best to use a screen with a measuring scale to gain absolute clarity.

**Consecutive-series photographs.** Split up movement into component phases.

**Contrast,** *see* p. 47.

**Contrast resolution.** This is a factor used in conjunction with the resolving power of a lens to give an indication of the sharpness of the photographs it will take. If it has a high resolving power, but poor contrast reproduction, the pictures will not be as sharp as those taken with a lens having less resolving power but better contrast reproduction. As yet no unit of measurement has been developed for this factor; it is a case of using the empirical method to find out which lenses react best under which conditions.

**Curtain effect.** A composition technique, whereby an archway or the branches of a tree are used to give the effect of tabs on stage, to lead the eye into the picture.

**D**

**Dark-field illumination.** A method whereby a subject is photographed against a dark background to absorb the shadows.

**Decamired.** A measure of the colour temperatures of light. The values engraved on blue and pink equalizing filters are in these units. You only need to work out the difference between decamired values of lighting and film type to choose the necessary filter for perfect colour reproduction.

A dark background does not necessarily constitute dark-field illumination. In this photograph the dark background merely arises from the composition of the subject: for dark-field illumination the background would have to be black.

**Depth, effect of,** *see* p. 139.

**Depth of field.** The area of a photograph that is in sharp focus. This area can be increased by stopping down the diaphragm or by using a lens with a shorter focal length at the same distance from the subject.

By comparing two lenses it is easy to see how much more depth of field is offered by a wide-angle lens than by a telephoto at the same aperture.

245

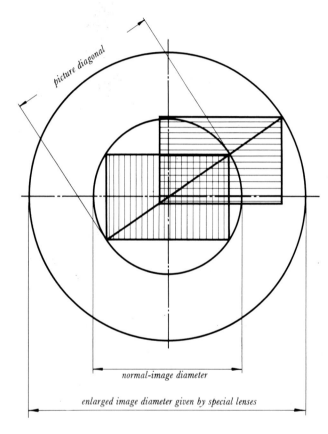

*picture diagonal*

*normal-image diameter*

*enlarged image diameter given by special lenses*

Diameter of the image circle.

**Depth-of-field scale.** This is put on all modern cameras immediately beside the distance scale: it shows the area in focus at any given distance and aperture setting.

**Depth of focus, depth of field,** *see* p. 36.

**Diameter of the image circle.** All lenses produce a circular image, which gets darker and less well defined towards the edges. This means that only the innerpart can be used for photographic purposes, so that the decrease in brightness and sharpness are less noticeable. The useful diameter of the image must be no smaller than the diagonal of the negative format; this eliminates the use of miniature camera lenses for large-format cameras, as a vignette would result. Studio cameras which can be manoeuvred to straighten perspectives need special lenses with a larger image diameter than the negative diameter: the same is true of PC lenses.

**Diaphragm, iris.** A series of moving steel leaves in more or less circular form, which can be set to

limit the intensity of the light falling on a film: unlike fixed-hole apertures, intermediate settings are possible.

**Diaphragm, sprung.** All modern single-lens-reflex cameras are fitted with this. A fraction of a second before the shutter is released it stops down to the preset aperture, and springs open again immediately afterwards. This means a brighter viewing image than with the aperture stopped down, and also means that the camera is more readily brought into action.

**Diffraction screen.** A lens supplement that disperses glare by means of a latticework and that can be made from a piece of (black) nylon stocking stretched across the lens and held with a rubber band. They are also available commercially, in which case they consist of a flat piece of glass with the lattice work engraved on the surface.

**DIN number.** Measure of film sensitivity, *see* p. 68.

**Dioptre.** A unit for expressing the refractive power of a lens, *see* p. 36.

**Distance measure, split-image.** Used in rangefinder cameras: the contours of the subject appear out of alignment until the lens is correctly in focus.

**Distance setting.** Used to focus on an object, using a reflex or rangefinder system. For a full depth of field it must be used in conjunction with the depth-of-field scale on the lens.

**Distorted lines.** These occur when the camera is not held vertically during exposure: the verticals seem to run together at the top or the bottom of the photograph.

a

b

**Distortion.** Produced by cheap wide-angle and variable lenses. Two basic sorts are distinguished: cushion distortion, where the lines curve inwards, and barrel distortion, where they bend outwards. The effect is worst at the edge of the picture. Such lenses are absolutely out of the question for reproduction, scientific, and technical work.

**Double cable release.** Used where no provision is made for automatic control with bellows or with extension and reversing rings to give the advantage of a fully automatic sprung diaphragm.

**Double-exposure stop.** Prevents one from accidentally taking two pictures on the same negative. For multiple exposures and ghost effects it must be possible to release the stop.

Image Distortion: a. barrelshaped (convex); b. cushion shaped (concave).

**Exposure, automatic.** Only possible with cameras having a built-in lightmeter: cf. fully and semi-automatic cameras.

**Exposure correction,** *see* p. 95.

**Exposure margin.** Depends (i) on how much contrast the film is capable of accepting and (ii) the subject contrasts. If the contrast range of the film is 1:64, and the contrast range of the subject only 1:16, the exposure margin is 4 stops on the aperture: it will decrease as the subject contrast increases, until it reaches 0 at 1:64.

**Exposure, measuring the,** *see* p. 92.

**Exposure meter.** Photo-electric lightmeter, hand-held or built-in q.v. For uses, *see* p. 91. The normal field of view covering 45–50° corresponds to that of the normal lens. Can be improved if they have a variable aperture. Spotmeters have a very narrow field of view: two sorts are available – CdS and Selenium cell.

**Extension rings.** These are put between the lens and the camera for close-ups and macrophotographs: the increased length of the lens permits one to approach the subject more closely.

**Exposure times.** On modern cameras each shutter-speed setting is exactly half or double that of the one next to it. This means that the speeds can be precisely correlated with the aperture settings. The speeds are:
1 1/2 1/4 1/15 1/30 1/60 1/125 1/250 1/500 1/1,000 sec. These values have a considerable advantage over those on older cameras where different intervals were used: 1 1/2 1/5 1/10 1/25 1/50 1/100 1/250 1/1,000 sec. (*see also* p. 33).

**F**

**Family photographs,** *see* pp. 185, 189.

**Field-of-view curvature.** The zone of sharpness extends over a curved, not a flat, surface, as though you were taking a picture of the inside of an umbrella; for normal photography, this fault is sufficiently corrected by the use of the aperture, and by the fact that more subjects are three dimensional. But special corrected lenses must be used for reproductions and microphotography.

**Field-of-view selector.** Some rangefinders have a field-of-view selector attached: brought into play by pressing a lever, it shows what picture will be taken with lenses of focal distances of 35, 50, 90 and 135 mm. Advantage: enables quick check on which lens is most apt for the subject.

**Film, anti-halation layer on.** Prevents reflections in the following way. The light projected on to the film by the lens does not only penetrate the light-sensitive coating, but also the film base, which will reflect a certain amount to form another image, or at least darken the emulsion, causing halos, which are especially distracting in high-contrast pictures.

To guard against this, the film base can be dyed, but it is more usual to interpose a dye layer between emulsion and film base, which is washed out in the processing to leave the film transparent. All reversal films have a layer of already blackened grains of silver between the emulsion and the backing, and they too are washed out with the exposed grains during development.

**Film, black-and-white.** This is composed of a layer of gelatine in which the light-sensitive material is embedded in a highly flammable backing made of acetyl cellulose, and, if this is not dyed sufficiently, an anti-halation coating.

**Film, choosing a,** *see* p. 67 ff.

**Film, colour.** Consists of three light-sensitive layers, one on top of the other, containing silver-bromide crystals and colour pigment. Each of these

layers corresponds to a particular area of the spectrum: ideally each one covers $\frac{1}{3}$ of the spectrum, not encroaching on the other $\frac{2}{3}$. Theoretically, all three react to white light, none of them to black. This is not quite the case in practice, since the close proximity of the layers can spoil the brilliance of the pictures: this is corrected by the use of filter or mask layers between the layers of light-sensitive material. Depending on the sort of film, processing produces either transparent positive films or negatives of the opposite colours, called reversal and negative films respectively.

**Film (colour), artificial-light.** Is sensitized to a colour temperature of 3,400°K (Type A) or 3,200°K (Type B).

**Film, colour negative.** Is available in two varieties, masked and unmasked, the former having an orange colour throughout. Masked is dearer, but produces more brilliant results on paper.

**Film, daylight colour.** Sensitive to light having a colour temperature of 5,600°K.

**Film, direct diapositive.** Gives black-and-white slides. As well as for projection, the film can be used to produce negatives by contact printing: gradation is considerably higher than with normal black-and-white film.

**Film, document.** Has a low light sensitivity, up to 25 ASA maximum, although it is not usual for this to be given precisely. It produces extremely hard contrasts, and is used mainly for printed matter or line drawings. If used and developed under special conditions magnificent detail will be given in photographs of landscapes and buildings.

**Film, false-colour.** A colour infra-red film particularly well suited to experimental photography; it can be relied upon not to give realistic colours.

**Film holder.** The manoeuvrable part of some medium- and all large-format cameras, permitting the introduction of cassettes and plates.

**Flash, indirect,** also called bounced flash. This involves the reflector being pointed directly upward at the ceiling: this gives a much softer light with reduced shadow. Compared to normal flash, the aperture setting must be increased by about two stops, *see also* p. 117.

**Film, infra-red.** Although sensitive to visible light, also has a layer sensitive to a specified IR spectrum.

**Film, light sensitivity of,** *see* Film speed, *see* p. 68.

**Film, masked negative.** Colour negative film appears orange even at the edges: this effect is brought about by two built-in correction-filter layers, one yellow, one red. This means that the three colour layers come very close to a perfect realization of the three-colour theory, which means more brilliance and sharpness in the image than would be produced by unmasked negatives.

**Film, orthochromatic.** Black-and-white film that is sensitive to blue and green light, but not to red.

**Film, orthopanchromatic.** Is sensitized to all colours, but makes blue rather too light.

**Film, panchromatic.** Is sensitive to all colours, but makes red appear too light: also called super-panchromatic; all high-sensitivity films are of this variety.

**Film, Polaroid.** Can only be used in cameras specially designed to take this. The film is composed of three parts: the negative layer, the reagent layer, and the positive layer. A capsule containing processing chemicals is burst and its contents spread evenly over the two surfaces when it is withdrawn from the camera. After the stated development time, the two parts can be peeled away from each other.

**Film, Polaroid cassette.** This is made for some medium-format cameras and plate cameras to broaden their scope, so that they, too, can produce instant photographs.

**Film, reversal.** Development produces slides for projection: intended for a specific sort of light, artificial or day, *see* p. 86.

**Film sensitivity.** The light sensitivity of a film is measured in ASA or DIN units, *see* p. 68.

**Film, superpanchromatic,** *see* Film, panchromatic.

**Film, sensitivity of.** The range of colours to which black-and-white film is sensitive must be taken into consideration. Depending on the tones of grey used to represent each colour, the films are labelled orthochromatic, orthopanchromatic, or (super-) panchromatic. The various layers in a colour film react to different colour temperatures, and are split into day- and artificial-light films.

**Filter, colour equalizing.** These are only used with colour films. They are available in six different colours, and serve to eliminate colour tinge. They also allow the photographer to participate actively in the colour composition of his work by introducing a dominant colour.

**Filter, contrast.** Used for black-and-white photographs: it gives different tones of grey to colours that would in normal circumstances come out the same.

**Filter, conversion.** When artificial-light colour film is used in daylight, a red R12 filter must be used to avoid colour tinge. When daylight film is being used under artificial light, a blue B12 filter is necessary: both these filters are quite pale.

**Filter, correction.** Used with black-and-white film to give dark tones for colours to which the film is less sensitive and would therefore reproduce as light greys, *see* sensitivity of black-and-white film and p. 69.

**Filter factors.** Are engraved on the mounting: the measured exposure time has to be multiplied by the factor to give a full exposure.

**Filter gels.** Are much cheaper than glass filters, but also correspondingly more delicate, and require a special holder.

**Filter, greased-glass.** A glass disc, mounted in front of the lens that has had its surface smeared with a thin layer of petroleum jelly or grease except for the central section: the result is a delicate transition on the photograph from sharpness in the centre to a pleasing haziness around the edges.

**Filter, grey equalizing.** Light round the edge, and getting darker towards the middle: used with extra-wide-angle lenses to neutralize the otherwise disruptive effect of a drop in brightness at the edges.

**Filter, grey or neutralizing.** Tones down light of all colours, but does not alter contrast or colour reproduction: is only used to reduce the intensity of the light.

**Filter, haze.** A pink- or salmon-coloured filter that cuts down blue radiation in light around midday, and improves colour reproduction.

**Filter, infra-red.** Opaque and black, and only used in connexion with science, technology, and criminology.

**Filter, interference.** Limits the light to a very narrow spectral zone.

**Filter, light-equalizing.** Either pale red or pale blue: they are used to produce pictures absolutely free of colour tinge.

**Filter, neutral.** Are available in a square format to fit into the collapsible mounting and are graded in factors of $0-16\times$. This allows the exposure to be controlled according to subject and composition.

**Filter, polarization.** Only lets light travelling in one plane pass through: the waves are said to be 'polarized' in this plane, *see* p. 175.

**Filter, POP.** These are monochrome and produce colour shots in that colour: interesting effects can be obtained by taking multiple exposures, using flash, changing the filter each time.

**Filters.** For colour work, *see* Filter, conversion and pp. 70, 103; for black-and-white, *see* p. 72. The best are those made of perfectly flat coloured glass, protected with an anti-flare coating. As far as possible, choose only filter sizes for the largest diameter lens you use: adaptors can be used to mount the filters on smaller lenses.

**Filter, segment.** Consists of several large glass segments, each of a different colour. They offer great possibilities to experimental photographers, especially if used in conjunction with a photoprism.

**Filter, skylight.** This is a pink or salmon-coloured filter, giving better colour reproduction around midday.

**Filter, soft-focus.** Two glass discs with concentric circles etched in them. Depending on the degree of softness wanted, either or both of them can be fitted in front of the lens.

**Filter, ultra-violet (UV).** Used for scientific and criminological purposes: they cut out visible light and only let the UV spectrum penetrate to the film: not to be confused with UV-absorbing filter.

**Filter, UV-absorbing.** Although ultra-violet radiation is invisible to the eye, it is registered on the film. Since it is broken up by the lens it can cause a haze and spoil the sharpness of the lines: this happens most by the sea or on mountains, where UV radiation is at its highest. UV-absorption filters make for clarity and prevent a blue veil appearing on colour films. In principle they can be left permanently in front of the lens except when taking photographs into the light, when it would cause unpleasant reflections. They do not require any increase in exposure time.

**Fireworks, photographs of,** *see* p. 125.

**Flare reduction.** Possible by using a polarizing filter.

**Flash bulbs.** Used to permit hand-held shots even in the dark, but can only be used once. They are used only in flashguns and are designated by a flash index, which rises as the light output increases. For daylight colour and black-and-white film, they have a blue coating, but for artificial-light colour film they must be clear; clear bulbs can still be used for black-and-white.

**Flash-bulb sockets.** Special flash bulbs have bayonet sockets, in particular the small AG socket. Very powerful lamps are fitted with a screw fitting. Certain flashguns have adaptors to permit use of any bulb: normal amateur flash attachments are only intended for use with AG and/or glass-socket bulbs.

Colour Plate 21: Usually a general view of rock formations says very little: their hidden secrets can only be discovered by systematic photographic probing and enlargement.

**Flash bulbs, burning characteristics of.** A peculiarity of all types of flash bulb. They light after 5 m/secs., and then the curve rises sharply to a peak before falling away and flattening out. The whole process involves 50–60 m/secs. Only the middle (shaded) portion of the curve is used for photographic purposes, i.e. the section above 50 per cent. The other two graphs show the difference between X- and M-contact bulbs.

**Flashcubes.** Require special sockets, but no reflector: they have their own mini-reflectors. Each cube contains four bulbs: after each flash the cube is turned through 90°.

**Flash effects,** *see* p. 119.

Burning characteristics of flash bulbs.

Colour Plate 22: Concentration on the essential is particularly important for botanical photographs.

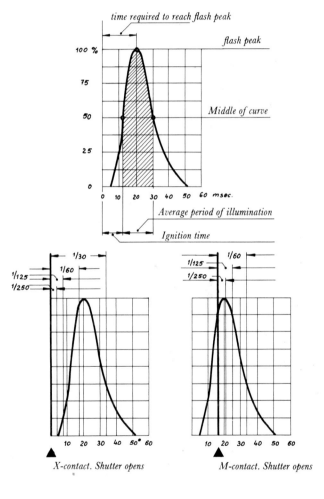

time required to reach flash peak

flash peak

Middle of curve

Average period of illumination

Ignition time

X-contact. Shutter opens

M-contact. Shutter opens

**Flash, electronic.** Works as follows: the current flows from the battery to a voltage transformer and then to the main storage container. The electrodes of the flash bulb have the same potential difference as the condenser throughout the operation: it cannot be discharged because the bulb is filled with inert gas, which will not conduct electricity until it is ionized by a high-voltage surge. This is achieved with the aid of a special ignition circuit.

This is done by leading off a very small current from the main condenser and storing it in the ignition condenser: this is discharged across the

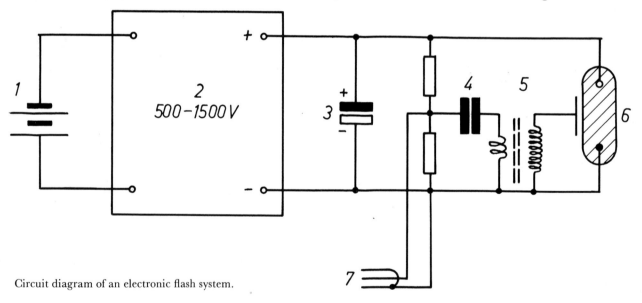

Circuit diagram of an electronic flash system.

ignition coil when the camera is triggered, the current stepped up and led to the flash tube. The gas is ionized, and the current in the main condenser is discharged to give a flash. Cheaper flashguns have no battery and must be run off the mains: adaptors to allow the same thing to be done with other guns are available: otherwise normal dry cell, lead, or nickel-cadmium batteries are used.

**Flash, free.** Gives the possibility of more light configurations than are possible with flash fixed to the camera. A synchronization extension cable is necessary.

**Flashguns, computer.** Electronic flashguns with a sensor that measures the light reflected by the subject and 'chokes' the flash when the correct exposure has been made. The exposure is not controlled by the aperture of the lens, but by the duration of the flash, which requires that the aperture be set according to the instructions. Computer flashguns can be used manually, in which case they are like ordinary flashguns.

**Flash, hot-shoe.** The circuit is completed through the base of the flashgun; no external wires are needed.

Circuit diagram of a hotshoe flash system: B – battery, $R_1$ – load resistor, $R_2$ – supplementary resistor (in some cameras), K – capacitor, L – flash bulb, S – synchronized switch (in the camera).

259

**Flashlight.** The brightest artificial light source, available as standard, electronic, or computer flash.

**Flash, moving.** In a completely dark room the camera is placed on the tripod and the shutter opened: the room is then lit by flash from various points, *see* p. 166.

**Flash, multiple,** *see* pp. 112, 166.

**Flash – open-flash method.** Is only possible in complete darkness: the camera is placed on the tripod and the shutter opened: the moving subject is illuminated by several consecutive flashes.

**Flash photography,** *see* p. 110 ff.

**Flash photographs,** fall in brightness with, *see* p. 116.

**Flash, ring.** Flash tubes can be bought in the form of a ring in a corresponding reflector. They fit round the lens and are used in macro- and close-up photographs to eliminate shadow completely.

**Flash synchronization.** Is fitted to all modern cameras. This means that the full burning of the flash coincides with the shutter opening, giving perfect exposure of the film. Cameras using a between-the-lens shutter have fittings for X-contact and perhaps also M-contact, whereas X- and FP-contacts are provided with a focal-plane shutter.

**Floodlights, soft.** Give a tender lighting effect without shadows: light baths are normally used for this.

**Floodlights, stepped-lens.** Have heat ventilation slits in the casing and a stepped (Fresnel) lens: inside there is a reflector and the bulb, which can be moved forwards or backwards inside the casing to change the angle of beam from 7° to 40°.

**Flowers,** *see* p. 218.

**Fluorescent lamps.** Especially good for soft lighting. They do not produce the full light spectrum, but only a spectrum band, which necessitates the use of colour-equalizing filters to avoid tinge on colour photographs.

**Focal length of a lens.** The number engraved on the body of the lens is the minimum distance from the central plane of the lens to the surface of the film that will give a sharp picture of an object at infinity. In practice, the focal lengths of the various lenses are directly proportional to one another, although strictly speaking this is only true at the ∞ setting. If, for example, you use a 500 mm. lens instead of a 50 mm. one, only 1/10th of the original image will be taken, but it will be magnified ten times.

**Focal point.** Is the point at which all light rays intersect after passing through a converging lens.

**Footlights.** These shine up from below, and have an unreal, theatrical effect.

**Format of pictures,** *see* p. 61.

**FP-contact:** Allows even the shortest shutter speeds with flash, but longer-burning bulbs must be used.

**Frame finder.** An attachable finder that only allows a rough estimate of the limits of the subject, since both frame and subject can never appear in focus at the same time. Used in sport photography to allow an overall view of what is happening, and also in underwater photography.

| Format group | Nominal format in mm. | Effective format in mm. | Surface area of negative in mm.$^2$ | Film | Number of Exposures |
|---|---|---|---|---|---|
| Micro format | 8 × 11 | 8 × 11 | 88 | 9·5 mm. | 15/36 |
| | 10 × 14 | 10 × 14 | 140 | 16 mm. | 20 |
| | 12 × 17 | 12 × 17 | 204 | 16 mm. | 18/24 |
| | 13 × 17 | 13 × 17 | 221 | cassette | 20 |
| Miniature format | 14 × 21 | 14 × 21 | 294 | 35 mm. | 28/56 |
| | 18 × 24 | 18 × 24 | 432 | 35 mm. | 40/72 |
| | 24 × 24 | 24 × 24 | 576 | 35 mm. | 30/54 |
| | 24 × 26 | 24 × 36 | 864 | 35 mm. | 12/20/36 |
| | 28 × 28 | 28 × 28 | 784 | cassette | 12/20 |
| Medium format | 30 × 40 | 28 × 38 | 1,064 | Rollfilm 127 | 16 |
| | 40 × 40 | 41·3 × 41·3 | 1,706 | 127 | 12 |
| | 45 × 60 | 41·5 × 57 | 2,365 | 120/220 | 8/16 |
| | 60 × 60 | 57 × 57 | 3,249 | 120/220 | 12/24 |
| | 60 × 90 | 58 × 86 | 4,988 | 120/220 | 8/16 |
| | 56 × 72 | 57 × 72 | 4,104 | 70 mm. | 53 |
| Large format | 90 × 120 | 84 × 114 | 9,660 | Sheetfilm | 1 or 6 |
| | 130 × 180 | 122 × 172 | 20,984 | or | 1 or 2 |
| | 180 × 240 | 172 × 232 | 39,904 | Plate | 1 or 2 |
| | | | | | Pictures per cassette |

**Gadget bags.** Unlike the carrying case, these hold the accessories as well as the camera, and are usually made of leather with removable sections inside: for a large quantity of equipment, an aluminium case is best, fitted with moulded sections inside for the various bits and pieces. They are shock-proof and suitable for use under tropical conditions.

**Gel holders.** Usually work by magnetism or have light springs.

**Ghost photography.** Double or multiple exposures showing the outside and the inside of an object simultaneously, *see* p. 178.

**Glamour photography,** *see* p. 201.

**Golden mean,** *see* p. 60.

**Gradation.** This is the scale used to indicate the hardness or softness of a film. High-speed films are the softest, and show a wide range of greys. The blackness curve for them is very flat: the contrary is true of low-sensitivity document films, which have a very steep gradation curve and are very contrasty.

**Ground-glass screen.** Found at the back of a large camera, exactly where the film normally lies. The image cast on it by the lens is the same size as the negative format, but it is inverted in both planes and gets darker at the edges. To see it clearly a dark cloth is needed to keep out extraneous light. The screen means that such cameras can only be used on a tripod.

**Half-frame format.** Miniature format of 18 × 24 mm. or 14 × 21 mm.

**Halogen lamps.** These have the edge on conventional photofloods in that they have a higher light output: their colour temperature remains constant at 3,400°K for as long as they last.

**High-key photographs.** Pictures where the emphasis is on delicate, light tones, *see* p. 198.

**Holiday photographs,** *see* pp. 44, 61, 81, 121 ff.

**I**

**Illumination contrast.** This is the difference in illumination of various parts of the subject, measured by the grey-card system or by indirect metering: used mostly with artificial light.

**Illumination for close-ups,** *see* p. 224.

**Indoor photographs,** *see* pp. 165, 166, 171.

**Infra-red effects,** *see* p. 45.

**Infra-red photographs.** These can be taken with any camera fitted with the correct filter; this filter prevents visible light penetrating to the film. Special IR cameras can be bought, and IR film must be used.

**Infra-red rays, heat rays,** *see* Light.

**Instant shots.** Those that can be taken with a hand-held camera without fear of camera shake.

**Jogging the camera,** *see* p. 42.

A comparison between the photograph of Istanbul harbour and this one clearly shows how the choice of subject can change the impression given by a picture. Whereas the former emphasizes the misty atmosphere, here it is the picturesque that is most strongly expressed.

**Kaleidoscope.** Three mirrors joined to make a triangle give this special photographic effect.

**Kelvin, K,** measure of colour temperatures, *see* p. 101.

**Lampstands.** These are available specially designed for the sort of artificial-light sources used in photography.

**Landscapes,** *see* p. 135 ff.

**Lead battery.** A cheap storage battery for electronic flash attachments. Heavier than NC batteries, but also longer lasting: needs constant checking; the charge can be read off from outside.

**Lens brush.** A fine sable brush used to keep a lens free of dust: to stop it becoming dirty the brush itself should be protected.

**Lens heads.** These merely consist of the lens system and diaphragm of a telephoto lens, which reduces their cost. They can only be used with reflex cameras or cameras that can be fitted with a reflecting chamber. A bellows extension makes up for the missing tube, and adjusts the focusing.

**Lens holder.** The part of some medium-format and all studio cameras that allows the lens to be manoeuvred.

**Lens hood.** An important accessory, which should not only be used when shooting into the light. It keeps out extraneous side light, rain, and snow. It must be the right size so that the image is not vignetted. Models with a bayonet or screw fitting are better than those that just clip on. Collapsible shutters are available, made of metal or rubber. A collapsible mounting makes a good substitute.

**Lens metering.** Lightmetering method whereby the meter eye is directed straight at the subject without the use of a light disperser.

**Lens papers.** Designed to clean lenses. First breathe on the glass and then without crumpling it up, wipe the paper over the surface: throw away after use.

**Lenses, aerial.** Produce great sharpness at the ∞ setting, and have no other distance settings.

**Lenses, with between-the-lens shutter.** Can be bought for cameras with a focal-plane shutter to allow complete flash synchronization.

**Lenses, bifocal.** Split lens for close-ups.

**Lenses, compound.** Partly fixed to the camera: only the front portion can be exchanged for another part; this gives a limited variety in focal lengths, but without the expense of full lenses.

**Lenses, converging.** Convex lenses thicker in the middle than at the edge. Unlike dispersing lenses they produce a recordable image. A magnifying glass is a converging lens, and in principle every combination of lenses in a camera forms a converging lens.

**Lenses, diverging.** These are concave lenses giving a reduced image, which cannot be focused on to a screen: they are built in to rangefinders.

**Lenses, fast focus.** Most used for sport and animal photography. Their extension is controlled by two handles separated by a spring: when these handles are squeezed, the two tubes composing the

*Lens*  *Field lens*  *Eye*

*Fresnel lens*

How Field and Fresnel lenses work.

lens are brought together: this means instantaneous focusing. The image sharpness is controlled on the focusing screen of a reflex camera.

**Lenses, field and fresnel.** Compensate for the decrease in brightness towards the edge of ground-glass screens, giving a viewer image of even bright-ness: sometimes the flat surface is frosted.

**Lenses, fish-eye.** Have an angle of view of 180°, and give a strange, crystal-ball look to photographs. Normally the image is round, leaving black corners to the photograph: if the negative is fully used, then the lens angle is not quite 180°. Supplementary fish-eye lenses are cheaper and do the same job, although the results lack definition round the edge.

**Lenses, high-aperture.** Special lenses for minia-ture cameras; they can take photographs without flash even under bad light conditions, although de-tails will not be as sharp.

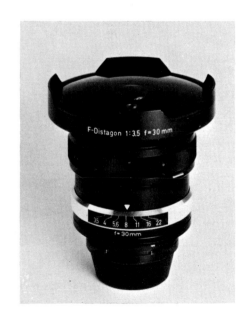

Example of a fish-eye lens: Carl Zeiss F-Distagon HFT 1:3·5/30 mm. for the Rolleiflex SL66, which gives a full-format pic-ture, not a circular image in the middle of the film.

**Lenses, intensity of.** Measured by the maximum possible aperture setting: it is reached by dividing the effective diameter of the lens by its focal length. The intensity is always engraved on the lens casing, either as a ratio (e.g. 1 : 1·9) or as an index (e.g. 1·9). The lower the number, the higher the intensity of the lens.

**Lenses, interchangeable.** Can only be used on cameras not fitted with a fixed lens.

**Lenses, long-distance.** Are all standard construction lenses with a long focal distance: they are relatively unwieldy and heavy, *see* Lenses, telephoto.

**Lenses, macro.** Give greatest sharpness when magnifying the subject. They are normally used with extension rings or bellows. But there are some with a telescopic tube, sometimes fitted with a microscope winding system, in which case they are fitted, with the camera, to a microscope in place of the ocular head.

**Lenses, mirror.** A combination of correction lenses and a parabolic mirror. Their main advantage over telephoto lenses is their compactness and lightness. They have a relatively wide aperture but no diaphragm to adjust it. To achieve correct exposure of the film full use must be made of shutter speed and neutral grey filters: it is impossible to alter the depth of field.

**Lenses, normal.** These give an image using the perspective which we are used to seeing, and have a field of view covering 40°–45°. The focal length corresponds to the diameter of the negative used.

| Format | Diagonal of of negative (mm.) | Focal length (mm.) |
|---|---|---|
| 24 × 36 cm. | 43 | 45 or 55 |
| 6 × 6 cm. | 85 | 75 to 90 |
| 6 × 9 cm. | 108 | 100 or 105 |
| 9 × 12 cm. | 150 | 135 or 150 |

**Lenses, partial image close-up.** Supplementary lens of which one half is plain glass, and the other half is a close-up lens. The result given is a clear image of a small object in the foreground with no tailing off in sharpness in the background.

**Lenses, PC** (perspective control). These have a larger image circle than can be fitted on the negative. It can be manoeuvred in various directions to eliminate perspective distortion in a way that is otherwise only possible with large-format cameras.

**Lenses, pop,** *see* Lenses, spot.

**Lenses, reproduction.** Have a specially high resolving power and are free of the lens defect causing image curvature: they produce greatest clarity with the lens wide open.

**Lenses, telephoto.** These are long-distance lenses fitted with a converging lens; this cuts down length and weight, since the rays intersect in front of the normal point.

**Lenses, wide-angle.** Have a short focal length and an angle of field over 60°; this is larger than that of our eyes. When the angle of field exceeds 90° they are known as super-wide-angle lenses, not to be confused with fish-eye lenses, *see* Lenses, retrofocus wide-angle.

**Lenses, retrofocus wide-angle.** Reflex cameras need to be extra wide because of the space taken up by the instant-return mirror, which means that the normal wide-angle lens cannot be used. A dispersing lens is inserted before the lens, which causes

the light rays to intersect behind the normal focal point. This is said to increase the diameter and length of the lens.

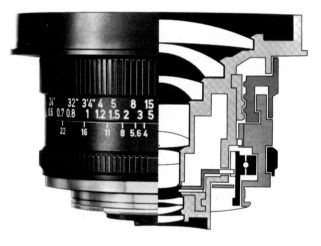

A Retrofocus wide-angle lens: the Super Angulon R 1:4/ 21 mm. by Leitz. To brighten the corners of the picture, the front lens is usually large.

**Lenses, spot.** These are flat in the middle and curved at the edge: they can be used to provide a 'romantic' distortion and haziness around a sharp centre field.

**Lenses, supplementary.** Positive lenses used singly or in groups in front of the lens to allow close-ups to be taken, *see also* p. 221.

**Lenses, variable.** Combine various focal distances in one lens. Their construction is very complex, since allowance has to be made for distortion resulting from adjustment. Used as zoom lenses during shooting, they can give special effects impossible with other lenses. They are only available for movie and single-lens-reflex miniature cameras, as well as for projectors.

**Lens, reversing the.** This means that that end of the lens normally pointing at the film now points at the subject. Used for macrophotography to achieve better sharpness: there is, however, no point in reversing a lens of symmetrical construction.

**Light.** Is produced by electromagnetic oscillations: different wavelengths give different colours of light: These wavelengths are measured in various units: nm. (nanometre), mμ (millimicron), μ (micron), or Å (Ångström), which relate to each other as shown in the footnote on p. 45.

**Light as a subject,** *see* p. 105.

   **used to convey feeling,** *see* p. 97.

**Light, artificial, use of,** *see* p. 107.

**Light index.** A measure of the illuminating power of flash bulbs and photofloods. The index is used to calculate the correct aperture.

Effect lighting captures that 'certain something' when using artificial light: it can, for example, give a silken sheen to hair in a portrait.

**Lighting, continuous.** Can be observed better than flash, and as a source of artificial light should always be chosen when the special speed of flash is not needed, and when the heat generated does not matter.

**Lighting, from the side.** Used to emphasize the plasticity of a subject.

**Lighting, studio.** Generally consists of four to five lamps: the main lamp, secondary lamp, effect light, and one or two for background illumination.

**Light, main.** The main source of light when using artificial illumination, *see also* p. 107.

**Lightmeter, built-in.** These give maximum ease of use; on automatic and semi-automatic cameras they are coupled to the diaphragm and the speed. Formerly only selenium-cell meters were used, but now there is a preponderance of CdS meters, to give exposure readings through the lens (TTL). Cameras that take the reading through the fully open aperture have the advantage of a sprung diaphragm, as well as that of a brighter view-image. Cameras whose aperture has to be stopped down to take the reading have heftier mechanics, a darker view-image, and no automatic diaphragm. There are two ways of taking a reading, integral and selective; many cameras now allow both sorts to be taken.

**Lightmeter, CdS.** A cadmium sulphide (CdS) cell no bigger than 2 mm.$^2$ increases in conductivity as the strength of the light falling on it increases: the change in resistance is measured by the current, supplied by a mercury battery, that is allowed to pass through the cell.

Advantages: Extremely robust and small. Most suitable for use as built-in lightmeter. The angle measured can be reduced to a spot. Much more sensitive to light than the selenium-cell meter.

Disadvantages: Reacts more strongly to red than to blue light. Needle deflection is sluggish, especially in bad light conditions. If a direct measurement is made into the sun, the meter will be blinded. There is a possibility of error if a series of readings are taken one after the other of subjects varying in brightness: the battery should be changed once a year.

Cutaway picture of the construction of a CdS lightmeter (a Lunasix 3).

**Lightmetering, indirect.** Using a light disperser, the meter is used directly in front of the subject, in line with the camera. In this way uneven illumination can be measured, *see also* p. 94.

**Lightmetering, integral.** The normal method, whereby an overall measurement of the whole field is taken. This means that the reading is the average of the bright areas and shadows, which makes it suitable for normal subjects, but not for those where there is a lot of contrast.

**Lightmetering, selective.** Is needed for very contrasty subjects: only the most important parts of the subject are read, either from close up or with a spotmeter.

**Lightmeter, selenium cell.** When light falls through the honeycomb glass on to a layer of selenium, a current is set up and is measured by a highly sensitive ammeter.

Advantages: reacts to colours in very much the same way as the human eye, and therefore follows

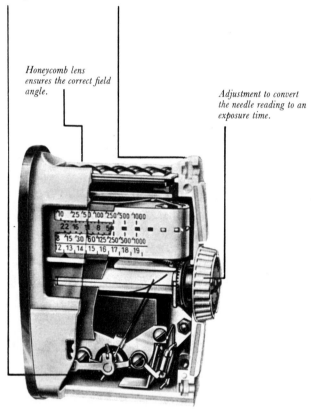

*A rotating coil measures the current by means of a needle.*

*Photo-element turns light into electric current.*

*Honeycomb lens ensures the correct field angle.*

*Adjustment to convert the needle reading to an exposure time.*

Construction and cutaway of a selenium-cell lightmeter (Sixtomat).

the sensitivity curves of the most frequently used films: no battery is required, and the needle reacts quickly.

Disadvantages: very sensitive to shock: not as large a reading scale as CdS meters, greater dimensions and a very wide angle of reading. Not so suitable for building in to cameras.

**Light painting and writing.** Achieved by using a moving pocket lamp: the light trace is recorded on the film for as long as the camera shutter is held open.

**Light, polarized.** Normal light vibrates in all directions, polarized light only in one: reflections, except those from metallic surfaces, consist of polarized light, but it can also be produced by placing a polarizing filter in front of the light source.

**Lights, film.** Produce a harsh source of continuous light.

**Light tent.** A cube or cone of transparent paper put round a subject with a small hole left for the camera lens: the tent is strongly illuminated from outside, the rays being so dispersed that the photograph will be free of shadows.

**Light value.** All aperture/shutter-speed combinations that result in the same exposure are grouped under a particular light value. The following table is made out for a 40 ASA film.

Aperture and speed are mechanically linked to each other; if a large depth of field, or a short exposure time, is chosen, a corresponding adjustment must be made to the other setting. The light value can be used in setting this automatically, except when flash is used, in this case the mechanical link must be disengaged.

Portraits of people wearing glasses must be photographed with particular care to ensure that there is no reflection which will obscure the eyes and make the face look anonymous. It is better for the glasses to appear slightly hazy than for them to contain reflections of their surroundings or even of the photographer.

**Lines, effect of,** *see* p. 58.

**Low-key shots.** Tend towards darkness throughout. Only the essential elements are brightly illuminated, *see* p. 199.

Light values

| | 1 | 1·4 | 2 | 2·8 | 4 | 5·6 | 8 | 11 | 16 | 22 |
|---|---|---|---|---|---|---|---|---|---|---|
| 1 | 2 | 1″ | 2″ | 4″ | 8″ | 15″ | 30″ | 1′ | 2′ | 4′ |
| 2 | 4 | 2 | 1″ | 2″ | 4″ | 8″ | 15″ | 30″ | 1′ | 2′ |
| 3 | 8 | 4 | 2 | 1″ | 2″ | 4″ | 8″ | 15″ | 30″ | 1′ |
| 4 | 15 | 8 | 4 | 2 | 1″ | 2″ | 4″ | 8″ | 15″ | 30″ |
| 5 | 30 | 15 | 8 | 4 | 2 | 1″ | 2″ | 4″ | 8″ | 15″ |
| 6 | 60 | 30 | 15 | 8 | 4 | 2 | 1″ | 2″ | 4″ | 8″ |
| 7 | 125 | 60 | 30 | 15 | 8 | 4 | 2 | 1″ | 2″ | 4″ |
| 8 | 250 | 125 | 60 | 30 | 15 | 8 | 4 | 2 | 1″ | 2″ |
| 9 | 500 | 250 | 125 | 60 | 30 | 15 | 8 | 4 | 2 | 1 |
| 10 | 1,000 | 500 | 250 | 125 | 60 | 30 | 15 | 8 | 4 | 2 |
| 11 | | 1,000 | 500 | 250 | 125 | 60 | 30 | 15 | 8 | 4 |
| 12 | | | 1,000 | 500 | 250 | 125 | 60 | 30 | 15 | 8 |
| 13 | | | | 1,000 | 500 | 250 | 125 | 60 | 30 | 15 |
| 14 | | | | | 1,000 | 500 | 250 | 125 | 60 | 30 |
| 15 | | | | | | 1,000 | 500 | 250 | 125 | 60 |
| 16 | | | | | | | 1,000 | 500 | 250 | 125 |
| 17 | | | | | | | | 1,000 | 500 | 250 |
| 18 | | | | | | | | | 1,000 | 500 |

**Macrophotographs.** These are 1:1 up to 50:1 enlargements: anything larger than this needs to be taken through a microscope. Macrophotography involves the use of bellows, extension and reversing rings, and macro-lenses, *see also* p. 219.

**M-contact.** Used with hot-shoe flashguns on between-the-lens shutter cameras at speeds greater than 1/30 second.

**Meter, colour-temperature.** This registers the predominant colour in the light, allowing the choice of the necessary colour-equalizing filter to eliminate colour tinge. They should not be used with fluorescent lamps.

**Metering, close-up.** This is done at a distance of 20–25 cm. from the subject, so that the whole of the subject falls within the angle of view of the meter.

**Metering, grey-card.** A method of metering using a grey card with a reflecting power of 18 per cent, *see also* p. 95.

**Metering, TTL** (through-the-lens), *see* Light-meter, built-in.

**Mired.** A measure of the colour temperature of light: to find this value in mireds, divide the colour temperature by 1,000,000.

**Mirror pictures,** *see* pp. 181, 200.

**Mist, photographs in,** *see* p. 125.

**Monopod.** A single telescopic rod on which the camera is placed. Only used with motion films.

**Moonlight photographs,** *see* p. 124.

**Motion studies,** *see* pp. 33, 207 ff.

**Motor-drive.** A small electric or clockwork motor, either fitted to the camera or purchased as an accessory. It winds the film on and takes the next shot, so allowing a consecutive series of photographs of fast movement. The normal rate is four shots a second. Motor drive can also be used at long distance to produce interesting photographs of animals in the wild.

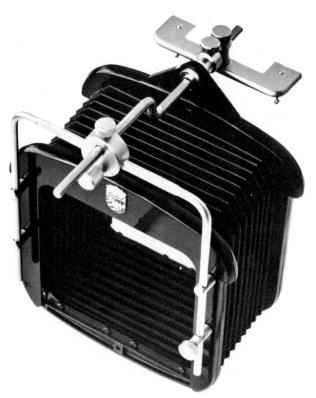

**Mountain regions, pictures in,** *see* p. 136.

**Mounting, collapsible.** Used as a lens shade or as part of a slide-copying apparatus, but also a convenient mount for dispersion filters, vignettes, or a greased-glass filter.

**Multiple exposures.** Deliberate superimpositions of one image or another for special effect. To avoid this happening by accident, most cameras cannot take double exposures without some deliberate adjustment.

**Multiplying prisms,** Photoprisms, *see* p. 199.

**Museums, photographs in,** *see* p. 167.

Right:
The fish-eye lens comes into its own when used to capture the curiosity of people crowding round the photographer.

Left:
Collapsible mounting, made by Linhof.

**N**

**NC cell,** a nickel-cadmium cell. Used for electronic flash because of its instantaneous response. It cannot be seen from outside how fully charged it is. It must be recharged after a long series of flashes.

**Neon signs, photographs of,** *see* p. 123.

**Night photographs,** *see* p. 124.

**Panorama shots,** *see* p. 137.

**Parallax.** A variation resulting from a different picture being seen in the viewfinder than that later appearing on the film. It can only be avoided by using a plate or a single-lens-reflex camera. Parallax is at its worst for close-ups and macrophotographs, and when the viewfinder is a long way from the lens.

**People at work,** *see* p. 201.

**People, in front of the camera.** *see* p. 185 ff.

**Perspective.** This results from the projection of the environment on to a surface, which if flat gives linear or central perspective, if cylindrical gives what is known as cylindrical perspective; a spherical perspective is also possible. Most normal cameras give linear perspective: cylindrical perspective is given by panoramic cameras, and spherical perspective by fish-eye lenses.

**Perspective, central.** That seen when an image is projected on to a flat surface: this is the perspective to which we are most used; beside it a photograph in cylindrical or spherical perspective appears unnatural.

**Perspective, cylindrical.** That seen when an image is projected on to the surface of a cylinder. Panoramas made up of several photographs joined together, and photographs taken with a special panoramic camera appear in cylindrical perspective, *see also* p. 158.

**Perspective, spherical.** Corresponds to the projection of an image on to the surface of a sphere: such an effect is given by fish-eye lenses.

**Photofloods.** Used to produce artificial light, either with a mirror and no reflector, or a reflector and no mirror.

**Photoprisms,** also known as trick lenses. Used like supplementary lenses they produce a multiple image on the film of a single subject.

**Plants, photographs of,** *see* p. 218.

**Polaroid films, development of,** *see* p. 52.

Polaroid photographs can only be taken with Polaroid cameras or those capable of taking a Polaroid cassette, *see* p. 51.

**Portraits,** *see* p. 193.

**Portraits, country life,** *see* p. 190 ff.

**Portraits, group,** *see* p. 190.

Photoprisms of various sorts. Each facet produces an image: by turning them and holding them at different distances from the lens various effects can be achieved.

**R**

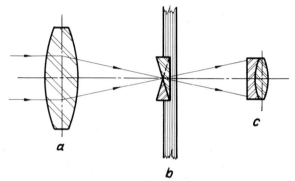

**Rainbows, photographs of,** *see* p. 127.

**Rain, photographs in,** *see* p. 127.

**Rangefinder.** A second window in the camera is used alongside the viewfinder. Inside there is a mirror coupled with the distance control of the lens. It projects its image on to a semi-transparent mirror lying at 45° in the viewfinder: when the two images coincide, the setting is correct, at other times they can be seen separately, one over the other: this is called the confused-image effect. If, instead of the semi-transparent mirror a small opaque-surface mirror is used, a split-image rangefinder is the result. In this the contours do not match unless focusing is correct.

**Rangefinder, confused-image.** Through this one sees two images superimposed until the distance is correctly set, *see* Rangefinder.

How the split-image rangefinder works.

How the microprisms work.

**Rangefinder, microprism.** Uses the principle of the split-image system. Up to 200 miniature wedges, the microprisms, are used in each square centimetre of a central circle on the screen. In use there is no apparent transition from the shimmering out-of-focus image to the sudden appearance of a clear, bright view. The big advantage of this system is that it can cope with flat surfaces as well as structured ones.

**Reflection, room.** This is an important factor in flash photography, since the indices take it into account; flash photographs outside, where this will of course not be relevant, need an increased aperture over that given for the index.

**Reflections.** As light penetrates a lens, a certain proportion of the rays are reflected off each lens surface: this causes a reflection, which is usually the shape of the iris diaphragm. Reflections reduce the brilliance of the photograph by veiling it slightly: the effect is worst with wide-angle lenses and lenses

built up of many component lenses, when photographs are taken into the source of light, or when there is a very strong brightness contrast. Most modern lenses have an anti-flare coating.

**Reflector screen.** Used to lighten shadows. Can be constructed from a simple piece of white card or from a white projector screen: reflection is improved if the cardboard is covered with grained silver or gold aluminium foil.

**Reflex chambers.** These can be attached to rangefinder cameras with a focal-plane shutter to give them the same advantages as normal reflex cameras, with the possibility of adding extension and reversing rings and bellows extensions.

**Reportage,** *see* p. 169.

**Reproductions.** Photographs of flat surface subjects, such as documents, drawings, and paintings, *see* p. 178.

**Reproduction scale.** Is the ratio between the size of the image and that of the object; if an object is reduced in size 50 times, the scale is 1:50, if the reproduction is actual size, 1:1, and at a 10 × magnification, 10:1.

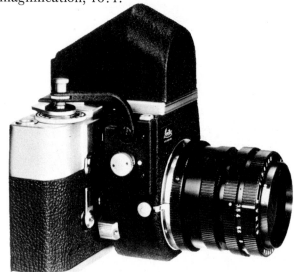

By adding a reflex chamber, you can turn a rangefinder camera into a reflex camera.

**Resolving power.** Measure of definition given by films and lenses, calculated with special test lenses, which count the number of lines per millimetre recorded separately. Low-sensitivity films give about 100 lines/mm., whereas only 30–50 are distinguished by high-sensitivity materials: by contrast a well-corrected lens gives 400–500. The resolving power alone does not control the sharpness of picture, which is also conditioned by film material and the contrast rendered by the lens.

**Reversing ring.** Used to attach the reversed lens to the camera for macrophotographs.

**Rocks, pictures of,** *see* p. 218.

**Sea, pictures by the,** *see* p. 144.

**Selective enlargements.** A means of subsequently eliminating unwanted elements in the picture during the printing of black-and-white or colour negatives: with slides, duplicates must first be made, and these can be expensive.

**Self portraits,** *see* p. 190.

**Sensitivity, conveyed by lighting,** *see* p. 96 ff.

**Shadows, to brighten,** *see* p. 117.

**'Shadow' shots,** *see* p. 200.

**Sharpness of contours.** In conjunction with resolving power shows the sharpness a film is capable of: the lower the sensitivity of the film the better this tends to be. For this reason, wherever special sharpness is called for, low-sensitivity, fine-grain film, developed in fine-grain developer, is essential.

**Shutter, between-the-lens.** Made of interleaved steel blades that open fully during the exposure and snap shut immediately afterwards. It differs from the focal-plane shutter in that the whole picture is exposed at once.

**Shutter, focal-plane.** Consists of two rolls of steel or rubberized cloth. They run in front of the film like curtains, and expose a continuous strip of the film. The width of this strip varies with the exposure time.

**Shutter release.** The lever or knob that operates the shutter to control the exposure time.

Colour Plate 23: Telephoto lenses are the only way of taking animals in the wild, but are also the best to use in the zoo; close-up technique is of course necessary in the aquarium.

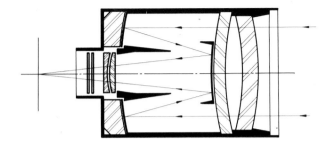

**Shutter release, automatic.** Already fitted to many cameras, but also available as accessories. After the clockwork mechanism has run out (*c.* 10 seconds) the shutter is triggered – this is sufficient time for the photographer to get himself into the picture.

**Shutter-release units, long distance.** These are pneumatic releases, which can be used up to a distance of 60 ft. Before trying them out, ensure that the pressure of a rubber ball being squeezed is enough to depress the button. Electric models are available; they are more reliable, instantaneous in their action, and capable of being used over longer distances. They can be operated either by pressing a button or by radio control. Cameras fitted with a photo-electric cell can also be operated from a distance by a flash or light.

Colour Plate 24: Before you start on underwater photography you must have a water-tight camera and at least be at your ease using a snorkel. Start on the non-moving life forms before progressing to more lively subjects.

**Shutter, releasing the,** *see* p. 42.

**Shutter speed.** The time for which the shutter exposes the film.

**Slides, adjustable.** Found on bellows attachments, or can be bought separately: they make it easier to focus on close-ups and macrophotographs. They can also be used to take stereo photographs with a standard camera, by allowing the camera to be moved to one side. Snapshot technique. The camera is preset and it only remains to press the shutter release button. This is the quickest way of capturing a brief photogenic instant.

**Snow, photographs in,** *see* p. 129.

**Split image.** Combines the advantages of the ground-glass screen with those of the rangefinder. Used on reflex cameras, this aid consists of two semi-circular wedges set opposite each other in the ground-glass screen so that the point where they meet is exactly on the focusing plane. Thus if an

289

object is not correctly in focus, two different pictures appear; these come together as the object is brought into focus. If the split runs horizontally, vertical lines are used for focusing purposes; vertical and horizontal lines can be used if the split runs at a slant. The split image can only be used with lenses opening to at least $f4$, and which do not have too long a focal length.

**Sport, photographs of,** *see* p. 212.

**Spotlights.** Give a narrow but intense beam of light, which is used as a special effect in artificial lighting.

**Spotmeter.** A CdS meter with a very limited angle of view. They are built into many reflex cameras. Gives the most reliable results by measuring individually the different parts of a subject. Close-up and compensatory measurements need not be made.

**Stands, table camera.** Small, very stable, but without adjustable height: because of their size they are easy to transport, and can also be used as chest supports.

**Star-effect glass,** *see* Diffraction grating.

**Stars, photographing the movement of,** *see* p. 124.

**Still life,** *see* p. 182.

**Storms, pictures of,** *see* p. 127.

Crowds are best taken with a telephoto lens. If a relatively long exposure time is used, an impression of hurrying can be conveyed. The strange effect of this picture is obtained by printing in negative form.

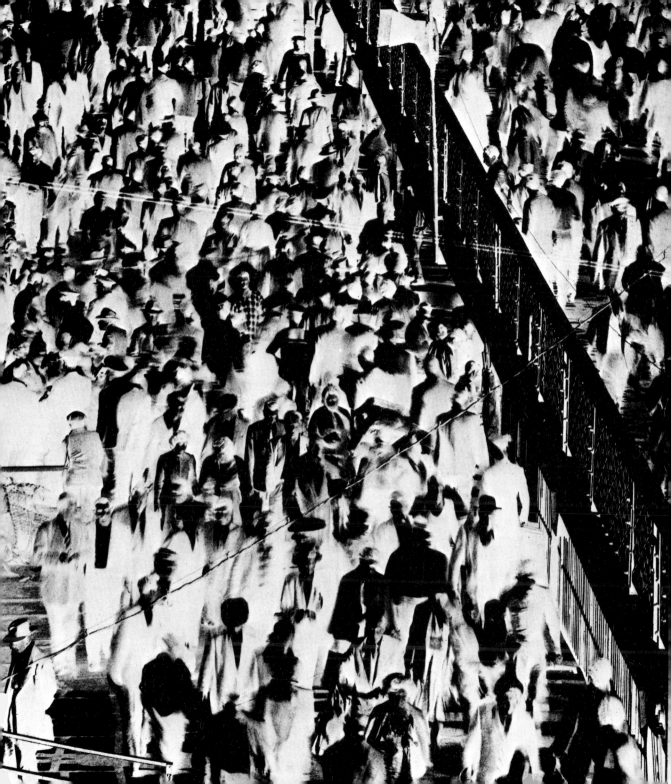

**Stroboscope.** A special high-output electronic flash operating at high speed: from 16 to 50,000 flashes per second can be produced, depending on the type. This is another way of isolating the individual phases of a movement, this time on one negative, *see* Motor-drive.

**Subject contrast.** This is the contrast between the brightest and darkest areas of the subject. It is used in conjunction with the reflecting power of the subject and the contrast of the lighting.

**Sunrise and sunset,** *see* p. 121.

**Superimposition projection,** *see* p. 206.

**Supplementary extension tubes.** Are available for miniature cameras in two different forms: they can either be attached to the normal lens or used by themselves. They are cheap, light, and convenient, but are only a compromise solution, since they can never produce the same quality of image as a lens of similar focal distance.

**Surfaces, effect of,** *see* p. 59.

**Synchronizing cable.** Extension cable for use with flash: branched varieties are available to set off several lamps at once.

The same subject as on p. 291. But this time the image is sharp because a short exposure time was used: the heavy contrast was achieved by taking several copies on line film in the darkroom, till the tones were reduced to black-and-white.

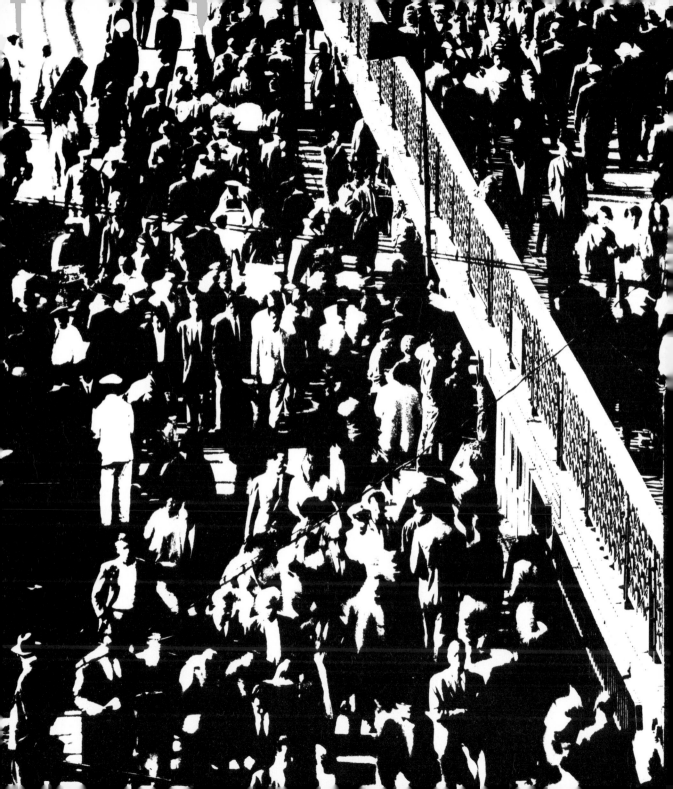

**T**

**Table-top photography,** *see* p. 181.

**Technical photographs,** *see* p. 172.

**Tele-converter.** A diverging lens mounted between camera and normal lens to double the focal distance of the latter. In the process the intensity of the lens is reduced by $\frac{1}{4}$ (i.e. 2 stops). The fact that the quality is not as good as with a true telephoto lens is counterbalanced by the low cost.

**Television screen, photographs from** *see* p. 182.

**Theatre, photographs in,** *see* p. 168.

**Three-colour theory.** Other colours can be produced by mixing the three primary colours, using the additive method, or the subtractive method if the secondary colours are mixed. Colour photography is based on this principle.

**Time exposures.** These cannot be hand held: a tripod is called for, or at least a solid object against which the camera can be held during the exposure, *see also* p. 42.

**Time settings, long.** These are worked by clockwork, and last from 2–32 seconds; used with a locking cable release, it is possible to take exposures that cannot be set on the camera itself.

**Towns, pictures in,** *see* p. 153 ff.

**Traffic, photographs of,** *see* p. 168.

**Tree support.** Small, light, and handy, will fit in any pocket. The ball-and-socket joint only lets it be used comfortably with a light camera, but it is well suited to holding either reflectors for bounced flash or light photographic lamps.

**Tripod.** Ensures that the camera will not shake when light conditions prevent hand-held shots: has to be sturdy so that it does not fail in this purpose.

Three-colour theory of colour composition:
Additive method: a – green
                b – blue
                c – red
                d – cyan
                e – yellow
                f – orange

Three-colour theory of colour composition:
Subtractive method: a – yellow
                  b – cyan
                  c – red
                  d – green
                  e – orange
                  f – blue

295

**Tripod, reproduction.** Specially for copying purposes, these are often fitted with a suitable lighting attachment.

**Twin-lens-reflex cameras.** Here the viewing image is not that going through the main lens, but is seen through a lens immediately above it.

**U**

**Underwater casing.** A watertight shell or housing for normal cameras so that they can be used underwater.

**Underwater photography,** *see* p. 231.

# V

**Variable-focal-length devices.** These are fitted on some cameras with a fixed lens; this makes the camera much more universal in its application and allows telephoto and wide-angle shots.

**Viewfinder, Albada,** *see* Viewfinder, light-frame.

**Viewfinder, box.** The simplest form of reflex view-finder. A collapsible light-proof box keeps out stray light, and a magnifying glass is hinged to the bow. Rigid boxes are available for reflex cameras to keep out all extraneous light.

**Viewfinder extensions.** Can be added to simple viewfinders and rangefinders to show the image given by lenses of different focal lengths: should be used with caution, parallax problems may easily arise.

**Viewfinder, light-frame.** Shows a larger picture than will appear on the film, the format reproduced is shown by a clear frame of light reflected onto the screen: picture and frame are equally sharp. When used on cameras with interchangeable lenses, the image within the frame is usually that for normal lenses, that outside being included for wide-angle lenses, and another, smaller, frame is used to show the image area of a telephoto lens. They can also be used on rangefinders.

**Viewfinder, prism.** These allow both upright and horizontal images to be seen on reflex cameras: they do not pose the same problems for large-format cameras as the simple box viewfinder. Accessories include: a rubber eyepiece to keep out extraneous light, optical correction lenses for people with glasses, and angle pieces that allow the viewer to be used in awkward positions.

**Viewfinder, reflex.** The image is projected upwards by a 45° mirror on to a ground-glass screen. This gives the best opportunity to judge a photograph before taking it.

**Viewfinder, simple.** Only shows the extent of the field of vision, having no control over the distance setting, *see also* p. 20.

**Viewpoint,** *see* p. 57.

**Vignetting.** Dark edges and corners on the image. Occurs when the diameter of the lens does not correspond to the format of the film, or when the lens hood is too long, *see* p. 177.

This photograph shows the delightful effect that can be achieved from shooting into the light.

**Window glass, photographs through,** *see* p. 200.

**Woodland, photographs of,** *see* p. 148.

**X-contact.** This is used on cameras with a between-the-lens shutter to synchronize hot-shoe flash with a shutter speed of 1/30 sec. and with electronic flash at all shutter speeds. It synchronizes electronic and normal hot-shoe flash with a focal-plane shutter: the shutter speed varies according to the make of camera, so read the instructions!

**Zooming.** This is the use of a variable lens during a shot, *see also* p. 209.

Distorted verticals need not be considered as a fault: if exaggerated, they increase tension and give a greater impression of height.

# ACKNOWLEDGEMENTS

Many deserve my thanks for their friendship and support during the compilation of this book. Illustration photographs were provided by Herr von Zydwitz of Ernst Leitz GmbH in Wetzlar, Herr Barnim A. Schultze of the Rollei works in Braunschweig, and by Arnold Richter KG in Munich. Much useful technical information was provided by Agfa Gevaert AG in Leverkusen. Pictures and material was provided by Herren Hoeck and Nowak of the Gossen GmbH in Erlangen, Herren Kufner and Braunwerk of the Linhof Precision Camera works in Munich and Herr Peter Haarhaus of the Polaroid GmbH in Frankfurt/Main. Herr Opitz of the B + W filter manufacturers in Wiesbaden gave me filters for comparative purposes. My special thanks go to Herr Günter Spitaing, who on behalf of the Philips Co. in Germany gave me invaluable answers to queries on flash technique, and who above all took the trouble to read the first copy of the manuscript.

Thanks also to the photographers who provided the photographs printed on the following pages:

Arnold & Richter, Company, Munich, 109, 110.

Gerhard Binanzer, Stuttgart, 31, 36 left, 59, 76, 77, 79, 82, 84, 99, 114, 116, 126, 129, 131, 142, 147, 148, 151, 155, 156, 157 top, 184, 188, 192, 194, 196, 202, 204, 208, 211, 214, 239, 247, 251, 269, 276, 281, 291, 293, 299.

Francke & Heidecke Company, Braunschweig, 16 top, 18, 22, 111, 259.

Gossen Company, Erlangen, 93, 95, 102, 244, 246, 287.

Jo Klein, Wiesbaden, 132, 134.

Leitz Company, Wetzlar, 15, 21, 179, 180, 222, 230, 245, 283, 288, 297.

Linhof Company, Munich, 16 below, 17, 40, 41, 44, 163, 164, 173.

Polaroid GmbH Company, Frankfurt, 24, 53.

Stanko Sosa, Wiesbaden, 90, 165.

Peter Scoones, Seaphot, 24.

Diego Goldberg, Camera Press, 30.

BBC, London, 183.